PUBLIC ADDRESS

Krzysztof Wodiczko

PUBLIC ADDRESS

ESSAYS

PETER BOSWELL

ANDRZEJ TUROWSKI

PATRICIA C. PHILLIPS

DICK HEBDIGE

Krzysztof Wodiczko

Public Address: Krzysztof Wodiczko

Walker Art Center, Minneapolis, Minnesota
October 11, 1992–January 3, 1993

Contemporary Arts Museum, Houston, Texas
May 22–August 22, 1993

Funding for *Public Address: Krzysztof Wodiczko* and for
the artist's residence at the Walker Art Center has
been provided by the Lila-Wallace-Reader's Digest
Fund, The Rockefeller Foundation, and the National
Endowment for the Arts.

Funding for the public projection accompanying the
Walker Art Center presentation of the exhibition has
been provided by The St. Paul Companies.

Funding for this book has been provided by The Andy
Warhol Foundation for the Visual Arts, Inc. This book
is also made possible in part by a grant from The
Andrew W. Mellon Foundation in support of Walker
Art Center publications.

———

Published in the United States of America by the
Walker Art Center, Minneapolis, Minnesota.

Library of Congress Catalog Card Number: 92–60605
ISBN: 0–935640–39–8 (pbk.)

Available through D.A.P./Distributed Art Publishers,
636 Broadway, Suite 1208, New York, NY 10012.

———

Edited by Phil Freshman
Designed by Kristen McDougall
with Lisa Clark Balke

This book was typeset by Eric Malenfant on a Macintosh
IIfx with Quark XPress using Memphis and Frutiger
typefaces. It was printed on U-Lite matte paper by
Toppan Printing Company, Inc., Tokyo.

Front cover digital illustration by P. Scott Makela. Front
cover inset illustration: public projection, Hirshhorn
Museum, Washington, D.C., 1988. Back cover illustration:
Krzysztof Wodiczko with *Poliscar*, 1991.

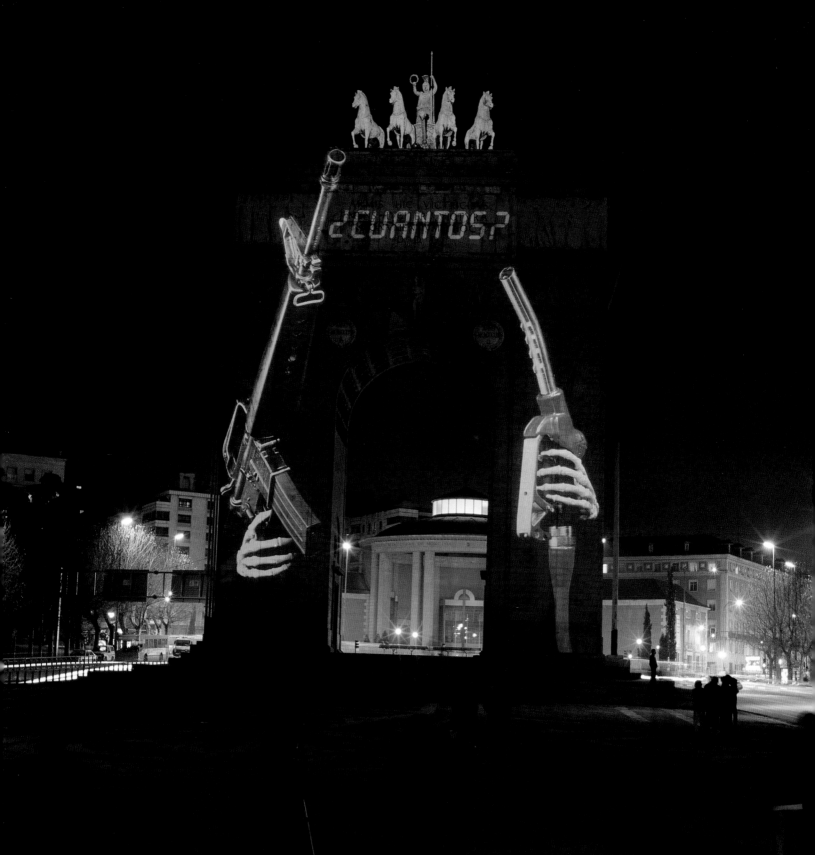

¿CUANTOS?

Arco de la Victoria, Madrid, 1991

Foreword

Spanning roughly a quarter-century of Krzysztof Wodiczko's career, this exhibition reveals the remarkable range of disciplines in which his work is based: industrial design, sculpture, performance, photography, architecture, urban planning, social theory, and critical writing. In order to understand fully the complicated nature and status of public space in contemporary society, it is necessary to analyze the overlap of these disciplines. The questions arising from this study—What is public space? Who operates there? Who controls it? How is it used? How can it be used? What is its social role?—may help us address many of the imbalances that threaten our communities today.

What emerges from Wodiczko's work is a profoundly democratic conviction that the public sphere is a place for communication, a place where people can speak, establish their presence, and assert their rights. With societies around the world struggling with one of the most basic questions of democracy—How can diversity be accommodated while retaining a sense of communality?—Wodiczko's art covers a territory important to us all.

Because the majority of his work is ephemeral and international in nature—lasting for just a night or two or for the duration of an exhibition and presented in far-flung reaches of the globe—and because his career has been neatly bisected by the Iron Curtain (Wodiczko has spent half his adult life in Poland and the other half in Canada and the United States), even ardent followers of contemporary art have for the most part only a patchy familiarity with him. Such relative anonymity is paradoxical for an artist who has devoted his life to the concept of the "public."

It is hoped that this exhibition and accompanying book will provide an antidote to that paradox. In their essays, Andrzej Turowski, Patricia C. Phillips, and Dick Hebdige concentrate on three major facets of Wodiczko's career: his early work in Poland, the celebrated public projections he has created since 1980, and the more recent Homeless Vehicle Project, respectively. In his role as curator of the exhibition, Peter Boswell provides a telling overview that picks out underlying threads running through the career of this multifaceted artist. He also has been instrumental in helping Wodiczko create a new public projection for the Twin Cities.

It is a pleasure for the Walker Art Center to have the opportunity to bring the work of this engaged and engaging artist into clearer focus.

Kathy Halbreich

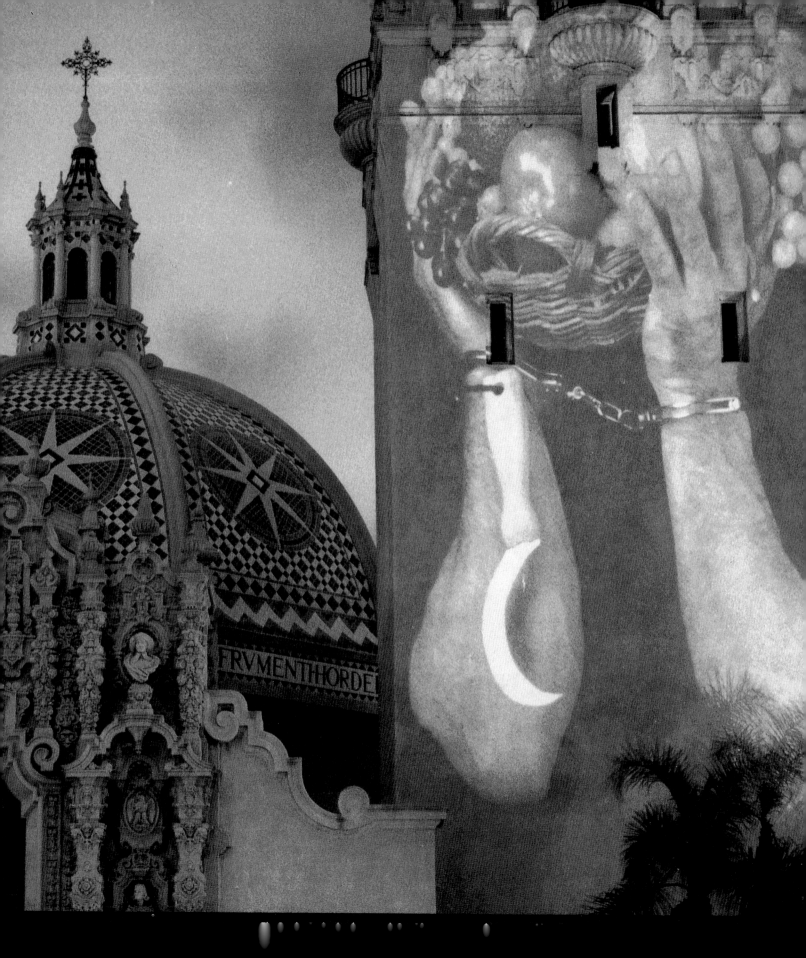

Krzysztof Wodiczko: Art and the Public Domain

PETER BOSWELL

SILENT ADDRESS Krzysztof Wodiczko is best known for the public projections he has been creating since the early 1980s—shimmering, ephemeral displays of colored light cast on public monuments worldwide. Typically, they use seductive means—monumental, even threatening forms cast in radiant, immaterial hues—to convey unsettlingly elusive images relating to concrete social issues. Wodiczko's projection events combine public spectacle with critical exposure.

But it is difficult to understand the dynamic interplay between activism and ambiguity, seduction and detachment, critique and entertainment that characterizes these spectacles without tracing their sources back to the artist's early career, when art served as both an extension of and an antidote to his work as an industrial designer for Polish state industries during the late 1960s and early 1970s. For it was in Warsaw in the late 1960s that Wodiczko began, hesitantly at first, but then with increasing authority, his investigation of art and the public domain.

After his graduation in 1968 from the Academy of Fine Arts (Akademia Sztuk Pieknych) in Warsaw with an M.F.A. in industrial design, Wodiczko's first job was in designing consumer electronic items such as televisions and radios. The international student uprisings of 1968,

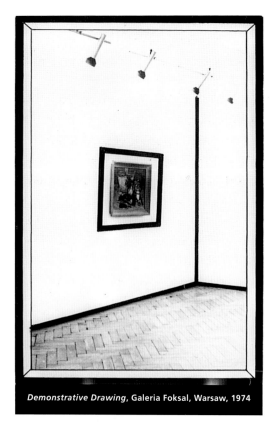

Demonstrative Drawing, Galeria Foksal, Warsaw, 1974

which also touched Poland, made this a difficult period for Wodiczko and many of his fellow artists and designers. Schooled in the Constructivist tradition, which by the 1960s had been largely depoliticized, he was committed to the ideal of the artist as working for the betterment of society. Yet in these first years he found himself designing mass-media products whose principal function was to broadcast the propaganda and directives of the repressive Polish state. (In 1970, however, he transfered to the Polish Optical Works [Polskie Zaklady Optyczne], where he designed instruments that were less susceptible to ideological manipulation, such as microscopes, telescopes, and compasses.) In a reversal of the influential Polish Constructivist Wladyslaw Strzeminski's dictum that the aim of art is to organize "the rhythms of life," Wodiczko came to the conclusion that, in a totalitarian state, the artist best served his fellow citizens by seeking "not to contribute to the further organization of 'the rhythms of life,' but to interrupt, interfere, and intervene in the already highly organized 'rhythms of life.'"[1]

In 1969 he began creating in his off-hours a series of works that commented obliquely on such themes as government control of the airwaves, surveillance, and the isolation of the artist from society:[2] *Personal Instrument* **(1969) (pp. 26, 32)**, a reaction to the plight of the individual in a totalitarian state, for which he wore a pair of headphones in order to filter and manipulate ambient sound in a metaphorical attempt to exert some form of control over an aspect of his life;[3] *Corridor* **(1972)**, a passageway partially bisected by a wall and equipped with four mirrors that allowed one to view continually one's reflection from behind, thereby becoming trapped in a form of perpetual self-surveillance; *Action in Space* **(1972)**, in which Wodiczko and two friends photographed one another from increasing distances until, finally, they had moved so far apart that they could no longer see each other; and *Vehicle* **(1972–1973) (pp. 22, 36, 37)**, a levered platform on wheels that was propelled at a slow pace and in a single, unchangeable direction by the artist-operator, who paced back and forth on the platform.

Wodiczko was able to attempt such "interventions" because the Polish government, unlike other Eastern bloc regimes, was relatively tolerant of avant-garde art as long as it avoided unsanctioned social commentary. In a 1980 article he cowrote using the pseudonym Andrzej

Ostrowski, Wodiczko cites an unnamed Polish critic who explains that "whatever Censorship in Poland does not understand in art is immediately rubber-stamped for public consumption."[4] Thus such relatively esoteric, art-for-art's sake styles as Minimalism and Conceptualism were tolerated and even encouraged by a government that sought to project a liberal image.

A number of Wodiczko's conceptual works and actions were performed in public. So oblique was their commentary that government censors, if they recognized the covert messages at all, could hardly intervene without drawing more attention to their own repressive roles than did the works themselves. Despite the deliberate obscurantism of these works, it was important to Wodiczko that they be shown and operated in the streets, outside the confines of the art gallery. Even if bystanders could not necessarily crack their coded commentary with any greater precision than could the official censors, the artist hoped that the very occurrence of these enigmatic and unorthodox activities in public thoroughfares would raise questions in the minds of his viewers.

The language of indirection that Wodiczko practiced in these early works has served him well in his subsequent public projections. For in these critical spectacles he has had to keep in mind the less centralized, but no less present, forms of censorship that prevail in Western democratic societies.

Wodiczko followed his early works, which tended to examine the role of the artist in society, with a series of installation pieces that examined the language of the artist by focusing on the simplest element in that vocabulary: the straight line. His relentlessly analytical works from the mid-1970s—**Drawing of a Stool (1974) (p. 33)**, **Demonstrative Drawing (1974) (opposite)**, **Ladder (1975)**, and **Line (1976)**—would seem to have little to do with the issue of public address. But in the course of questioning the illusionary function of line, Wodiczko came to examine first how viewpoint determines interpretation, and then the relation of image to architecture, whether in physical or metaphorical terms. In **Drawing of a Stool**, for example, a simple stool is rendered from three viewpoints; one of these views is drawn in a corner of the room, so that if it is viewed from one certain point, the perspective is true. But if it is viewed from any other spot, the perspective falls out of whack; reality and illusion are thus literally relative to one's point of view. In **Demonstrative Drawing**, a found image is surrounded first by a wooden frame and subsequently by a series of black lines that underscore its relationship to the wall, to the gallery, and ultimately to the space beyond the gallery. In other words, each frame focuses the viewer's attention on what is outside rather than inside the frame and ultimately questions the relationship of art to the world outside.

At this point, Wodiczko was taking frequent advantage of the permission to travel

1 Krzysztof Wodiczko (with Douglas Crimp, Rosalyn Deutsche, and Ewa Lajer-Burcharth), "Conversation with Krzysztof Wodiczko," *October* 38 (Winter 1986), p. 37.

2 Wodiczko has noted that many Polish artists in this period worked for state organizations by day in order to pursue their "pure" or apolitical art at night. He laments that only a few of them understood that, by acceding to this state-approved division, "they were really acting as collaborators with the system not in the morning but in the evening." Supra, note 1, p. 32.

3 "The instrument is a public-private exaltation of the individual's 'freedom,' a work of private, aesthetic counter-censorship. 'I am an artist in listening, not in speaking, and though I do not have the right to say what I really want to say ... let me at least be allowed to listen to what I want to hear...,' says the instrument's user.... The *Personal Instrument* was the origin of all my public works, since it was my first attempt to metaphorically define the situation of the individual as 'citizen' in a dominated 'public space.'" The artist interviewed by Maria Morzuch, in *Muzeum Sztuki w Lodzi, 1931–1992: Collection-Documentation-Actualité*, exh. cat. (Lyon: Musée d'Art Contemporain and Espace Lyonnaise d'Art Contemporain, 1992), p. 261.

4 Andrzej Ostrowski (pseud.) and Karl Beveridge, "West/East: The Depoliticization of Art," *Fuse* (March 1980), p. 140.

accorded him by the Polish government due to his status as a valued professional—industrial designer, educator, and artist. In 1975 he began a series of residences at colleges and universities in the United States and Canada. His exposure to these cultures gave him a new perspective on Polish society: "It was extremely crucial for me to see Poland from the outside," he said. "Each time I returned to Poland I was more aware of the extent to which social questions were neglected, how thoroughly we were locked into the prison of an Eastern European perspective.... So I wanted to continue to travel back and forth. How naive I was! Obviously there was no such possibility."[5]

This critical perspective manifested itself in a pair of installations that dealt with the concept of line in a new context. In *Show and Conversation about Line* **(1976)** and *References* **(1977) (below)**, Wodiczko examined the relationships of line to image and art to society by taking a series of photographs of political leaders, news events, architecture, and art, most of which came from official Polish media sources. He projected them onto three canvases inscribed with vertical, horizontal, or diagonal lines that underscored the basic compositional lines of the images. By the randomness of their order, he revealed that each type of line could be equally suitable to images regardless of subject matter, thereby illustrating, in his words, the "'artistic' character of propaganda images and the 'propagandistic' character of art images."[6] In short, by combining line with images found in the press, he was making the transition from the language of image (line) to the rhetoric of image. As part of this effort

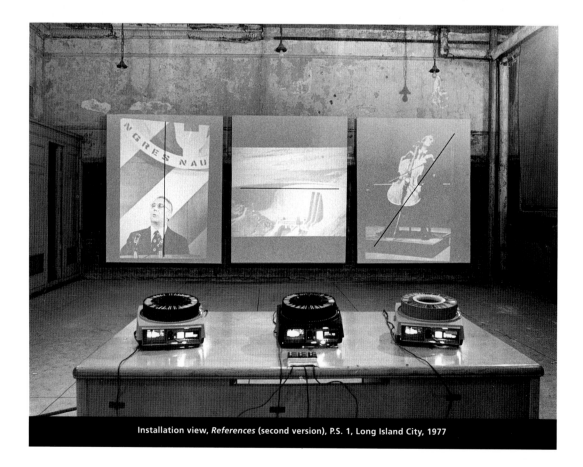

Installation view, *References* (second version), P.S. 1, Long Island City, 1977

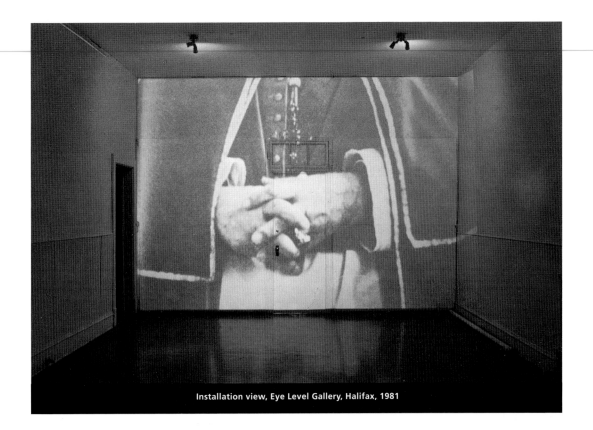

Installation view, Eye Level Gallery, Halifax, 1981

Wodiczko attempted to draw parallels, on a two-dimensional level at least, between the structural properties of architecture and of images—a relationship he eventually would pursue in three-dimensional form in his public projections, in which he superimposes photographic images on an architectural "screen."

But by incorporating images from news sources into his art, Wodiczko ran afoul of the Polish censors. In his 1977 **References** exhibition at Galeria Foksal—a small, highly influential Warsaw gallery founded by artists and critics—his use of several images drawn from the state press was questioned, and a few were not allowed to be reproduced in the catalogue. In Poland in the mid-1970s, he wryly noted, "individuals don't own images; the state does. The result is that it is impossible to change the context of images, because the state is perfectly aware of the semiotics of the image."[7] When he left the country later that year to pursue a teaching residence in Canada, several of his friends at home were subjected to surveillance and harassment. Fearing that if he returned to Poland, he would be forced to collaborate with the authorities in order to receive an exit visa in the future—those who transgressed the government's limits regarding what was permissible in art were subject to an increasing restriction of their privileges, including travel, public exhibition, employment, and social intercourse—Wodiczko had to decide whether to go back home or remain in the West. He chose the latter and established residence in Toronto.

5 Supra, note 1, p. 41.
6 Krzysztof Wodiczko, "Guidelines" (1978 exh. flyer), repr. in Ailsa Maxwell, *Poetics of Authority: Krzysztof Wodiczko*, exh. cat. (Adelaide: Gallery of the South Australian College of Advanced Education, 1982), unpaginated.
7 Supra, note 1, p. 39.

THE ARCHITECTURE OF IMAGE Wodiczko's period of residence in Canada, from 1977 to 1983 (he retains dual Polish and Canadian citizenship), was one of reassessment, refinement, and innovation. He developed a series of proposals for new vehicles that at once expanded upon and clarified the issues at work in his 1972–1973 *Vehicle*. The new designs included a Sisyphean workers' vehicle, powered by sliding a heavy weight back and forth along a levered ramp; a vehicle for the intelligentsia, powered by verbal debate; a democratic vehicle, powered by the random wanderings of participants on a plaza; and, finally, a dolorous gallows vehicle, powered by the operator's self-execution (pp. 38–41). In each case, the labor required to power the vehicle greatly exceeds the motion the vehicle is able to produce. Significantly, in each of these metaphorical designs the vehicle advances in a single direction regardless of the will of the operator—an ironic commentary on the Stalinist and post-Stalinist view of history proceeding in a straight line toward a better future.

While he was working on the vehicles, Wodiczko continued his investigations of the structure of images through a series of installations: *Lines on Culture* (1977), *Lines on Art* (1977), and *Guidelines* (1977 and 1978). Unlike the earliest line and image works, these new versions included images from the Canadian and United States press as well, particularly that most seductive form of Western propaganda—commercial advertising.

In his 1978 *Guidelines* installation at the Hal Bromm Gallery in New York City, Wodiczko began actively engaging the architecture by projecting slides at an angle on the wall, distorting the images in order to point out their main compositional lines and emphasize the gallery's role as a support system. This accentuation of the gallery space as screen or frame was made more explicit in a 1981 exhibition at the Eye Level Gallery in Halifax, Nova Scotia, where he was teaching at the Nova Scotia College of Art and Design (p. 13). Here the projected images occupied an entire wall: floor to ceiling, corner to corner. The images focused exclusively on gesture, eliminating the identities of the participants by cutting them off at the neck. The effect was such that the rectilinear edges of the wall underscored the carefully staged rhetoric of gesture and image—the architectural authority of the image—while the projected photos also revealed the power of the built environment physically to mold perception and behavior. At the same time, the cropping of the images by the architectural frame seemed also to draw attention to what lay outside the frame, an effect related to that of Wodiczko's earlier *Demonstrative Drawing*. The images seemed to be expanding beyond the bounds of the gallery and going back out into the world from which they had come.

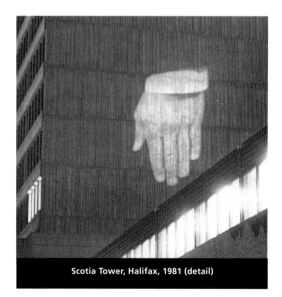

Scotia Tower, Halifax, 1981 (detail)

THE BODY PUBLIC Wodiczko did in fact break out of the gallery when he projected images on three structures around Halifax during the run of the Eye Level exhibition (pp. 14, 88). "All of those manipulations with images projected in the gallery were not effective enough," he said, "because the architecture of the gallery did not relate to anything, either the building or the street. As an act of desperation, I moved out."[8] His first experiment with outdoor projection had come the year before, at the University of Toronto, when he beamed images taken from the press onto the walls of campus buildings. Unhappy with the results of these initial efforts, he decided to create his own images for the Halifax projections. Using masked slides that allowed him to escape the rectangular format of the photo, Wodiczko projected male hands extending from suit sleeves onto the flat sides of buildings. By creating a physical equation between the "body" of the building and that of an individual, he facilitated a reading of the structure's personality—rigid, internalized, inexpressive. These early projections equating buildings with single figures established an open-ended dialogue among the individual body, the architectural body, and the corporate body symbolized by the suit and the male hand.

Wodiczko has described these projections and those he made during the next two years as "phenomenological," in that they analyzed the physical properties of a building in terms of the human body. At the same time, the projections underscored the role of architecture as a vehicle of authority. Of the validity of his work for different audiences, he says, "Despite all the differences, there are great similarities in our everyday lives in relation to our physical environment, whether in Poland, Canada, the U.S., or the Soviet Union. There are similarities in the ways that architecture functions as an ideological medium, a psychological partner, in the way it educates, orders, participates in the process of socialization, in the way it integrates its 'body' with our bodies, in the ways it rapidly changes or even destroys our lives."[9]

In these early projections, Wodiczko used identical or similar images on different buildings, regardless of architectural style. By "clothing" them in suits and striped ties, he identified them as products of the patriarchal establishment. But he quickly moved beyond such generalizing analysis to focus on the architectural language of specific buildings and their place in society.

One of Wodiczko's most ambitious early projections occurred on the neoclassical facade of Memorial Hall in Dayton, Ohio, in 1983 (p. 97). Flanking the entrance to the public theater are the statues of two soldiers—a Revolutionary War minuteman and a World War I doughboy. Above them are found inscriptions memorializing "those who in the hour of the country's danger, tendered their lives." Wodiczko employed "slide projection-intervention" intended to confront the "sculptural-textual" projection already existing on the architectural facade of the monument. His goal was to "temporarily impose the contemporary meaning" of the structure in light of current events, specifically the escalation of the arms race in the first years of Ronald Reagan's presidency.[10] On the six columns of the facade he projected downward-pointing missiles,

8 Leah Ollman, "At the Galleries," *Los Angeles Times*, January 28, 1988, pt. 6, p. 21.
9 Supra, note 1, p. 39.
10 Quoted in *Quintessence* 6 (Dayton: City Beautiful Council, 1984), p. 11.

whose presence posed a clear and present danger to a crowd of figures projected onto the monument steps. Flanking the missiles were identical symmetrical images of women in lamentation, taken from a portion of the French Neoclassical painter Jacques-Louis David's *The Lictors Carrying off the Bodies of the Sons of Brutus* (1789). Wodiczko used David's painting to evoke the sacrifice of young lives in the name of a patriarchal state, and the ritualized role of women as mourners in such a scenario.[11]

IDEOLOGY OF ARCHITECTURE In his move from indoors to outdoors, Wodiczko shifted from investigating the architecture of images to interpreting the iconography and ideology of architecture. Of the Memorial Hall projection he said, "I'm not questioning the specific achievement (memorialized by the building), or the moments in history which required heroism and devotion. What I *am* questioning is our uncritical acceptance of certain myths behind those war memorials—our general acceptance of war and the demand that we uncritically follow the call to service.... I am suggesting that these war memorials are 'sacred' objects of a very indirect ideological nature; they are universalizing war; they are promoting the concept that war *has* to happen and will *always* happen."[12]

Unlike Wodiczko's earliest projections, the Memorial Hall image exploited the specific didactic scheme of the building, expressed in this case through sculpture, the use of text, and a neoclassical architectural style—a style that has, historically, symbolized the authority of the state and that, in the nineteenth and twentieth centuries, has been employed with equal relish by totalitarian regimes of the right and left as well as by democratic governments. Through this projection, he transformed a didactic scheme that invoked the past in order to ensure the future, and he forced the building to address a quintessentially contemporary concern: the arms race. He thus updated the monument and focused its abstract rhetoric on something immediate in the lives of his viewers. This has proven to be a fruitful tactic for Wodiczko, who generally prefers to project his images on edifices that are purported to embody public values ("state architecture") rather than edifices built primarily for commercial purposes ("real estate architecture").

By projecting his images on the facades of these buildings, which are already projecting an image through their architecture and decoration, Wodiczko seeks to unmask the buildings' existing rhetoric, which more often than not is accepted uncritically. Regarding the authority of structures, he has written, "We feel desire to identify with or become part of the building.... Superficially, we resent the authority of its massive monumental structure. We rebel against a tyranny of its deaf, motionless, immortal walls, yet in our heart of hearts ... we will allow ourselves to become intoxicated and seduced by its structural ability to embody, and to artistically grasp our intimate, unspoken drive for the disciplined collaboration with its power." To counteract this, Wodiczko argues, "What is implicit about the building must be exposed as explicit, the myth must be visually concretized and unmasked.... This must happen at the very place of the myth, on the site of its production, on its body—the building."[13] In dealing with the public sphere, he thus seeks to counteract the "official" public statements embodied in our

architecture and monuments. For him, public space is an arena in which no single authority reigns and multiple voices can be heard. By raising issues in his projections that the viewers may interpret and debate, Wodiczko wrests authority away from the monument builders and returns it to the public, thereby "defending the public as communal against the public as private."[14]

Wodiczko's earliest projections on buildings in Canada were what he terms "technical and aesthetic experiments,"[15] often performed unannounced or before limited audiences made up of artists, students, and casual passersby. In time, he has come to nurture and develop his audiences with greater care. By choosing prominent landmarks for his projections, coordinating them with other public events that bring large numbers of people to the given area, and

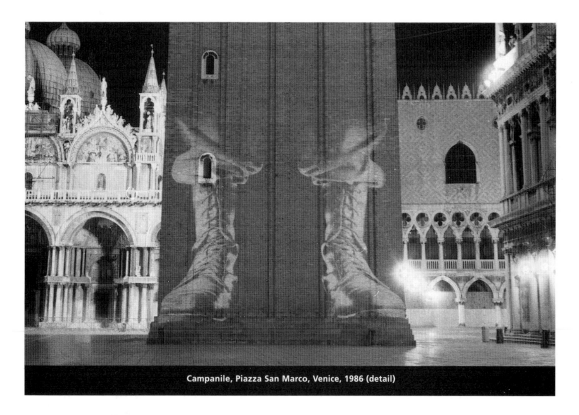

Campanile, Piazza San Marco, Venice, 1986 (detail)

working with sponsoring organizations to publicize the times of the projections, he seeks to ensure large and diverse audiences for his illuminated interventions. He also has moved from the simplest technical arrangements, such as ordinary slide projectors set on the pavement, to high-powered projectors mounted on scaffoldings or flatbed generator trucks.

Along with this increased organizational and technical sophistication, Wodiczko has developed a heightened sensitivity to the site and historical moment of the productions. Increasingly, he has tended to tailor his images to the specifics of each venue, not only with regard to the physical and symbolic traits of the

11 Brutus, first consul of Rome, reputedly ordered the execution of his sons when they were found to have participated in a plot to overthrow the Republic.
12 Richard Schwarze, "The Intent Is to 'Demystify'," Dayton Journal-Herald, May 21, 1983, p. 29.
13 Krzysztof Wodiczko, "Public Projection," Canadian Journal of Political and Social Theory 7 (Winter–Spring 1983), p. 186.
14 Ibid, p. 187.
15 The artist in conversation with the author, February 9, 1991.

landmarks on which he is projecting but also to issues of common concern at the given time of the projection. In the summer of 1986 in Venice—the city Wodiczko likened to an "art-Disneyland" serving as "a strategic center" of "tourism's global empire"[16]—he reflected on the threat of terrorism then prevailing in Europe (pp. 17, 124–131). In January 1988 he produced a two-part projection in the border towns of San Diego and Tijuana that addressed the links between illegal immigration into the United States and California's economy, in which migrant labor plays a key role (pp. 8, 45, 144, 145). In November of that year, just before the United States presidential election, he shone an image of a pair of hands holding a pistol and a candle on the Hirshhorn Museum building (p. 150). Located on the Mall in Washington, D.C., halfway between the Capitol and the White House, the projection was inspired by the conflicting appeals to hope and fear that characterized the rhetoric of the presidential campaign. In January 1991, at the outbreak of the Gulf War, he abandoned his original idea for a projection on the Arco de la Victoria in Madrid, a monument that had been built by Generalissimo Francisco Franco, in order to produce a spectral image that took the war as its focal point (pp. 6, 162).

COUNTER-SPECTACLE Several factors contributed to the refinement of Wodiczko's approach in the mid-1980s. In 1983 he moved to New York City, where he came in frequent contact with artists such as Dennis Adams, Alfredo Jaar, and Barbara Kruger, who also work in a socio-political vein and are looking for an alternative audience to the usual gallery- or museum-goer. Operating independently, these artists have devised myriad strategies for public address, including illuminated light boxes, posters, LED (light-emitting diode) signs, and temporary structures, all of which transmit the artist's message for a given period of time and then disappear.

The hit-and-run tactics practiced by Wodiczko and fellow "critical public artists" were influenced in part by the writings of the Situationist International, an underground confederation of politically inclined European artists and writers clustered around the French artist, social critic, and filmmaker Guy Debord from 1957 until 1972, when the group officially disbanded. Wodiczko became drawn to their work in the mid-1980s, an attraction stimulated in large part by the Situationists' active engagement with urban issues and the psychological impact of the built environment. Debord's 1967 book *The Society of the Spectacle* includes a succession of provocative pronouncements regarding mass consumption and the degradation of everyday life into pure "spectacle":

In societies where modern conditions of production prevail, all life presents itself as an immense accumulation of spectacles. Everything that was directly lived has moved away into a representation.

The spectacle is not a collection of images, but a social relation among people, mediated by images.

The spectacle within society corresponds to a concrete manufacture of alienation.

The spectacle ... is the diplomatic representation of the hierarchic society to itself ...
[it] is the existing order's uninterrupted discourse about itself, its laudatory monologue. It is the self-portrait of power.[17]

The linking of authority and image, and the indirect, even subliminal, authority of image over the life of the individual, are central themes in Wodiczko's deconstruction of public architecture. Debord's antidote to the authority of the spectacle involved the creation of "situations"—spontaneous street events and transformations of familiar images/events/concepts through changes in context—that would serve to awaken passersby from the torpor and alienation imposed by the spectacle. "The construction of situations begins in the ruins of the modern spectacle," Debord wrote. "We must develop a methodical intervention based on the complex factors of two components in perpetual interaction: the material environment of life and the comportments which it gives rise to and which radically transform it."[18]

The critic Jonathan Crary points out that Debord, in his 1988 *Commentaires sur la société du spectacle*, "sees the core of the spectacle as the annihilation of historical knowledge.... In its place is the reign of the perpetual present." Crary goes on to identify the Surrealist movement's countering of organized spectacle in the 1920s through the "strategy of turning the spectacle of the city inside out through counter-memory and counter-itineraries.... The strategy incarnated a refusal of the imposed present, and in reclaiming fragments of a demolished past it was implicitly figuring an alternative future."[19] In a similar manner, Wodiczko turns to public edifices and monuments as a means to invoke history and counteract the contemporary spectacle:

Not to speak through the city monuments is to abandon them and to abandon ourselves, losing both a sense of history and the present.

Today more than ever before, the meaning of our monuments depends on our active role in turning them into sites of memory and critical evaluation of history as well as places of public discourse and action. This agenda is not only social or political or activist, it is also an aesthetic mission.[20]

Surrealism's use of displaced imagery to subvert expectations and its sense of play and counter-spectacle directly affected the tactics espoused by Debord and his fellow Situationists. However, the Situationists firmly rejected Surrealism's enthrallment with imagination and the subconscious mind as a form of decadent self-indulgence that eventually led to the coopting of that movement's subversive intentions.

It is here that Wodiczko breaks with Situationism, for the legacy of Surrealism is clearly evident in both his imagery and writings.[21] His portrayals of buildings as living beings and attribution to them of human, or even superhuman, powers are rooted in the sense of animistic metamorphosis that pervades the Surrealist psyche. Although he calls for the demythification of architecture, he repeatedly does so by unmasking its facade to reveal a menacing being that hides within. His use of montage—the bringing together of separate components to form

16 In Krzysztof Wodiczko, "The Venice Projections," leaflet accompanying the artist's projections on various landmarks in that city, June 25–30, 1986; repr. in *October* 38 (Winter 1986), pp. 18–20.
17 Guy Debord, *The Society of the Spectacle*, rev. English edn. (Detroit: Black & Red, 1983), unpaginated.
18 Idem, "Report on the Construction of Situations and on the International Situationist Tendency's Conditions of Organization and Action." Excerpts repr. in Ken Knabb, ed., *Situationist International Anthology* (Berkeley: Bureau of Public Secrets, 1981), pp. 22, 25.
19 Jonathan Crary, "Spectacle, Attention, Counter-Memory," *October* 50 (Fall 1989), pp. 97–106.
20 Quoted in *Krzysztof Wodiczko WORKS*, exh. brochure. (Washington, D.C.: Hirshhorn Museum and Sculpture Garden, Smithsonian Institution, 1988), unpaginated.
21 Like many activist artists before him, Wodiczko has published a number of critical essays and manifestos that spell out his agenda of the moment. See Selected Bibliography and Public Projections in this book.

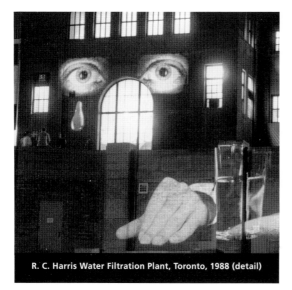
R. C. Harris Water Filtration Plant, Toronto, 1988 (detail)

an evocative composite image—holds the promise of both threat and seduction and calls to mind the potent irrationality of Dali, Ernst, and Magritte.

For his own part, Wodiczko cites the inspiration presented by the German artist John Heartfield, whose vitriolic collages and photomontages skewered the emerging fascism of his native land in the 1920s and 1930s. Wodiczko's own language in describing his projections attests to his reliance on dream imagery and the latent Freudianism of his nocturnal assaults on public architecture:

The attack must be unexpected, frontal, and must come with the night when the building, undisturbed by its daily functions, is asleep and when its body dreams of itself, when the architecture has its nightmares.

This will be a symbol-attack, a public, psychoanalytical seance, unmasking and revealing the unconscious of the building, its body, the "medium" of power.[22]

THE ABSENT IMAGE Critical to Wodiczko's aesthetic is the ephemerality of his projections. Their temporality ensures that they serve to counter rather than complement the didactic or decorative scheme of the edifices on which they are projected. At the end of a 1983 manifesto on public projection he wrote, "Warning: Slide projectors must be switched off before the image loses its impact and becomes vulnerable to the appropriation by the building as decoration."[23] This temporality echoes another of Debord's dicta:

Our situations will be ephemeral, without a future; passageways. The permanence of art or anything else does not enter into our considerations.... Eternity is the grossest idea a person can conceive of in connection with his acts.[24]

In a 1985 interview, Wodiczko explained how the ephemerality of a projection affects its impact: "When the projectors are switched off there is another projection starting. The absence of the image is often more powerful than when it was there, it can have a more lasting effect than if the image were carved there, or if it were graffiti or a mural."[25] And to Phyllis Rozensweig, who coordinated his Hirshhorn Museum projection three years later, he said, "Those structures will never be the same; [the projections] will be visible in a new way after the projector is switched off. The absence of the image will be present."[26]

The temporality of Wodiczko's works is linked also to the temporality of public affairs: what may be compelling at one time may be irrelevant at another. He recognizes the relativity

of meaning when he says that "the same structure in the same part of the city will have a different meaning at different times."[27] The effectiveness of a projection is therefore contingent on its aptness at a given moment. This does not mean that the impact of a projection does not linger: fundamental to his strategy in conceiving a projection is the creation of an image of sufficient evocative power to linger in the memory of those who see it, or even a reproduction of it, so that in the future, the sight of the building will always evoke the memory of the image projected on it. It is here that Wodiczko's Surrealist inheritance, with its emphasis on haunting, ambiguous images whose potency can never be fully rationalized, is of critical importance.

Thus Wodiczko ponders the eternal values supposedly expressed in monumental architecture through temporary illuminations on their sculptured facades. His projections serve, in effect, as counter-spectacles, theatrical special effects that question the language of authority enduringly embodied in the built environment.[28] For Wodiczko, the city at night, when the spectacle is at rest, is an empty stage set waiting to be activated by the projector's illuminating beam.

THE POLITICS OF SPACE Despite his abiding intention to question authority, Wodiczko typically seeks permission for his events and performs them under official sponsorship. His training in Constructivist tradition stressed above all the artist's duty to society rather than the adversarial contesting of bourgeois expectations that has characterized much of Western avant-garde thinking. "Constructivism ... suggested a certain complexity—an understanding of the relations between culture, politics, and design as well as individual and social life. I'm trying to continue that tradition in a critical way."[29] He breaks from the utopian ideals of early twentieth-century Constructivism, however, in choosing to stimulate an awareness of the present rather than build toward an ideal future. This unmasking of existing ideologies provides the link between his early works, such as **Personal Instrument** and **Vehicle**, and his projections.

It was in those early works that Wodiczko learned that one of the prerequisites of critical public art is the study and appreciation of what he terms the "psychology of bureaucracies." This is as true for his projections in the West as it was for his work displayed in pre-Solidarity Poland. No one would be so naive as to think that censorship does not exist in Western democracies, though its forms are certainly less centralized and more ambiguous than in totalitarian states. The ambiguity of his imagery provides a deterrent to censorship by whatever authorities may exist at the sites of his projections.

But this ambiguity is not simply a ploy to defuse bureaucratic opposition. Continuing the interrogative line of thinking he had first established in Poland, Wodiczko has determined that the role of the critical public artist is not to espouse political

22 Supra, note 13, p. 187.
23 Ibid.
24 Supra, note 17.
25 Quoted in Steve Rogers, "Territories 2: Superimposing the City," *Performance Magazine*, August 9, 1985, p. 38.
26 Quoted in Ned Rifkin and Phyllis Rozensweig, *Works 88*, exh. cat. (Washington, D.C.: Hirshhorn Museum and Sculpture Garden, Smithsonian Institution, 1989), p. 43.
27 Ian Smith-Rubenzahl, "Krzysztof Wodiczko: An Interview by Ian Smith-Rubenzahl," *C 12* (Winter 1987), p. 58.
28 The unexpected way in which Wodiczko's projections alter facades that we tend to take for granted, and that may influence us subconsciously as much as consciously, gives his works an impact that is lacking in those by many of his contemporaries whose use of text or image in places where we expect messages dilutes their effect. The presence of information, no matter how subversive, in locations where we expect information to be foisted upon us—billboards, advertising space, LED signs, and so on—makes them as easily assimilable, digestable, and forgettable as the advertising slogans normally found there.
29 Supra, note 27, p. 58.

positions so much as it is to illuminate and question established positions. His means of accomplishing this has been to develop images that refer to topical issues but whose meaning is open to interpretation and therefore left largely up to the viewer. More often than not, his imagery evokes a sense of menace, but the exact cause of the threat is left in doubt and the issue of solutions not even addressed. The open-endedness of the images is intended to galvanize public debate, for Wodiczko seeks to provoke thought and discussion rather than to preach.

This is not to say that there is not a subversive element to his work. But rather than his espousal of a specific and contrary point of view, Wodiczko's subversion consists in his illuminating and focusing on topics that authorities would prefer to leave in the dark, dormant and unexamined.

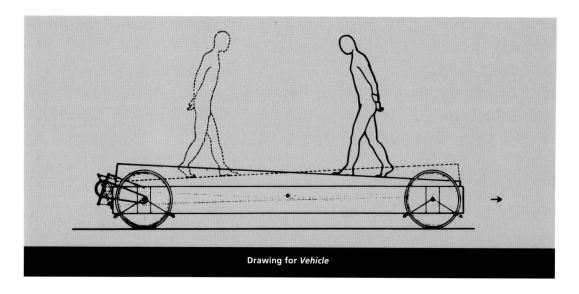

Drawing for *Vehicle*

PUBLIC ADDRESS Wodiczko's preoccupation with architecture and the public sphere does not necessarily limit itself to a concern with individual buildings but extends to the built environment as a whole—the way buildings and space interact to shape the social setting. Essential to his working method is an understanding of who uses public space and how they use it, particularly at night, when his projections take place.

Living in New York City since 1983, Wodiczko has come to realize that the most routine users of public space in our cities are the homeless, a population that most people—including our political leaders—seem to have been doing their best to ignore, if not actively suppress. If in earlier times our society filled its public spaces with grand monuments, it would seem that in our time, as urban redevelopment removes the poorest elements of our downtown populations from their dwellings and forces them out onto the street, our society is populating these same spaces with more fragile, living monuments to our own neglect. Wodiczko writes:

Such forced exteriorization of their estranged bodies transforms the homeless into permanently displayed outdoor "structures," symbolic architectural forms, new types of city monuments: THE HOMELESS.

Homelessness has been a recurring theme in Wodiczko's work since 1984, when he projected a padlock and chain on the Astor Building in New York City, home of the New Museum of Contemporary Art (p. 110). At the time, the floors above the museum were vacant as its owners struggled to find money to redevelop the building. The projection was inspired by the presence in the same neighborhood of Manhattan's two main homeless shelters—the coexistence of empty buildings and homeless people seeming to be a condition endemic to New York and other major American cities.

Subsequent work dealing with the plight of the homeless included projections on the Soldiers and Sailors Civil War Memorial in Boston (1986) (p. 136) and the Westin Bonaventure Hotel in Los Angeles (1987) (p. 138). The link between gentrification and homelessness in New York City is the subject of a trio of his indoor projection environments: *The Homeless Projection: A Proposal for Union Square* (1986) (pp. 76, 77), *The Real Estate Projection* (1987) (pp. 78, 79), and *New York City Tableaux: Tompkins Square* (1989) (pp. 80–83).[31]

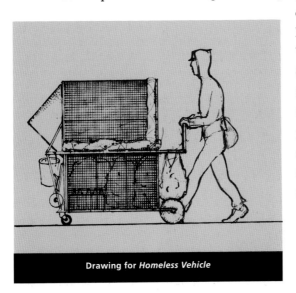

Drawing for *Homeless Vehicle*

Wodiczko's sensitivity to these urban nomads is perhaps due in part to his own status as a displaced person. A cultural refugee from his homeland, he has been living as a resident alien since 1977, first in Canada, then in the United States. In addition, his work has kept him continually in transit, either creating projections at sites around the world or working as a guest lecturer and an interim professor at numerous art schools and universities. It is impossible not to speculate that this rootlessness, this status as a perpetual outsider, has been partially responsible for the urgency with which the plight of the homeless has been imprinted on his imagination.[32]

In the late 1980s Wodiczko devoted most of his energies to developing and modifying several versions of his *Homeless Vehicle* (pp. 67–70), a project undertaken with the cooperation of homeless people, whose input was crucial to the design, development, and testing of the vehicles.

Not intended as a solution to the housing needs of the homeless, this example of "portable architecture" is designed, like his 1972–1973 *Vehicle*, to be metaphorical rather than functional. Literally a "stretch" version of

the shopping carts many homeless people use to pack their belongings, the telescoping *Homeless Vehicle* is equipped with storage bins for the recyclable bottles and cans that provide many of these individuals with a small source of income. Side bins and bags hold the operator's possessions, and a flip-down washbasin handles hygienic needs. Fully extended, the vehicle provides a bed and shelter for its operator.

The differences between the early Polish *Vehicle* and the *Homeless Vehicle* attest to the differences between life in a totalitarian socialist state and that in a democratic capitalist one. *Vehicle* was concerned with locomotion—the effort expended in order to sustain motion and the results of that motion: progress in a straight line, without regard for destination. It was for the exclusive use of the artist, his ineffectual pacing a metaphor for the sense of isolation imposed upon the intellectual who remained free to do as he chose only so long as his work was segregated from and irrelevant to society.

By contrast, *Homeless Vehicle* is designed to make manifest the needs of its operator, who is, specifically, *not* the artist. Unlike the Polish vehicle, its trademark is mobility and adaptability—it is designed to free the operator to go anywhere and meet his or her most fundamental needs for storage and shelter. While *Vehicle* was a prison, *Homeless Vehicle*, with its gleaming metal frame and pointed nose cone, is a free-ranging urban missile, an active metaphorical weapon in the war against poverty, neglect, and displacement. Where *Vehicle* is introverted and self-reflexive, *Homeless Vehicle* is extroverted and, like the projections, intended to stimulate public discussion and debate.

It also is a continuing project, whose lessons and implications are integrated into each successive design. Wodiczko's most recent variation on the theme is *Poliscar* **(1991) (pp. 71–73)**, a pseudo-military minicar that employs high-tech equipment—Citizens Band radios and video monitors—in the war against poverty. While ostensibly intended to promote the concept of community within the displaced population and break down the prejudice against individuals by stressing the collective nature of the homelessness problem, the vehicle's tanklike design also vividly calls forth the economic and class warfare that increasingly plagues America's major cities.

——

The thought of such openly militaristic vehicles in our city streets is an unsettling one for most Americans, though it is becoming increasingly familiar as various types of urban assault vehicles are added to the arsenals of metropolitan police forces. (Clearly, *Poliscar* is a response to this urban arms race.) The sight of such vehicles, however, is a more familiar one to Europeans, who have seen tanks and armored cars rumble through their streets to put down uprisings through much of this century.

Poliscar highlights an intriguing circularity that seems to characterize Wodiczko's career as a public artist. It is, of course, intimately related to the *Vehicle* he designed in Poland twenty years ago. Now it seems to bring the turmoil of Eastern Europe into our own city streets as if to identify the next social battleground.

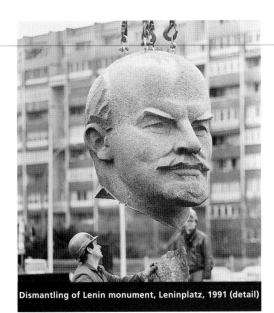

Dismantling of Lenin monument, Leninplatz, 1991 (detail)

Whereas once he had left Poland to pursue his art, now, with the tumultuous events that have changed the face of Europe, Wodiczko is able to return to the East to engage an art form he developed in the West, an art form he could never have practiced in a totalitarian society that nevertheless championed the public function of art. In 1990 he created a pair of projections in what were then still West and East Berlin, one on the Huth-Haus in Potsdammer Platz (p. 159), the other on the Lenin monument in Leninplatz (p. 158). In the latter, Wodiczko transformed for one night the founder of Soviet state socialism into an eager consumer, equipped with a shopping cart laden with cheap electronic components. Lenin was reduced to the status of his historical minions, desperately taking advantage of the opportunity to indulge in the bourgeois "decadences" of the West. The rhetoric of this heroic sculpture was completely subverted through monumental irony.

Yet Wodiczko's nocturnal intervention was benign compared to the fate that ultimately befell the sculpture. Within a year, the Lenin monument was dismantled and removed, a victim of the iconoclastic backlash against Communist rule. This act of historical erasure exemplifies one of the dilemmas of public art in the face of change, be it aesthetic or political: whether it is better to forget or remember. When we are left with an empty plaza, or the photographic memory of Wodiczko's intervention, the wisdom of impermanence seems clear.

Peter Boswell is associate curator at the Walker Art Center and organizer of the exhibition *Public Address: Krzysztof Wodiczko.*

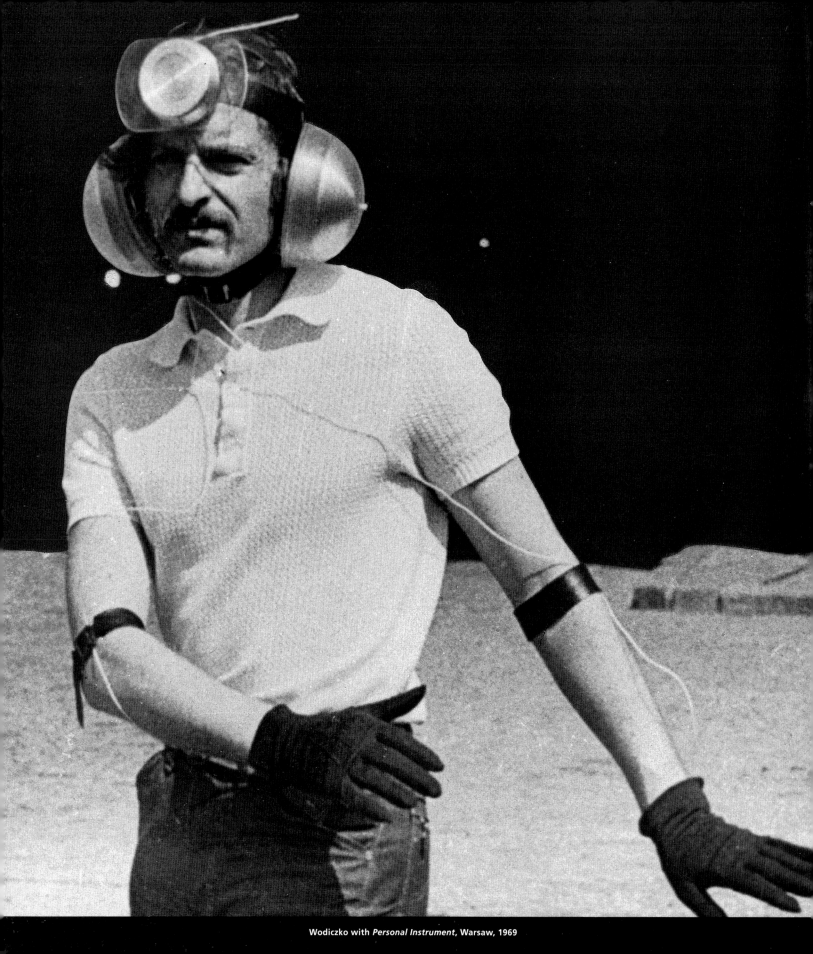

Wodiczko with *Personal Instrument*, Warsaw, 1969

Wodiczko and Poland in the 1970s

ANDRZEJ TUROWSKI

In a 1977 interview, Krzysztof Wodiczko stated his conviction that "artists are concerned with the exploration of reality, [and] they even attempt to transform it." They are not producers of beauty, he continued. If they were, they would just be "narcotizing society by means of art."[1] His position was closely related to the tradition of revolutionary Constructivism, with which he was becoming acquainted at the time through exposure to work by the Soviet artists Vladimir Tatlin and Aleksandr Rodchenko and the Polish artists Katarzyna Kobro, Wladyslaw Strzeminski, and Mieczyslaw Szczuka. A standpoint such as this situated his investigations squarely within the realm of social reality. As Strzeminski had written in the 1930s: "Instead of decorating

1 The interview, entitled "Jestem za Akademia" ("I Am for the Academy"), appeared in the newspaper Sztandar Mlodych (The Young People's Banner) 184 (8487), August 4, 1977, unpaginated.
2 Wladyslaw Strzeminski, "Sztuka nowoczesna w Polsce" ("Modern Art in Poland"), in Jan Brzekowski et al, O sztuce nowoczesnej (On Modern Art) (Lodz: Wyd. Tow. Bibliofilow, 1934), p. 92.

life with pictures, contemporary art can become an organization of the processes of collective life."[2] Today, it may seem simplistic to attempt a search for deeper structural affinities between revolution in the arts and in politics. Still, one must concede that when an artist's functioning is based on a critical analysis of reality, it may be viewed as an intervention in public life; and thus it bears all the characteristics of revolutionary activity. In this sense, it is not aesthetic structures but artistic and political strategies that vie with each other to establish a critical or an affirmative judgment and appropriation of reality. Avant-garde utopias and ideologies of power may be seen as the modernist precursors of this state of affairs. With these considerations in mind, I would say that it was a process of historical reflection, undertaken in the context of Poland in the 1970s, that introduced Krzysztof Wodiczko to his present mode of work.

I once defined *ideosis* as the space in which dominant political options hold sway over individual choices.[3] It really does not matter whether this dominance is justified by "historical necessity," by "reasons of state," by a "common understanding," or by a "proper goal." What is important is that these justifications are formulated from the position of a political power that aims to subsume the decisions of individuals.

From the end of World War II until the upheavals of the 1980s, Polish art was subject to the constant pressure of just such an ideosis. Thus a correct appreciation of the attitudes that the art of this era produced and the values it represented cannot be limited to reflections concerning the Polish, or even to a universal, artistic tradition. Even assuming that full cultural independence can only be an illusion, the essential question is the extent to which political power seeks, and manages, to subordinate culture to its own aims. In postwar Poland, political power held culture in its monopolistic sway for many years, but the means implemented to uphold this monopoly varied over time.

In the so-called culture of Socialist Realism in Poland during the 1950s, the position assigned to the artist was that of an object. The aim was the total degradation of his social role. The artist was compelled to choose between negative options—to abandon his artistic position or dissimulate it. The only positive alternative that remained was to take on the role of the political activist who accepted the idea and form of realism, as defined by the

authorities. Artists thus were either turned into political agitators merely carrying out decisions made by the political ideologues, or they were led to abandon all public activity.

The end of Stalinism and the political evolution of Poland in the second half of the 1950s put the political condition of the artist into a new light. A public discussion on culture was generated by Wladyslaw Gomulka (who had just been named first secretary of the Communist Party),[4] but it was a discussion that had its roots entirely in the Stalinist period and that, significantly, focused on the traditional Marxist opposition between realistic and abstract pictorial styles. The first steps were to restore to the artist the right to manifest his position openly, and to outline the boundaries within which the artistic consciousness might intersect with political tactics. This was not always an easy task for the authorities, who had no intention of disclosing their real motivations. For that reason, the debate was quite soon reduced to art itself and the formal limits of abstraction. This debate obviously enlivened artistic life, and certain individual works went beyond purely Polish problems to enter the realm of the universal problems of art. From that point on, official policy in the cultural sphere was based on limiting, stimulating, or appropriating already existing or emerging means of representation and containing them within the orbit of sanctioned ideologies. It no longer imposed definite artistic formulas.

In Polish artistic life of the 1960s the discussion of modernism reached full maturity, a development that manifested itself in a universalization of artistic attitudes. In the realm of painting this led to the consolidation of the formalism of abstract art in all its variations. Although initially tied in with the post-Stalinist breakthrough, by the beginning of the 1960s abstraction had become a mass convention, undergoing a process of stereotyping. From a political standpoint, it could be justified on the basis of the aesthetic theory of "a realism without bounds,"[5] a philosophically inspired attempt to find existentialist elements in Marxist doctrine. Among other things, this theory vindicated the concept of "creative individuality" and initially enabled the political authorities to use abstract art as a means to legitimize their own role. On the one hand, the geometricism of abstractionism was assimilated by industrial design. On the other hand, the painterly base of the *informel* made it possible to launch the "Polish school" of the poster, which had its roots in expressionist pictorialism.

In Poland, the negative impact of Socialist Realism was (and continues to be) so immense that the only response on a major scale to the model of culture imposed in the 1950s was refusal. Consequently, all vestiges of realist doctrine were erased, without any critical revision, from the collective social memory by the formalism of abstract art and, later, by the self-referentiality of conceptual art—a development that greatly suited the authorities. The events of 1968 in Poland brought no fundamental change in this respect.[6] Considered by society as having been manipulated by the government, these events brought about a superficial critique in the field of culture, but opposition was limited to the

3 Andrzej Turowski, "L' 'idéose' polonaise: La politique culturelle du pouvoir communiste en Pologne, 1945–1981" ("Polish Ideosis: The Cultural Politics of Communist Power in Poland, 1945–1981"), *Ligeia* (Paris), no. 1 (1988), p. 30.
4 Gomulka was head of the Polish Communist Party (PZPR) from 1956 to 1970. Under one-party rule, which lasted until mid-1989, the government was subordinated to the Central Committee of the Communist Party and its first secretary.
5 Roger Garaudy, *D'un réalisme sans rivages* (*Of a Realism without Shores*) (Paris: Libraire Plon, 1963) and (Warsaw: Czytelnik, 1967; Polish edition).
6 In March 1968 students at Warsaw University, and then at universities throughout Poland, stood up to defend political and artistic freedom and to oppose censorship. Strikes and violent demonstrations lasted for several months. As a result, brutally repressive measures were taken against both students and the intelligentsia.

interference of censorship in the national heritage. The revolt, initially aimed against the rule of the Communist Party bureaucracy, gave rise instead to a campaign of anti-Semitism (a campaign that had been planned as an element in the factional struggle for power within the Party) along with a governmentally manipulated wave of resentment against the intelligentsia. There had been no fundamental questioning of cultural institutions and policies or of the social functions of art. The role of the bourgeois tradition, of the avant-garde, of ideology, and of artistic utopias had not been contested. Thus, after 1968, artists continued to think in terms of the antinomy of realism and formalism (although realism already had suffered a total defeat) in the sense defined by Györgi Lukács.[7]

The late 1960s and early 1970s was a period of turmoil in the arts, the result of the confused political situation surrounding the ouster in 1970 of the Gomulka regime. During the first half of the 1970s, the reform government of Edward Gierek attempted to take advantage of this situation in the arts.[8] Using an official art critic as a mouthpiece, the Party expressed its tactical doubts concerning the opposition between "realism and the avant-garde, which—as we have read in a programmatic statement—need not necessarily be a radical one."[9] While proposing an "open" point of view of all cultural phenomena, this rhetoric in fact advocated administrative control of the "social tasks of realism" and claimed the right to judge "the avant-garde's capacity to reassess the tasks it set for itself."[10] This fundamental encroachment upon creative freedom was due to characteristics of the Polish art scene at the time. The new figurative movement in painting, drawing, and the graphic arts was developing a narrative form of art. In light of the political tensions of the early 1970s, the verism of this art form could all too easily have taken a critical form, directed against the Party as well. For this reason, the attempt was made to encourage the Polish version of Pop Art (after first fallaciously identifying it with the avant-garde), to the extent that it could be institutionally controlled. What is more, the new Gierek government, with its "consumer society" policy, was in need of a "modern" aesthetic wrap—and all forms of art that were related to mass culture could be useful in this context. From a political point of view, it was quite unimportant that a form of art that was born of a critique of mass culture became, in Poland, its decorative surrogate. Of course artists responded to this attempt to realign the entire avant-garde under a realist banner with increased "anti-realistic" attitudes. Thus Conceptual Art, which was just developing in the early 1970s and had come out decisively on the side of the avant-garde by appealing to the well-known opposition between realism and formalism, turned out to be not so much a critique of formalism as a rationalized version of it. This turn of events led the Party to modify its strategy again, although use of the old blueprint greatly facilitated that task.

To understand this process in full it is necessary to return for a moment to the 1960s and outline another trend in Polish art. By this I mean the extra-pictorial radicalization of the avant-garde, grounded in artistic tradition and so significant for the 1960s—the entire realm of Happenings, events, and environments. This trend presented the Party with a difficult political problem. For these manifestations did not fall within the theoretical definition of realism. Instead, they often took place outside the gallery-and-exhibition structure and were therefore

not always easy to control. From the very start, then, the authorities, unable to dominate this form of art, attempted to limit its influence. A social motivation also was found for certain of these manifestations, which might take place under the sponsorship of large industrial enterprises (in the name of worker patronage) in the course of state-organized artists' seminars and retreats. Other events, those that could be circumscribed by the official formula "shaping the environment aesthetically" (i.e., that could be defined within an already controlled urban space), also met with a certain measure of approval. I mention this because the first generation of Polish Conceptualists was recruited from this circle of artists, a fact that does not cast doubt upon the theory of the formalist roots of Polish Conceptualism but that somewhat complicates its definition. I would like to emphasize that it was precisely this formalism that made it so easy for many artists who were supposedly working "beyond the realm of art" to pass to the level of a purely tautological quest within the framework of art itself.

While the government, through its new policy of the 1970s, loudly proclaimed "artistic pluralism," it was giving silent support to purely formalist works—in spite of the doctrine of realism, which was still officially defended at the time. All of this fit in perfectly well with the slogans about the modernity of the state and its politics, a further legitimation of the government's cultural liberalism. This liberalism also differentiated Polish cultural policy from that of other countries in the Eastern bloc. One should, however, not assume that the Party had abandoned its claim to ideosis. Conceptual Art could be of use to the Party only if it gave up its acuity of expression. Consequently, when dealing with this tendency, it was never the Party's aim to limit its meanings (since these referred to art itself) but to deprive them of their conceptual values and their inherent analytical potential. It is indeed no paradox that, in their cultural policies, Polish political authorities tended to maintain the formalist status with which the artists themselves had endowed Conceptual Art.

In this context, a significant trait of the new policy was its acceptance of the avant-garde's "differentiated modernity." This acceptance took the form of sponsorship of numerous exhibitions and debates, usually conducted under the patronage of state-controlled socio-political organizations. Conditions for apparently independent artistic choices were created, with a preference given to those of a commercial nature. One could say that what most characterized these years was the political acceptance of "modernist" art that made use of avant-garde devices, formulas, and categories but that already had been tamed and deprived of its analytical and critical artistic value.

Although behind the times ideologically, the cultural policy of the Party was, in practice, effective. It confirmed the theses of the philosophers of revolt of the 1960s, such as Herbert Marcuse, who claimed that the annihilation of the autonomy of art (and thereby of its utopia) and the basing of autonomy within strictly formal categories

7 Lukács put forward this definition in his essay "The Ideological Foundations of Avant-Gardism," the Polish translation of which first appeared in the Communist Party publication *Zeszyty teoretyczno-polityczne* (*Theoretical-Political Notes*), nos. 9 and 10 (1957), pp. 41–46.
8 Gierek utilized the mass discontent stemming from a stagnant economy and from Gomulka's bloody repression of the Gdansk shipyard strikes of 1970 to rise to the position of first secretary of the Polish Communist Party in 1971. Aided by Western credits, the new government was able for a short time to raise the standard of living. This period was followed by a deep economic crisis, which led to another wave of strikes, to the formation of Solidarity in 1980, and to Gierek's removal from power the next year.
9 Krzysztof Kostyrko, "Realizm i awangarda" ("Realism and the Avant-Garde"), *Sztuka*, no. 1 (1974), p. 2.
10 Ibid.

leads to a paralysis of the oppositional power of art. The effect of this paralysis is that works of art may finally be assimilated within the bounds of utilitarian values and transformed to serve the ends of mass propaganda and commerce. In Poland, where there had been no true revolt in the 1960s, few artists were aware of the authorities' intentions. Moreover, the opposition between realism and formalism there had never been reconciled. This opposition turned into a long-lasting component of the negative tradition of Socialist Realism in Polish culture—and was shrewdly exploited by the authorities. Taking these two facts into consideration, one must conclude that official policy in the 1970s succeeded in implementing the cultural policy of the first post-Stalinist years to a notable degree. Works of art were almost totally deprived of their

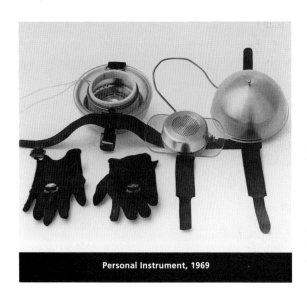

Personal Instrument, 1969

A microphone placed on the forehead receives sound from the environment and transmits it to the electroacoustic filters located in two soundproof earphones. The filters are controlled by two photo-receptors, fastened to the palm of each hand. The movement of the hands regulates the amount of light reaching the photocells and thus the degree of filtering. The right-hand photoreceptor controls the low-pitch filter, and the left-hand photore-ceptor controls the high-pitch filter. The waving of hands creates a "glissando" effect, sliding up or down the acoustic scale. When both hands are closed into fists (photocells dark), the filters block out all sound. By turning the hands directly toward the light, the filters are switched off and all envi-ronmental sounds are heard.

artistic and social identity, yet the social role of artists was not called into question. For this reason, the emergence of Solidarity in 1980 and the imposition of martial law the next year by the government under General Wojciech Jaruzelski left Polish art totally disarmed.[11] It took several years—under conditions in which political opposition was widespread—to elaborate, in neo-Dadaist form, possible responses to the situation of martial law.

This is the context in which Krzysztof Wodiczko's work in Poland in the 1970s must be viewed. One might suggest that his first artistic questions concerned the creative subject and the problem related to it: "How is one to create?" Within the general ideological mystification surrounding him, along with his everyday experience of urban space, the question fairly imposed itself. The metaphysical dimension—the artistic "I" ("he who creates")—was a subsequent stage of the artist's interest in the environment. Where are the boundaries of the artist's intervention in the world to be found? Which fragment of the world is accessible to the cognition of the artist? Two of his earliest exhibitions, **Personal Instrument** **(1971) (above and p. 26)** (stemming from a work of 1969) and **Self-Portrait** **(1973)**, can be seen as the expression of his dealing with further problems. The instrument that Wodiczko constructed

with the help of the technologies available to him was exclusively intended to enable the artist to "capture sounds and light" from the environment. The ultimate, and ambiguous, achievement of this performance work was virtuosity—a questionable goal from the creative point of view. This is why in **Self-Portrait**—a photographic representation of the artist as Narcissus the Creator, seen gazing at his own reflection in a mirror placed on the floor beneath the photograph—Wodiczko questioned the sphere of private creation by the artist engrossed with himself and caught within his own aestheticism. He concluded that the attempt must be made to abandon the egoistic position of the artist situated at the center of creation. Genuine creativity is a public dialogue, and the shaky balance between the interlocutors in this dialogue is the result of the play of arguments, rhetorical modes, positions, and strategies.

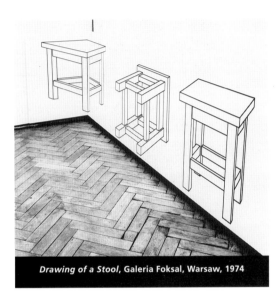

Drawing of a Stool, Galeria Foksal, Warsaw, 1974

This attempt to comprehend the laws that govern dialogue led Wodiczko to analyze the structure of artistic language, whose form has always defined itself through illusion. **Drawing of a Stool (1974) (left)**, an analytical drawing of a few lines creating the illusion of an object; **Ladder (1975)**, an attempt to construct the object itself according to the laws of illusion; and finally, **Line (1976)**, a minimalist reduction of a line to its concept, were works that moved Wodiczko to dispute the value of all arguments about illusion in art that ignore the concept of reality as a historically and an ideologically defined phenomenon. From this point of view, there was a breakthrough in **References (1977) (p. 12)**, an exhibition in which the illusional "law of vision" exploited in art was replaced by an ideological discourse. In the exhibition, horizontal, vertical, and diagonal lines were superimposed on images from a slide projector: stock political photographs, fragments of official architecture, and works of art defined the message within categories of domination and rule.

To understand better the importance of this exhibition and its relationship to other works by the artist, let us turn to the first **Vehicle**, constructed in 1972 (pp. 22, 36, 37). Although built with an almost engineerlike precision, it was not characterized by technological perfection. In fact, it bore greater kinship to Vladimir Tatlin's fantastic *Letatlin* (1929–1932)—the impractical, human-powered "air bicycle" Tatlin hoped would become an object of daily use by the masses—than to the shining surfaces and aerodynamic shapes of present-day high-speed vehicles. Tested on the streets of Warsaw—"perfectly functional," one might

11 Jaruzelski, long Poland's minister of defense, was named Party first secretary early in 1981. He introduced martial law in December of that year in an effort to break up political opposition and Solidarity. In 1989, by agreement between Solidarity and the Communist Party, he was made president of the country. He resigned in 1991, clearing the way for postwar Poland's first free and universal election, in which Lech Walesa was chosen president.

say—it fulfilled its function in that the "stationary movement" of its author, who walked up and down in the vehicle, produced the "forward movement" of the entire vehicle. Through its allusion to function and progress, **Vehicle** was a caricatured version of both the grounded Icarus of Tatlin's utopia and the socially useful machines produced by the Bauhaus. One may well see in this work the origin of what was to become Wodiczko's primary ongoing focus: the critical project as artistic action. Of course, **Vehicle** should not be viewed in isolation, any more than his other work should. Understood as a whole, his output elucidates a whole series of problems. In the 1970s his work was typified by a process of reflection on the structure of language and on history. As he made clear in statements at the time, Wodiczko did not seek any essentialist dimension in history, but he strove to disclose through his work (although he did not reduce it to) the history of subordination, expropriation, and domination. Although he did so openly only in the 1980s, he was in the 1970s already aware of this manipulation and attempted to make use of the "language of culture" that depicts the history of victories to reveal instead the history of barbarism. Wodiczko's vehicles, including his latest ones for homeless people, contribute to a general historical discourse from a critical point of view, a critique of history in which the concepts of function, progress, altruism, "the Other," security, and so on are seen as ideological components of the social vision of political power. In both his art and his historical and theoretical investigations, Wodiczko's attitude has enabled him to reject the game of appearances (illusion) by consistently disclosing the underlying fallacy (ideology).

At this point, the ideas apparent in the realized vehicles encountered the problems seen in Wodiczko's **References** and, from 1981 onward, in his public projections. Specifically, he situates the latter in that historical sphere in which construction and negation form a dialectical identity. "Universal history should be constructed and negated," the late German philosopher Theodor Adorno wrote. "In the face of past and future catastrophes it would be cynical to maintain that a blueprint of the world, aiming at improvement, manifests itself in history and organizes it. On the other hand, one cannot for this reason negate the unity which binds the discontinuous, chaotic moments and phases of history and which since the subjection of nature has passed to the rule over people and finally to the subjugation of their inner nature. There is no universal history that leads from savagery to humanism. But there is one which leads from the sling to the megaton bomb. It ends with a total threat to organized people by organized humanity, that is with the very essence of discontinuity."[12] In this sense Wodiczko's work, seen as a whole (with its roots in the 1970s), is not, strictly speaking, a political statement. He has never abandoned the social role of artist and accepted the characteristics that define it. He is not afraid of being ideological, which in essence today means the abandoning of utopias and a concurrent penetrating intervention into the "historicity" of such concepts as power, freedom, coercion, and poverty.

In the Poland of the 1970s, Wodiczko was one of a handful of artists who viewed historic and artistic problems in the critical perspective described here. In the 1977 interview quoted at the outset of this essay, he expressed disagreement with the professors at Polish art schools, stressing that, by situating their reflections outside the contemporary world, they

were unconsciously situating themselves outside history. "Suspended in 'extra-temporal art' they claim to have contact with its 'spirit,' and they have power and position—which always have magic. But the issue here is not art but position and consequently the preservation of current institutional structures."[13] It is therefore no wonder that in his work of that decade Wodiczko sought a different tradition than the formalist one for Polish art. To a certain extent, he found what he was looking for in the writings of Wladyslaw Strzeminski. That highly influential Polish Constructivist defined the history of visuality as the point where art (formalism) and reality (realism) intersect. This, in its most general outline, is the thesis one can draw from Strzeminski's 1948 book *The Theory of Vision*. A consequence of the modernist "zero degree" of Unistic painting, his theory attempted to capture history through the prism of the "rationalized view" of reality, by means of which successive social strata strove to gain power or maintain it. Seeing, the "post-Unistic" Strzeminski would have said, is the history of domination and deception. "There is no one absolute realism," he wrote, "no realism as such. But there is such a thing as concrete realism, conditioned by given historical relations. Under different historical conditions, this very same realism ceases to be a method of disclosing reality and becomes a means of falsifying and masking it."[14]

Krzysztof Wodiczko finds the roots of his present work in his questioning of the Polish cultural ideology of the 1970s and, in a wider context, in the ethos of the Left, which is itself deeply rooted in the intellectual thought and social and artistic activity of the twentieth-century avant-garde.

(Translated by Sophie Roznkowska)

Andrzej Turowski is a Polish critic who has lived in France since 1984 and is currently a professor of art history at the Université de Bourgogne, Dijon. His books include *In the Circle of Constructivism: The Avant-Garde in Eastern Countries, 1910–1930* (1975), *Polish Constructivism, 1921–1934: A Reconstruction of the Movement* (1980), *Is There an Art of Eastern Europe?* (1986), and *Great Utopias of the Avant-Garde: Artistic and Social Utopias in Russian Art* (1990).

12 Theodor Adorno, *Negative Dialectics* (Frankfurt am Maim: Suhrkamp, 1966), p. 440.
13 Supra, note 1.
14 Wladyslaw Strzeminski, "Realism w malarstwie" ("Realism in Painting"), *Wies*, no. 47 (1948), p. 6.

The vehicle moves slowly in uniform, straight-line motion in one direction only. The artist, walking up and down the tilting platform, causes a seesaw movement; the energy thus generated is transmitted by a system of cables and gears to the wheels, which, in consequence, drive the vehicle ahead. The vehicle is for the exclusive use of the artist.

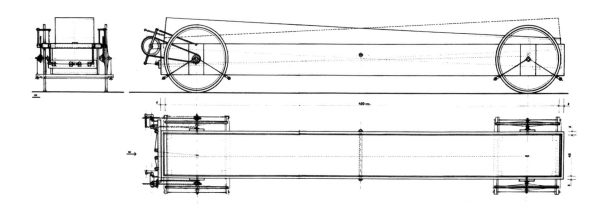

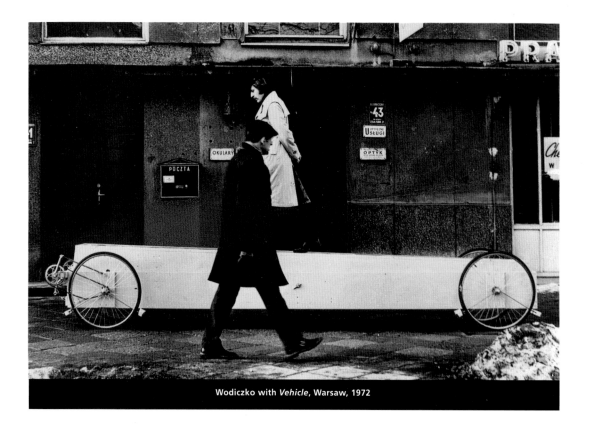

Wodiczko with _Vehicle_, Warsaw, 1972

The movement of a mass pushed cyclically forward
and backward by a worker along a tilting platform
causes its seesaw motion. The energy thus generated
is transmitted through an adjustment of gears into the
rotation of the wheels. The momentum of the vehicle
and the dynamism of the labor sustains the vehicle's
straight, linear, one-directional motion.

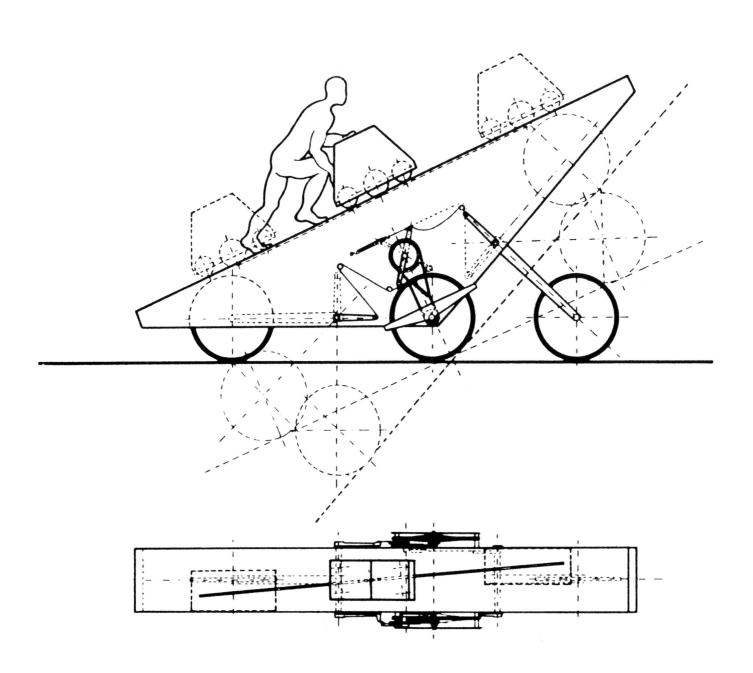

Movement of people operating on the surface of the large square platform of the vehicle is free and multi-directional. The movement generates energy, which, through mechanical and pneumatic systems installed in the floor of the platform, is accumulated and transmitted into the rotation of the wheels. The vehicle moves slowly, in a straight line, in one direction only.

Vehicle—Coffee Shop 1, 1973/1979

The voices of the conversants activate the engine of the vehicle. The liveliness of the conversation sustains the vehicle's continuous motion. The vehicle moves in a straight line in one direction only.

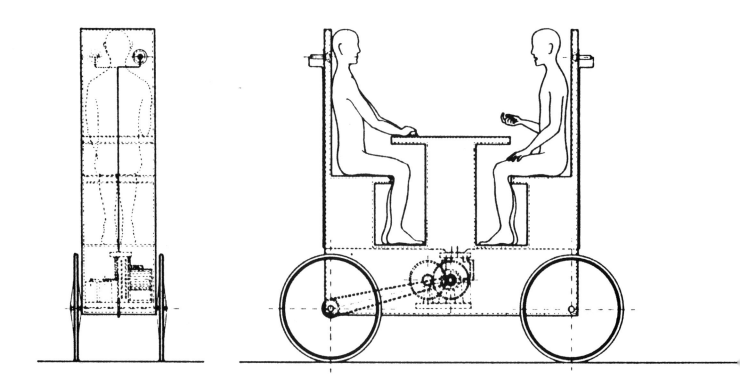

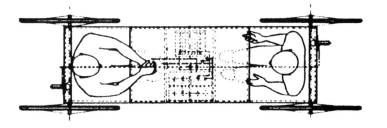

The movement of the bodies of the conversants causes a swinging motion of the table and seats of the vehicle. This motion is transmitted through a system of gears into a rotation of the wheels. The vehicle moves in a straight line in one direction only. The speed of the vehicle is dependent upon the dynamism of the discussion.

40
41

Wodiczko and Poland in the 1970s
Andrzej Turowski

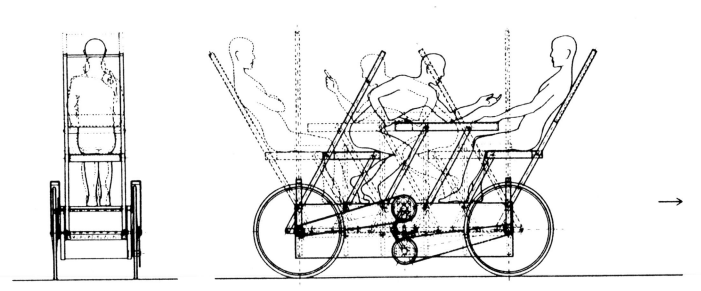

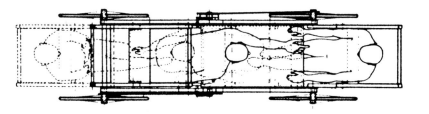

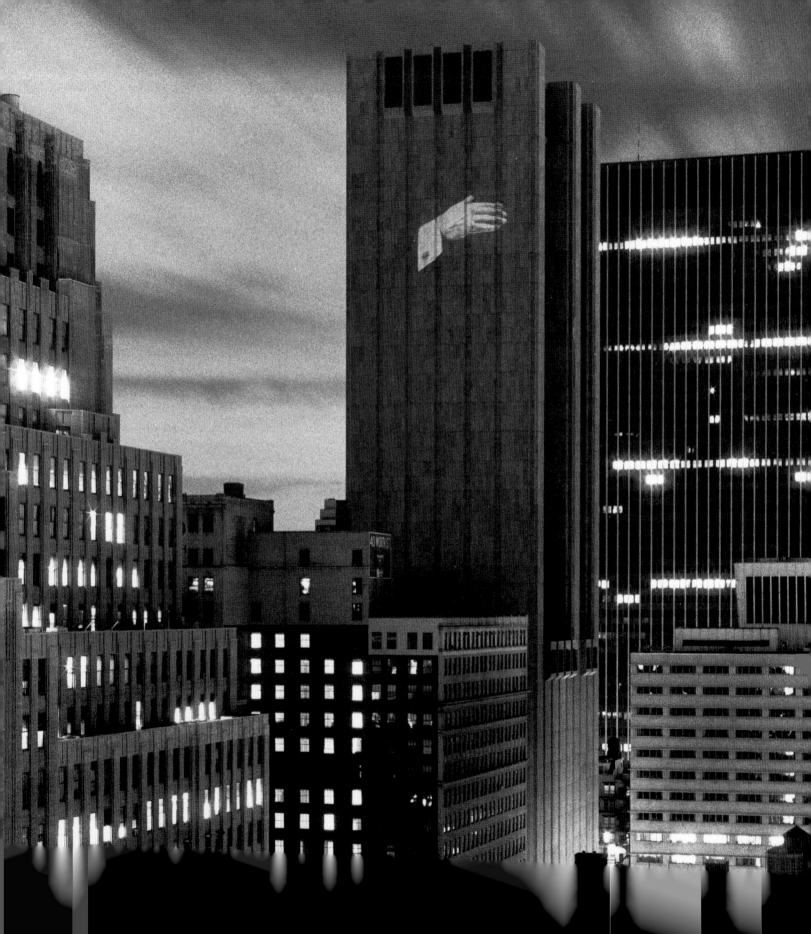

Images of Repossession

PATRICIA C. PHILLIPS

> Whatever the future may have in store, one thing is certain. Unless local
> communal life can be restored, the public cannot adequately resolve its most urgent
> problem: to find and identify itself. But if it be re-established, it will
> manifest a fullness, variety and freedom of possession and enjoyment of meanings...
> John Dewey[1]

In one of his most subtle but restive projects, Krzysztof Wodiczko threw a beam of light on a stark elevation of the AT&T Long Lines Building in lower Manhattan one autumn evening a few days prior to the 1984 United States presidential election. This sinister-looking, windowless bulwark for telephone equipment is a bully of a building. It looms above its older architectural neighbors. The bulky, granite-clad tower, with its cornice of massive air vents, is an apt location for an image dealing with the coalescence of corporate power in the twentieth century.

On its north face Wodiczko projected a lighted image of an open hand, looking as if it were pressed to the heart of the building in a pledge of allegiance (opposite and p. 106). At a

1 John Dewey, *The Public and Its Problems* (Chicago: Shallow Press, 1927), p. 216.

moment when Ronald Reagan's rehearsed posture of patriotism was sending many voting citizens into choruses of unquestioning praise, this Polish-born designer, who had arrived in the United States by way of Canada, chose to spotlight not only the rampant insincerity of one leader but also the corrosive complicity of the American government and its corporate supporters. For a few moments, Wodiczko's taking possession of this urban monument illuminated a new vision of public life in a way that beckoned the local community to engage in critical inquiry.

The past twenty years have seen widespread hand-wringing on the part of a range of social critics and concerned citizens about the decline of the local community, the dissipation of meaningful public sites and events, and the dissolution of public customs in American cities. Signs of slippage in civic life have been readily apparent as well in the quickening decay of inner cities and in the growing corporate territorialism that leads to the building of tightly controlled plazas and interior atriums—new environments that offer but an ersatz experience of public place.[2]

While those who decry the neglect and abuse of the public realm point to variable lists of causes and culprits, their litanies are often linked by a nostalgic harking-back to the eighteenth and nineteenth centuries—the time before the electronic media—when established patterns and conventions of public behavior presumably ensured collectivity. Taken together, these dark observations about the present and hazy notions about the nature of the past suggest that the radical changes that have occurred in our time have devastated the public sphere.[3] The obvious oversight here is that traditional models, methods, and measurements are neither reliable nor applicable to current conditions; they cannot help us interpret the present disintegration meaningfully, nor can they give us practical inspiration as we consider how to deal with it.

Curiously accompanying the reported demise of public life during the past two decades has been a burgeoning interest in and production of public art. But the facts also discourage; the debate of public issues through aesthetic practice remains curiously moribund. There exists a plethora of organizations, agencies, and incentives to generate public art, but at the same time a strange silence affects the subject of the contemporary "polis."

In his public projects of the past decade, Krzysztof Wodiczko has conducted a series of active mediations that combine significant public sites, tough subjects, and aggressive statements that are only possible because of their temporality. He applies the immediate force of performance to social and political problems. The rhythms of extenuating events and the brevity of each installation give his projected episodes the intensity of public, political demonstrations. His thoroughly staged, illuminated images often require months of preparation, yet they seem like surprise attacks—fiercely focused parasitic invasions of renowned institutional hosts.

For example, in January 1988 Wodiczko staged *The Border Projection*, a pair of projections seen on successive nights; the first was in San Diego and the second in Tijuana (opposite and pp. 8, 144, 145). He conveyed related issues by casting contrasting images on dramatically dissimilar public edifices. For the Panama-California Exposition of 1915–1916 the architect Bertram Goodhue and his firm had created a World's Fair city, on the occasion of the opening of the Panama Canal in 1914, to pay tribute to Spanish culture and its role in the

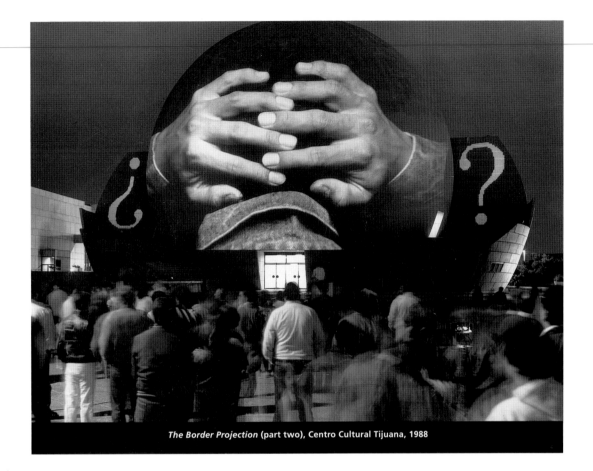

The Border Projection (part two), Centro Cultural Tijuana, 1988

Images of Repossession
Patricia C. Phillips

settlement of the West. The center of this environmental extravaganza, which was located in Balboa Park, was Goodhue's own *California Building* (today the San Diego Museum of Man) —an imposing structure layered and encrusted with ecclesiastical and patriotic references to conquest and colonial history. On the face of this loud, promotional building Wodiczko projected an image of unabashed consumption. Astride the main entrance was a pair of well-attired hands clutching opulent utensils; they looked poised to pound a dining table for service. At the same time, featured in the middle of the soaring tower above and to the right were two coarse, outstretched hands holding an ample basket of fruit; these hands were manacled at the wrists. The relationship of dominance and submission is the ugly subtext of all colonial triumphs. Goodhue's architecture, dedicated to the glories of colonialization, became, for one brief evening, the site of ghastly, and ghostly, insinuations.

The next night, across the California-Mexico border seventeen miles to the south, Wodiczko performed a projection at the Centro Cultural Tijuana. Erected nearly

2 "In the present day, public space is conceived of as a commodity, as a volume with an explicit market value. Civic-minded politicians and investors claim to give up this potentially profitable space for the greater good, for the needs of society. Into this public space will be placed all the necessary activities which do not immediately produce revenue.... But profit-taking is never far from anyone's mind; in fact, public spaces are designed to prevent any challenges to this profit-taking—the efficient functioning of the system remains paramount. The social is defined as a financial question rather than a philosophical one, and so public experience is seen as an engineering problem rather than the political issue it is. The terms of economic efficiency inevitably reflect the interests of the patron rather than the public." Richard Bolton, "Figments of the Public: Architecture and Debt," *Threshold* 4 (Spring 1988), p. 44.
3 For a book that deals fully with this kind of nostalgia, see Richard Sennett, *The Fall of Public Man* (New York: Alfred A. Knopf, 1977).

seventy years after Goodhue's homage to colonial mythologies, the Tijuana building is dedicated to an enthusiastic display of Mexico's rich artistic, natural, and touristic qualities. The spartan, geometric forms of ahistorical modernism contain a bright anthology of selected Mexican history.

Casting images upon the smooth dome of the Centro Cultural, Wodiczko addressed a far-from-uplifting aspect of present-day Mexico. As in the San Diego projection, a pair of hands figured prominently in this temporary renovation of existing architecture. Two hands were clasped behind a man's head in the position assumed when one is arrested and searched. On each side were question marks—one inverted, one right side up—used in Spanish grammar to frame an inquiry. This image dramatized the plight of the undocumented worker, apprehended and interrogated at the border. The architectural revel was for a moment silenced by an image of desperation and humiliation.

This pair of illuminated images highlights the suppleness of architectural style— its capacity to present limited, edited visions of progress and development. Whether stylistically baroque or spare, buildings deliver the lessons of a particular, dominant history. Here the aggressive, pleading, restrained, or defensive positions of human hands were used to unwrap, to peel apart the concealing surfaces of official propaganda. The crafty relationship of surface and reality was brilliantly, if briefly, featured.

Speculating about the temporality of his own work, the French Conceptual artist Daniel Buren said:

First, how long is ephemeral? Two weeks, two years, fifty years or two thousand years? Beyond that, what do we have?... And what time/space relationship are we talking about when it comes to art?... All works should attempt to be ephemeral. This should be their ambition. In this sense, ephemeral means: not to claim to have produced something which is of interest to anybody whatsoever today.... It's to accept our limitations, our sparse knowledge, our times, our misery.... It's to accept that a stroke of lightning can be impressed upon our memory just as strongly as a pyramid.[4]

These eloquent observations take us to the heart of Krzysztof Wodiczko's public projections. His work requires both the "pyramid" and the "stroke of lightning." The persuasiveness of the work resides in its intense alchemy, its highly charged mix of ideas whose residuals linger on, phantomlike, long after the projectors have been switched off. The ideas are transported, shaped, and revised by people's memories and stories—the detailed and distorted impressions of a single night of lighted, layered images. Rather than continuing as structures whose order and points of view are unthinkingly accepted, the buildings on which Wodiczko focuses become incentives for public discourse.

Wodiczko's projections at sites worldwide have addressed local communities and universal issues. Most have lasted only hours—or, at most, a few successive evenings— but they have rejoined specific sites and broad political questions, ephemeral images and enduring urban monuments, guerrilla activity and sanctioned art, event and artifact, audience and the public domain. The work is boldly political, powerfully constructive, and deeply subversive; it transcends site-specificity and revises the common perception of art-

making as the production of "objects," things that are unyielding and permanent. His ~~projects do not promote naive nostalgia for the past or robust romanticism for the future.~~ These transitive projects are a present tense activity.

For two decades there has been great confusion about the definitions of and distinctions between site-specific art and public art. The terms have been used interchangeably—and sometimes disingenuously—to refer to art located outdoors. A prime instance of this confusion was the debate leading up to the removal of Richard Serra's sculpture *Tilted Arc* from New York City's Federal Plaza in March 1989. Serra's Cor-Ten steel wall was a superb manifestation of site-specific art; it aggressively attacked the barren autocracy of the surrounding architectural environment. As public art, however, the work was more problematic; it appeared to disregard the political and psychological subtleties of place as phenomenological. *Tilted Arc* addressed a rampant alienation—but may also have exacerbated it. Clearly, a concern for the characteristics of a given site—for its history, its physical forms and materials, and for the ways in which it is used—has favorably inflected the production of and response to much art made for sites. But site-specific art also has led to a certain myopia, a rarified and insulated view of context. Site is often viewed as a kind of protected oasis, a place where an inwardly focused aesthetic gaze is sanctioned; the surrounding environment is, in effect, shut out.

If public art is not only to prevail but also to move on to a new stage of response and resonance, it needs to become a truly inclusive activity, less restrained by specific site and more receptive to the far-reaching, complex operations of a city, its architecture, and its infrastructure. Public art must evolve into a connective, synthetic practice that extends beyond the articulation and enhancement of a single place to encompass a truly ambitious, abstract urban vision and range of objectives. Context has to be considered comprehensively and subtly; content can be at once specific and general.

Wodiczko's interpretation of site is intellectual and emblematic. He selects and assembles representational images for his public performances; however, unlike most projections, these illuminated signs are never thrown against neutral white screens. His "screens" are ambiguous, imperfect architectural surfaces; they have color, texture, age—and a didactic scheme that presents carefully edited narratives. Like familiar but unexamined faces, these architectural screens have lines and marks that distinguish; they suggest interior activities and functions; they manifest meanings and mythologies. All of this information is suggestively shown on the surface. Wodiczko's work concerns the volatility of this combination of trusted architectural characters, established institutions, and the momentary insinuations brought by a beam of light cast through a celluloid image.

Wodiczko casts light and images that make dependable architectural neighbors just strange enough so that we may feel compelled to try to understand them again—and afresh. The projections reinvigorate tired relationships, remind us that comforting beliefs need to be challenged, and allow for the possibility that discoveries may make us richer but far less

4 The artist interviewed in *Daniel Buren: 42e Bennale de Venise, Pavillion française des Giardini* (Paris: Association française d'action artistique, 1986), unpaginated.

certain of what we really know, what it is we think our public life is. His projections illuminate the potential for the public to repossess monuments presumably made in its name.

Wodiczko uses architecture as his accomplice. These days, cities are hardly strangers to spontaneous amendments made on the surfaces of buildings. Certainly, the most prevalent form of this appropriative activity is graffiti. Its destructive edge angers the city official. Its raw poetry occasionally inspires the admiring writer or intellectual. Whether seen as energetic clandestine street art, ugly defacement, or vandalism, the signs and marks of graffiti are customary features of many urban neighborhoods.

Graffiti is roaming and restless; it appears on ordinary and distinguished buildings alike, along sidewalks, on the outsides of subway cars and buses, on posters and walls, and overlaid on earlier graffiti. Whether applied to surfaces that are stationary or movable, it is produced in an effort to claim part of the environment, to give the city's surfaces a new iconographic urgency. However applied, graffiti is a gesture against individual—and political—submission.

Like siblings who have grown up and finally apart to live radically different lives, Wodiczko shares a certain kinship with the urban graffitist—although he is never mistaken for one. Like the graffitist, he seeks out and depends on the architectural surfaces of the city to perform his spectacular, lighted constructions. For different reasons, with other intentions, he confirms that there is an irrepressible, if often overlooked, public dimension to all architecture. The forms and surfaces that surround people influence and affect their activities and ideas. Through their adoptive work, Wodiczko and other street artists urge citizens to interpret, challenge, and lay claim to these architectural forms and ubiquitous institutions rather than to submit quietly, often unwillingly, to their authority.

The graffitist uses parts of the city that are most readily available, including those sections that are grimy, marginal, rejected, and unsavory. In contrast, Wodiczko engages another kind of unacknowledged site, the consequences of another kind of apathy. He is concerned with the iconic clichés of the famous and familiar—the beloved monument, public-service building, and common site—that convey historical and ideological messages. Often the monuments have become obvious, the messages rote and superficial like political platitudes. No critical structure remains—just architecture as so many sound bites.

A prime instance of Wodiczko's work in this vein occurred in London in 1985. He was there to do a projection on Nelson's Column in Trafalgar Square (p. 114). The artist reports that, at the same time, a delegation from South Africa had arrived to appeal for money from the British government.[5] Departing from his usual deliberate approach, the artist was surprisingly rash, taking advantage of serendipitous events to refocus public attention on a structure whose symbolism had been ignored or taken for granted. He turned the lens of one projector away from the column to beam a swastika on the pediment of the nearby South Africa House. Beneath Wodiczko's impromptu emblazonment was the relief of a boat surmounting the words "Good Hope" (opposite and p. 116). The projection was suspended after two hours, decreed a "public nuisance" by the police. Planning was enriched by fortuity; like any good street artist he seized an unusual, if dangerous, opportunity.

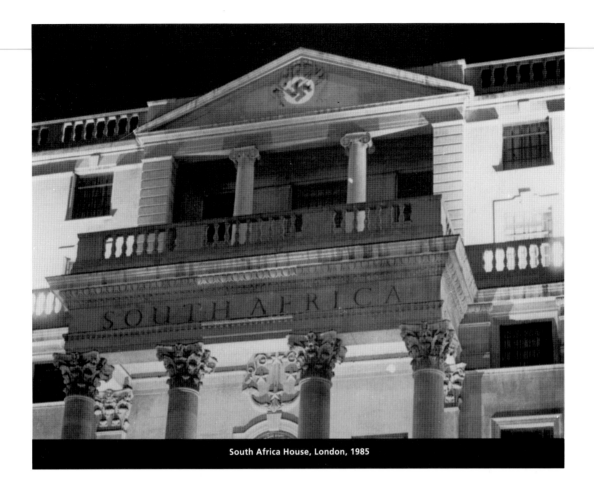

South Africa House, London, 1985

But it was history, wasn't it?
The acrimonious twilight fell
into the hollows between gray
and red building.[6]

Wodiczko appears in the dark of night at noted sites to reinscribe selected surfaces of the city with penetrating, ethereal images of light and color. His work does not, cannot, exist in the light of day. He and his art are part of the nocturnal culture of the city; the ideas are about the night side of things. The projections speak through the darkened skies for the disenfranchised, the invisible citizen, for the men and women of long, sleepless nights. Night is the perfect time for Wodiczko. It is when assumptions are thrown into question, scattered with flashes of visionary clarity and anxious doubt. Like the semiconscious apparitions of a fitful sleep, there is always a powerful ambiguity. Was it simply a dream? Did something actually occur? Will things be different in the light of day?

The logistical requirements and limitations of light and photographic projection shape the characteristics of Wodiczko's

5 See the artist's statement regarding this projection in *Counter-Monuments: Krzysztof Wodiczko's Public Projections*, exh. cat. (Cambridge, Mass.: Hayden Gallery, List Visual Arts Center, Massachusetts Institute of Technology, 1987), unpaginated.
6 Elizabeth Hardwick, *Sleepless Nights* (New York: Random House, 1979), p. 32.

projections. Every project employs sophisticated technologies and complex calculations. In the end, however, each is dependent on the diurnal and nocturnal passages of each day. Nowadays, there are few things in this world that cannot happen at any time. In fact, the activities vulnerable to the vagaries of natural events have slowly disappeared—or have moved indoors to controlled environments. Many sports stadiums now have great domed roofs to keep out the unruly elements. We sit in darkened, hushed theaters to watch a film on the brightest of days. But Wodiczko's work is curiously current and anachronistic. It is always subject to uncertainties of nature, technology, and people. And these prevailing variables make the work both brisk and timeless.

———

In spite of the many signs of social retreat and withdrawal, most people remain in need, even desirous, of an invigorated, active idea of *public*. Yet what form the modern-day "polis" is supposed to take is far from clear. One certainty is that the future will be identified by keen and purposeful observation rather than by dark accounts of what has been damaged or lost. Possessing a public life is an activity involving creation and construction, not repair and retrieval.

What must we change in order to establish an invigorated conception of public life and engage individuals as public agents? And what must occur within the intricacies of each mind in order for a fresh idea of collectivity to take hold? In 1927 the educator and philosopher John Dewey gave a series of public lectures that were collected under the title *The Public and Its Problems*. His ideas about identification, possession, and the multiple meanings of *public* coincide with Krzysztof Wodiczko's aesthetic practice.

Wodiczko's work makes significant connections between public possession and imaginative invention; it embodies Dewey's belief that, to construct a new sense of public, individuals must claim and occupy the physical space and intellectual life of the polis. At present, the animating principle of the public life in American and European cities and communities is absentee ownership. At best, most citizens feel like tenants, perpetual itinerants passing through a world of disconnected events and disappearing audiences. The increasing transience of public activities has been used as a persuasive argument for dispossession and detachment. But an alternative view—the idea of public possession—proposes a spirited, steadfast ownership of a concept of public. In its fullest sense, this possession would be both zealous and rational, equally a state of urgency and thoughtful participation in a contemporary civic idea.

But the question of possession in the public domain has no easy response. Is something public because everyone has a stake in it—or because no one person does? Is a place public because everyone enjoys the possibility of access at all times, because there is an episode or spectacle—planned or fortuitous—that anyone might encounter? Public possession surpasses and transcends the conventions of rightful title, including deeds, property rights, and boundaries. It suggests an ownership of another form—a civic-social contract that concerns the responsibilities and possibilities of a deeply felt public propriety.

Calls for change that mean to be more than rhetorical must encompass and identify the sources and sites of persuasion—the facts as provided, perceived, and influenced. What are these sources? Who are the agents of change? Which are the sites that affect ideas and behaviors? In his book *The Power of Images* the art historian David Freedberg argues that the history of response to images is a long, turbulent legacy of aesthetic experimentation that has incited great acts of generosity, violence, dedication, and passion.

> People are sexually aroused by pictures and sculpture; they break pictures and sculptures; they mutilate them, kiss them, cry before them, and go on journeys to them; they are calmed by them, stirred by them, and incited to revolt.... They have always responded in these ways; they still do.[7]

> For the higher criticism to stand back from those aspects of behavior, belief, and response about which more ordinary people are candid is to deny the truths upon which cliché, topos, and metaphor are founded.[8]

While Freedberg does not look at contemporary art in developing his iconoclastic view of the imagistic potential of art, he nonetheless provides lessons that are useful in the present context. In the past century, our relationship to images has altered dramatically. We have gone from being selective spectators to increasingly voracious consumers in the face of a relentless, often volatile, onrush of visual information. But in this revised environment there yet remains a potential for engagement with artistic images ranging from the overtly propagandistic to the subtly political.

If the actual configurations of this new visual environment are still unmapped, there is nevertheless an incontestable awareness that we experience more images in common. Not only is there the traditional visual field of the public environment, made up of architecture, streets, spaces, and artifacts, but there is also the phenomenal realm of light, transparency, and ephemerality of film, video, and television. Whether "more is less" is a much-debated question: Are we more sensitive to visual information nowadays, or has the abundance of it made us less susceptible and skillful?

Wodiczko is as preoccupied with the world of images as he is with the ideology of monuments.[9] He is a skillful scavenger, selecting visual information and then composing it for a more critical encounter. In the fall of 1988, four years after his projection on New York City's AT&T Long Lines Building, the artist acknowledged a new presidential election whose outcome would be virtually the same as the last. On three evenings preceding Election Day, he cast an amalgamation of the most persuasive images and themes of the campaign on the cylindrical Hirshhorn Museum in Washington, D.C. (p. 150). In a city whose destiny is driven by calculated images, he picked those most vigorously promoted by the incumbent party. He projected a podium bedecked with media microphones. The right hand of the speaker held a revolver, and the left clasped a lit candle. The assembled images signified the Republican Party's "anti's"— abortion, gun control, and social welfare.

7 David Freedberg, *The Power of Images* (Chicago: University of Chicago Press, 1989), p. 1.
8 Ibid, p. 53.
9 For Wodiczko's early investigations of the language of images, see Peter Boswell's essay in this book, pp. 11–12.

Architecture was a particularly cooperative collaborator in this projection. The museum's drumlike shape distorted the moral codes of candidate George Bush's "kinder and gentler" nation. A slice of windows above the entrance formed a malicious grin on the otherwise headless torso—like a mouthpiece without a brain. In fact, the museum's conspicuous presence on the Mall, its relationship to its other institutional and governmental neighbors, presented an ambitious arena of images to examine and critique.

The use of images in public life of images is a rich, complex activity that is the province of no single discipline or field. In fact, one must willingly cross over, attempt various routes and passages in order to realize John Dewey's plea for an "enjoyment of meanings." How do we begin this process of the repossession of the public environment—its events, fortuitous demonstrations, buildings, spaces, and images? How do we reclaim what has been built in our name while accepting that what we will ultimately possess is a radically revised domain of public?

If a large number of artists are today interested in doing "public work," it is largely because they see it as an open, generous field containing opportunities and commissions that occur infrequently in the private world of galleries, dealers, and patrons. But many of these artists remain uninformed—uninterested in the conditions of a contemporary public life. Many public artists are indefatigable decorators of city sites. Amid this flurry of activity, much of it inconsequential, Wodiczko sets a rigorous and risky standard.

Wodiczko's architectural interventions enable the public to repossess the city through the activities of perception, memory, action, and application. The ephemeral projections activate a skepticism about meaning in public life that unamended monuments seldom do. There is evidence all around that if contemporary publics—if citizens—do not identify and project a new sense of the polis, then someone or some organization will set the terms for the future. Cities have long illuminated their architectural treasures to present beautiful, bedazzling images of themselves. But this is a light that temporarily blinds and partially obscures. Wodiczko's lucid, clarifying illuminations examine and reveal the potential of public possession. The work is darkly skeptical; it begins with night side of things. But finally, it offers a possibility of radical—and enlightened—revision.

Patricia C. Phillips is an associate professor of art at the State University of New York at New Paltz.
Her essays on public art and architecture have appeared in *Artforum* and *Ottagono* and
have been included in collections published by the MIT Press, Rizzoli, and the Princeton Architectural Press.

Images of Repossession
Patricia C. Phillips

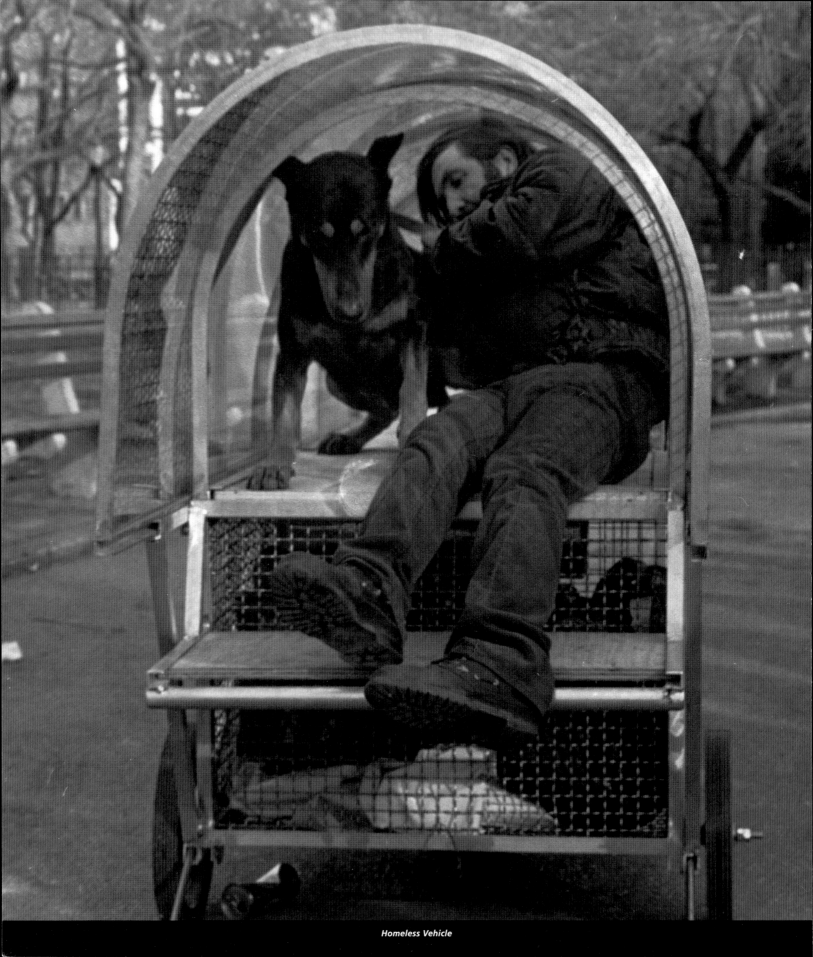

Homeless Vehicle

The Machine Is *Unheimlich*:
Wodiczko's Homeless Vehicle Project

DICK HEBDIGE

As necessarily as it produces machines and men-machines, the bourgeois world ... produces the
Tramp, its reverse image. The relation between the Tramp and the bourgeois
order is different to the relation 'proletariat-bourgeoisie'. In particular it is more immediate,
more physical, relying less on concepts and demands than on images.

Henri Lefebvre in *The Critique of Everyday Life* (1991)

TRAMP STEAMER

TRAMP, v. 1. To walk with a firm, heavy step; to trudge. n.1. A heavy footfall; b. A heavy rhythmic
tread, as of a marching army; 2. A walking trip or hike; 3. A person who travels aimlessly
about on foot, doing odd jobs or begging for a living, as a vagrant; 4 a. A prostitute,
b. A promiscuous girl or woman; 5. A cargo vessel that has no regular schedule but takes on
freight wherever it may be found and discharges it wherever required. Also called "tramp steamer."

The American Heritage Dictionary of the English Language (1969)

The first time I saw Krzysztof Wodiczko's *Homeless Vehicle* was
in a square-cropped monochrome photograph on a black
catalogue cover, where it sat, suspended in the gloom, like one
of the artist's nocturnal projections—ominous and dislocated
—as if transplanted from another dimension. The image
showed a streamlined, four-wheeled metal object, reminiscent

of a high-tech version of a supermarket cart, encased in a skin of plastic or rubberized fabric stretched across a skeleton of metal hoops. A wire cage containing cans and plastic bags was visible, bolted or welded to the chassis. But what drew the eye instantly was the gleaming metal nose cone pointing off over the viewer's shoulder so that the whole vehicle bore a strong resemblance to a missile, primed and locked onto some invisible target. Parked under direct light on the parquet gallery floor, its hard, reflective surfaces shone with the spooky luminosity of a UFO in a 1950s science fiction movie. Exhibited in this image like a prototype in a pamphlet at a munitions or medical appliances trade fair, the vehicle appeared imbued with a powerful mystique as "a superlative [designer] object."[1]

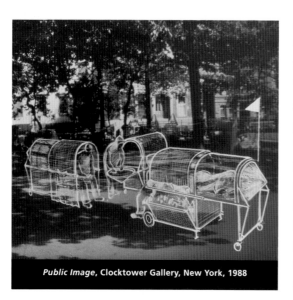

Public Image, **Clocktower Gallery, New York, 1988**

The parody of professional design and display codes in the presentation of the *Homeless Vehicle* as late-modern gadget is integral to Wodiczko's critical probing of "the symbolic, psychopolitical and economic operations of the city."[2] It is a key part of that larger strategy of projection, which, as Rosalyn Deutsche has argued, might be chosen as an evocative title for all his work, once we acknowledge that the word *projection* designates not just a technical mechanism but also "first, a symbolic operation by which concepts are visualized as external realities and, second, a rhetorical device for speaking with clarity at a distance."[3]

The *Homeless Vehicle* was unveiled before the gallery-going public in an exhibition at the Clocktower Gallery in New York City in 1988, though the rhetorical strategies it embodies had been prefigured in Wodiczko's public projection works. Two earlier projects are of particular relevance: the Astor Building-New Museum of Contemporary Art padlock-and-chain projection in 1984 (p. 110); and the proposal two years later to "disable" the statues of Lincoln, Lafayette, Washington, and Charity in the recently "refurbished" Union Square Park by projecting images

of bandages, wheelchairs, and derelict buildings directly onto them (pp. 76, 77). In both these projections, the homeless are revealed to be less the victims of their own inadequacies than of that linked process of economic and social transformation which Marshall Berman has dubbed "urbicide" — a process whereby speculative property development, the suspension of planning controls, redlining, blockbusting, gentrification, soaring rents, the casualization and deskilling of manual labor, and the drastic reduction of welfare and public housing programs actively conspire to *produce* homelessness.

The Homeless Vehicle Project disturbed conventional views of homelessness still further by targeting an occupational subculture of single homeless men (those who survive by redeeming empty cans and bottles for five-cent deposits) as potential user-consumers of an ostentatiously designed object. The prototype on view in 1988 consisted in a hinged metal unit, which could be extended to provide sleeping, washing, and toilet facilities as well as a can-storage compartment. The product had been tested by a panel of homeless "consultants" and adapted to the precise subsistence needs of its prospective users.[4] This replication of design and market-research procedures parodied the "logic" of the late-capitalist equation between consumption and active citizenship and was carried over forcefully into the final "product launch." The vehicle stood in its fully extended "sleeping mode" at the center of the exhibition, surrounded by sketches of early prototypes and diagrams advertising its versatility and design features (such as the hinged nose cone that transformed into a washing bowl, the toilet-and-tarpaulin configuration for guaranteed privacy, and the large rear wheels for stability and enhanced maneuverability). In another room, slides of public spaces in New York City were projected onto the gallery walls, the scenes overlaid with blurred images, blown up from sketches, of the vehicle being pushed through the city by a ghostly hooded figure in a tracksuit. Meanwhile, extracts from Wodiczko's taped discussions with the homeless consultants were relayed through loudspeakers.[5] A document produced by Wodiczko and David Lurie was also on display. Like the vehicle itself, the document has gone on circulating, in slightly different forms, ever since, its arguments refined and adapted in light of further consultation with the client group for which it is intended. "This vehicle," they write, "is neither a temporary nor permanent solution to the housing problem, nor is it intended for mass production. Its point of departure is a strategy for survival for urban nomads—evicts—in the existing economy."[6]

THE MACHINE IS *UNHEIMLICH*

Wodiczko's vehicles actively invite a sense of déjà-vu. As Patrick Wright has pointed out, they look "unlike anything that has ever existed before, and yet deliberately engineered out of resemblances to things familiar" so that the solidity of the vehicle itself threatens to dissolve under the weight of its constitutive analogies.[7]

1 Roland Barthes, "The New Citroën," *Mythologies* (New York: Hill and Wang, 1972).

2 Krzysztof Wodiczko, "Strategies of Public Address: Which Media, Which Public?" in Hal Foster, ed., *Dia Art Foundation Discussions in Contemporary Culture*, no. 1 (Seattle: Bay Press, 1987), p. 42.

3 Rosalyn Deutsche, "Architecture of the Evicted," in Exit Art, *New York City Tableaux: Tompkins Square* (New York, 1990), p. 31.

4 Consultants and prototype operators have included: "Allan Benjamin, Pierre, Oscar and Victor, residents of Tompkins Square Park; Alvin, a homeless person in San Diego; homeless workers at the WECAN Redemption Center, New York; Vanessa Brown, John Alston and Vernon Wilson, operators in Philadelphia; Arlene Wilson, Margaret Stevens, Marie General and Harvey Wilson, from the National Temple Recycling Center, Philadelphia." Krzysztof Wodiczko with David Lurie, *The Homeless Vehicle Project* (Kyoto: Kyoto Shoin International, 1991, ArT RANDOM series), copyright page.

5 Transcripts of these discussions are included in Exit Art, *New York City Tableaux: Tompkins Square* (New York, 1990) and in Wodiczko with Lurie, supra, note 4.

6 Krzysztof Wodiczko and David Lurie, "The Homeless Vehicle Project," in Exit Art, *New York City Tableaux: Tompkins Square* (New York, 1990), p. 22.

7 Patrick Wright, "Home Is Where the Cart Is," *The Independent* (London), January 12, 1992, pp. 12–15.

But the sense of familiar unfamiliarity engendered by these objects—their capacity to go on "making strange" our habituated ways of seeing—cannot be explained solely by reference to the connotative density of the objects in themselves. Instead, it is in the temporary conjunction of text and context—in the precise combination of image, site, and object—that Wodiczko's work acquires its peculiar resonance: that echo-chamber effect which can suddenly suffuse a neutral exhibition space or a dead historic building with new and unexpected meanings. For the homelessness of the Homeless Vehicle Project derives in part, like the spectral portability of film, from the nature of the apparatus through which the project as a whole is articulated. It is integral to his mode of operation as an itinerant artist and teacher. Wodiczko's vehicles are not just metaphors or tools. They are not just "about" homelessness any more than they are simply "for" the homeless. They are also *unheimlich* (literally, "unhomely") in that other, stranger sense to which Sigmund Freud alluded in his essay of that title.[8] For while these peculiar contraptions come equipped with storage compartments for redeemable tin cans, they are also at the same time *uncanny* vehicles.

Like the Trojan Horse, they work undercover in the labyrinth, which, wherever you find them in the real world, remains their only true location. And it is as well to remember that the full disturbing impact of the Homeless Vehicle Project gets disclosed only after the machines have been wheeled through the gates of our attention and left to stand there in the silence, unloading their secret cargo while the guards are still asleep. For the power of insinuation is by no means incompatible with the process of interrogation that the project sets in train. In Wodiczko's cryptic phrase, "something is damaged":[9] after one sees his work, a supermarket cart, a homeless person, a public statue, or a war memorial will never seem quite the same again. Rather than diminishing the urgency or bite of Wodiczko's timely interventions, it is this dreamlike incandescence of the afterimage—its chilly, smiling aftermath—that in the end makes the agenda he proposes for art's critical relationship to the city really stick.

INTERROGATIVE MACHINES The *appeal* of Wodiczko's work is that it steps straight into the breach left by the continuing trend within much acclaimed contemporary art away from direct engagement in the war zone of today's metropolitan scene. Its *beauty* consists in the tact, precision, elegance, and wit with which it highlights—literally, in the case of the public projections—not just the hidden face of power in the city but ways of approaching "problem issues" and addressing audiences and constituencies which have remained resolutely unapproachable within the terms laid down by 1970s and 1980s "art language." And its *interrogative power* derives from the way Wodiczko facilitates multiple and sustained questioning of the authority of social "probabilities" by turning his art into a rhetorical tool, which, in marked contrast to the "empty" rhetoric of morally outraged "political art," is designed to work directly *in* the world rather than *upon* it.

We are forced by the interrogative mode in which Wodizcko frames the Homeless Vehicle Project to ask the question, "What exactly are the homeless vehicles *for*?" Are they, as one critic asked of Wodiczko's metaphorical vehicles of the 1970s, "working prototypes,

functioning models or engineering blueprints?"[10] Do we regard them, first and foremost, as provocations to thought and action—what Harvey Garfinkel has called "aids to sluggish imaginations"—or as stopgap measures for dealing with the housing problems of homeless men? Alternatively, are they intended as a communications aid for an emergent homeless "constituency"? Or are they conundra in a broader sense—open questions, impediments to closure, propositions designed to lengthen the hiatus between what we think is probable and possible. In the awkward process of interrogation that they initiate, the vehicles make everybody—except their intended users—feel uncomfortable. What makes it so difficult to dismiss the project out of hand is the challenge it issues to all those who enter into dialogue with it to improve upon Wodiczko's own "modest proposals." For, like Jonathan Swift's "solution" to the "Irish problem"—put forward in his famous 1729 pamphlet written for (or rather at) the English, suggesting that impoverished Irish peasants rear children to be killed and sold for food—Wodiczko's machine-offensive on the streets of United States cities demands that we acknowledge the existence of a specific crisis, reflect upon its causes, and respond to the question it provokes: "If not *this*, then what do *you* suggest?"

Rather than representing either "homelessness" (by framing it iconically) or homeless people themselves (by "standing in" or "speaking for" them), Wodiczko conducts inquiries into the conditions that produce and reproduce the displacement of evicts and offers survival and self-imaging strategies for homeless people—strategies developed and adapted in consultation with relevant homeless organizations (such as New York City's WECAN Redemption Center) and with evicts on the street.[11] Each variant of the vehicle incorporates design modifications suggested by the homeless themselves (such as the reinforcement of structural components, incorporation of the semitranslucent Plexiglas roof sections that enhance visibility at night; curtains for privacy; and a fire escape). The vehicles are thus hybrid propositions, which bear an organic relation to the "ground" on which they move, that is, the conditions facing single homeless people.[12]

It is this originary entanglement of the vehicles in the actual lives of the (can) "redeemers" that endows them with their (other)worldly force. Wodiczko is designing for a "fallen" world; and it is this acknowledgment of complexity and imperfection that distinguishes his project, its motivations and objectives, from the start-from-scratch heroics of the modern movement and from the cynical indifference to social inequality, scarcity, and waste of today's designers-for-consumption. At the same time, the work and the rhetorical strategies

8 "The German word '*unheimlich*' is obviously the opposite of '*heimlich*' ('homely'), *heimisch* ('native') — the opposite of what is familiar.... In Daniel Sanders's *Worterbuch der Deutschen Sprache* (1860, vol. 1, 729), the following entry ... is to be found under the word '*heimlich*': Heimlich, adj., subst. *Heimlichkeit* (pl. *Heimlichkeiten*): 1. Also *heimelich, heimelig*, belonging to the house, not strange, familiar, tame, intimate, friendly, etc.... Note especially the negative '*un-*': eerie, weird, arousing gruesome fear: 'Seeming quite *unheimlich* and ghostly to him' ... 'These pale youths are *unheimlich* and are brewing heaven knows what mischief.' '*Unheimlich* is the name for everything that ought to have remained ... secret and hidden but has come to light' (Schelling)." Sigmund Freud, "The Uncanny" (1919), *The Pelican Freud Library*, vol. 14: *Art and Literature* (Harmondsworth: Penguin 1985). It is in this sense that I suggest Wodiczko's projection machines are *unheimlich*.

9 Quoted in Ailsa Maxwell, *Poetics of Authority: Krzysztof Wodiczko*, exh. cat. (Adelaide: Gallery of the South Australian College of Advanced Education, 1982), unpaginated.

10 Kenneth Coutts-Smith, "Vehicles: Krzysztof Wodiczko at Optica, Montreal, and Eye Level, Halifax," *Artists Review* (Toronto) (April 1979), pp. 2–4. Ailsa Maxwell's suggestion (in *Poetics of Authority*) that we "understand Wodiczko's vehicles as interrogative models of social realities, not as utopian models" has influenced the arguments put forward in the present essay.

11 The WECAN Redemption Center was founded by Guy Polhemus in 1986 as a nonprofit organization to provide a central bottle-and-can depository for the homeless. The depository makes such redemption a viable source of income for people who would otherwise waste time lining up outside stores that generally would not accept more than a few containers at a time.

12 The likelihood that women using the vehicles for "temporary emergency shelter" would be exposed to risk became apparent to Wodiczko in the course of his conversations with homeless females.

it embodies are predicated on a recognition of the limited effectiveness of "radical" polemic (its partial use/truth value).

But despite Wodiczko's explicit caveats about the vehicles' wider signifying functions, many critics, understandably, continue using the project first and foremost as a pretext for reflecting on the immediate conditions in which homeless people live. Some have condemned the artist's "failure" to offer political solutions capable of transforming current social realities. One of the most common objections leveled at his work, especially by those involved with professional agencies representing the homeless or catering to their perceived needs, is that the project threatens to trivialize homelessness by appearing to offer pragmatic solutions to a problem that can only be tackled at its root (i.e., through the provision of permanent accommodation). These objections continue to haunt reception of the work, despite Wodiczko's insistence that, as Rosalyn Deutsche puts it, "implicit in [the vehicle's] impermanence is a demand that its function become obsolete."[13]

It is here, perhaps, that we begin to touch on the deeper sources of the discomfort many people feel when confronted by a vehicle which moves with apparent ease back and forth between sedimented categories (art/not-art; use value/sign value; play/problem). The project's provenance within the institutionalized realm of art and "Art Theory" can only confirm this feeling of awkwardness. For the fundamental problem, which is likely to dog anyone out to get a purchase on Wodiczko's work with and on the homeless, remains not just the impossibility of the vehicle-as-practical-solution but also the qualitative discrepancy between the space of legitimated art and the day-to-day experience of actual evicts, between Wodiczko's signifying strategies and their displaced (and terrifying) referent, homelessness itself. An unbridgeable gulf inserts itself between the muted, plush if tastefully "austere," interiors of art galleries and catalogues and the catastrophic, unwalled, uninhabitable exteriors in which homeless people struggle to survive. Any critical engagement with the Homeless Vehicle Project is obliged to acknowledge the existence of that gulf in whatever way it can.

NO PLACE LIKE (HOME)

They look at us like a lot of empty bottles that they don't intend to fill.... Imagine all the decent things that they could do with just a little common sense if you were not just thinking of this situation as a penalty for failure.

Homeless woman interviewed by Jonathan Kozol in *Rachel and Her Children* (1988)

Far from seeking to reduce by pious hoping or "political" rhetoric (claiming "shared humanity" or "solidarity") the distance between the homeless and the domiciled (or *evicts* and *non-evicts*, to use Wodiczko's preferred terms) the Homeless Vehicle Project, through all its evolutions, accentuates the irreducibility of the distinction between having and not having "a place" (to live in/speak from). This double exile (from the community of non-evicts/the body politic) is in itself hardly new. But the registers in which it is currently experienced, together with the wider socio-political and ethical conundra such extreme

forms of exile pose for artists and intellectuals intent on intervening critically in today's urban arena, are peculiar to the late-modern scene.

While the "homeless" label may, as Wodiczko indicates, ultimately be of doubtful use (it lumps "Them" all together, detaches causes from effects, and tends to reinforce victim status by making a lack, i.e., the absence, of a "home" an identity marker), the category remains active in policy terms; and it needs to be understood historically before it can be dismantled or replaced. It is often pointed out that the picture of the homeless found in most contemporary fiction, reportage, charity appeals, and policy documents has its historical roots in the nineteenth-century literature of "social concern" and "social exploration" (William Booth, Charles Dickens, Henry Mayhew, Emile Zola), in the photographic imagery of early practitioners such as Jacob Riis and John Thompson and the inheritors of that tradition in the 1930s: Farm Security Administration documentarians such as Walker Evans and Dorothea Lange and softer-focused European *photo-flâneurs* such as Brassaï.[14] The fixing of the image of today's homeless within archaic nineteenth-century discourses has direct consequences on the diagnosis and "treatment" of homelessness-as-problem, not least in Great Britain, where homeless teenagers are still routinely charged as "rogues and vagabonds" under the provisions of the Vagrancy Act, introduced nearly 170 years ago to clear London's streets of destitute veterans of the Napoleonic wars.[15] However, the construction of the outsider-tramp as civilization's repudiated (or scapegoated) Other—variously the object of compassion, fear, desire, and disgust—has, of course, a much longer history.

The exclusion (hence mythologization) of the nomad and the wanderer-pariah is as old as the walls around the first city.[16] Full or "proper" citizenship has always implied not just rootedness in place but also property ownership. In classical Mediterranean cultures, once the hospitality traditionally extended to the stranger had been exhausted, access to the *civitas*— the community and its sustaining networks of ritual, privilege, and obligation—remained contingent on a more primeval order of belonging: an investment in the *urbs*, literally, in the stones of the city.[17] With the establishment in eighteenth-century Europe of a bourgeois public realm where differences, ideally, were to be "aired"—hence reconciled by Reason as they circulated openly in the new coffee shops and classically proportioned squares—owning property and speaking "properly" became the dual prerequisites for being heard at all. (The democratic injunction "Stand up and be counted" requires, after all, a place to stand up on.) Later, the two fundamental bases of human ontology—language and habitat—became further (con)fused at the point when the state began demanding a "fixed address" in exchange for citizenship rights.

The social and economic polarization of today's "dual cities,"[18] where, during

13 Rosalyn Deutsche, "Uneven Development: Public Art in New York City," *October* 47 (Winter 1988), p. 51.

14 See, for example, H. J. Dyos and M. Wolff, *The Victorian City: Images and Realities*, vols. 1 and 2 (London: Routledge and Kegan Paul, 1980); Ian Jeffries, *Photography: A Concise History* (London: Thames and Hudson, 1981); Ivy Pinchbeck and Margaret Hewitt, "Vagrancy and Delinquency in an Urban Setting," in M. Fitzgerald, G. McLennan, and J. Pawson, eds., *Crime and Society: Readings in History and Theory* (London: Routledge and Kegan Paul, 1981); and John Tagg, "Power and Photography," in T. Bennett et al, eds., *Culture, Ideology and Social Process* (London: Batsford Academic and Educational in association with the Open University Press, 1981).

15 See John Carvel, "Destitute Teenagers Face Jail Penalty," *The Guardian*, September 12, 1989.

16 See, for example, Bruce Chatwin, *The Songlines* (New York: Viking, 1987); Richard Sennett, *The Uses of Disorder: Personal Identity and City Life* (Harmondsworth: Penguin, 1971); and idem, *The Fall of Public Man* (New York: Alfred A. Knopf, 1977).

17 See Richard Sennett, *The Conscience of the Eye: The Design and Social Life of Cities* (New York: Alfred A. Knopf, 1990).

18 See Manuel Castells and John H. Mollenkopf, eds., *Dual City: The Restructuring of New York* (New York: Russell Sage, 1991).

the 1980s, the survival of a growing mass of low-paid casual-service workers came to depend on the consumption choices and discretionary tips of high-salaried finance and communications élites, has ensured that the exclusionary terms of this bourgeois social contract have been set in concrete. At the same time, this contract has produced new forms of disenfranchisement for an outsider class whose visible lack of means prevents it from even getting past the security guards stationed at the entrances to air-conditioned shopping malls and luxury estates. This pattern of selective exclusion, denial, and withdrawal is reproduced at other levels through less immediately trackable forms of spatial restructuring.

Today, when the "universal placelessness"[19] of electronic-communications technologies, cheap air travel, and the globalizing pressures of "nomad capital"[20] have combined to produce the "exploded" or "overexposed city,"[21] the demands of state surveillance and the security policing of private enclaves in the city have become that much more insistent and intrusive, and the exile of the homeless that much more complete. At the same time, the language of 1980s and 1990s political populism operates a subtle, though no-less-effective, doorkeeping policy. The de-centering of the contemporary metropolis and "the ruling image of the screen"[22] may mean, as Todd Gitlin puts it, that "uprooted juxtaposition" is simply "how [all] people live" these days.[23] But the countervailing stress in populist discourses promoting individual "responsibility" and "community belonging" on the values and virtues of the home automatically disqualifies the literally uprooted evicts from even entering the game.

The language of "rights" and "natural justice" has been so thoroughly diverted from its origins in seventeenth- and eighteenth-century social radicalism that George Will could argue in a TV discussion on the urban homeless in 1986 that the presence of beggars in front of midtown Manhattan office buildings constituted an "infringement of the rights" of the already harassed executives who worked in them.[24] In the same spirit, Norman Lebrecht, writing in 1989 in the London *Sunday Times*, took the board responsible for administering the Thameside South Bank Arts complex to task for failing to "protect the fundamental rights of concert patrons," harassed by vagrants "pestering them for small change and pursuing them far into the lobbies" in an "intolerable" ordeal, which "takes the civilized experience of concert-going out of the realms of Orpheus and plunges it deep into an underworld of dereliction."[25]

Rhetorical excesses such as these are predicated on a splitting of social space into two antagonistic camps (public/Them vs. private/Us), organized around a set of oppositions that has already been institutionalized in the fiscal, housing, and law-and-order policies of successive United Kingdom and United States administrations. The dominant moral order becomes spatialized, to borrow at length from Mike Davis' description of "Fortress L.A.," in the division between "good citizens, off the streets, enclaved in their high-security private consumption spheres [and] ... bad citizens, on the streets (and therefore not engaged in legitimate business) caught in the terrible, Jehovan scrutiny" of police helicopter surveillance.[26] Some of the most dystopian design and policing initiatives to date derive from this pathological terror of the (revenge of?) the disenfranchised Other. Davis lists a few local examples: painfully uncomfortable "bum-proof" barrel-shaped bus benches; beaches closed

at dusk, patrolled by police dune buggies; and the ultimate mean-machine, stationed outside a fashionable seafood restaurant, a "$12,000 baglady-proof trash cage made of 3/4-inch steel rods with alloy locks and vicious outturned spikes to safeguard priceless mouldering fish heads and stale french fries."[27] The same mentality is activated to keep the homeless perpetually on the move: the head of Los Angeles' city planning commission explained to reporters in 1987, after Mayor Tom Bradley had ordered police to clear the "cardboard condos," that it was not illegal to sleep on the streets "only to erect any sort of protective shelter."[28]

In this paranoid bisected universe, the dereliction of both public space and the outsider class who "own" (i.e., have "stolen") it is contrasted with the perfectibility of the private realm, where rightful ownership is (ideally) never in dispute. We hardly need reminding, in the late twentieth century, of the success of ideological appeals to the "primary" commitments of home and homeland or of the abiding power of the deep psychic (and financial) investments people everywhere continue to make in their private domestic spaces. But whatever contortions are produced in national populations by the manipulation of the "homing instinct" for political or commercial gain, the imbrication of libidinally charged images of *heimat* as first place and safe place in constructions of legitimate belonging seems immune to historical or geographical variation.[29] The idealized shelter as recollected "firm position"[30] is, perhaps, the fundamental trope in narratives of identity-formation. The lost time-space of the nurturing source remains the radiant wall onto which all our fantasies of closure, all our desires for ontological security, are ultimately back-projected.

The overwhelming sense of shame most of us experience when confronted by the spectacle of homeless shantytowns and cardboard cities must stem in part not simply from the affront they represent to any sense of achieved social justice but also from the ragged edges they impose around the frames of our most cherished fantasies, from the cracks they open up in our fundamental sense of what and who we are as human beings. In the words of Crystal Waters' "Gypsy Woman," the first homeless hit song of the 1990s, "She's just like you and me but ... (she's homeless, she's homeless)."[31]

POLISCAR: ARTICULATED VEHICLE

The name of the vehicle, "Poliscar," comes from the same root as police, policy, and politics, namely from the Greek word for the city-state, *polis.* In ancient Greece the word referred more to a state of society characterized by a sense of community and participation of the citizen (*polites*) than to an institution or a place."

Krzysztof Wodiczko[32]

19 See Joshua Meyrowitz, *No Sense of Place: The Impact of Electronic Media on Social Behavior* (New York: Oxford University Press, 1985).
20 See Raymond Williams, "Community," in *What I Came to Say* (London: Hutchinson Radius, 1989).
21 See Paul Virilio, "The Overexposed City," *Zone,* nos. 1 and 2 (New York: Urzone, 1986), pp. 14–31.
22 See Robert Hewison, *Future Tense: A New Art for the Nineties* (London: Methuen, 1990).
23 Todd Gitlin, "Postmodernism—Roots and Politics," *Dissent* (Winter 1989), pp. 100–108.
24 See David Lurie, "Krzysztof Wodiczko," *Arts* 60 (March 1986), p. 130.
25 Norman Lebrecht, "Why Pleasure Is at Bay in the South Bank's Concrete Jungle," London *Sunday Times,* February 26, 1989.
26 Mike Davis, *City of Quartz: Excavating the Future in Los Angeles* (New York: Vintage Books, 1992), p. 253.
27 Ibid, p. 233. Other examples Davis cites include: the introduction of automatic, twenty-four hour preprogrammed water sprinklers strategically placed to deter homeless catnappers in public parks; and an "imbrication of the police function into the built environment" so naturalized that the rooftops of some homes in exclusive housing developments have been painted with identifying street numbers to facilitate helicopter surveillance.
28 Idem, "Los Angeles: Civil Liberties between the Hammer and the Rock," *New Left Review,* no. 170 (July–August 1988), pp. 37–60.
29 For an interesting examination of the abiding power of notions of *heimat* (literally, "homeland") in contemporary Europe, especially with reference to the formation of Germany's postwar identity, see David Morley and Kevin Robins, "No Place Like *Heimat,*" *New Formations,* no. 12 (Winter 1990).
30 Agnes Heller, quoted in Joan Kron, *Home-Psych: The Social Psychology of Home and Decoration* (New York: Clarkson N. Potter, 1983). Kron also quotes Gaston Bachelard ("Home is our corner of the world ... our first universe, a real cosmos in every sense of the word") and Kimberly Dovey ("Home is an ordering place of loving ... a place where one has some degree of control ... an option to modify").
31 Crystal Waters and B. Collins, "Gypsy Woman (She's Homeless)" (Polygram Records, Inc., 1991). Sung by Crystal Waters.
32 *Poliscar,* exh. cat. (New York: Josh Baer Gallery, 1991), unpaginated.

The *Homeless Vehicle*, as an interrogative tool for examining existing social relations rather than as yet another "engine of history," yet another utopian deliverance machine, is perhaps the key articulating metaphor within Wodiczko's politicized aesthetic. The various prototypes operate rhetorically insofar as they actively effect changes in the way the homeless see themselves and are seen by the non-homeless. As they move around the city, the vehicles and the discussions they provoke work to shift the terms in which homelessness is discussed and understood, so that the concealed structural links between development and displacement can be exposed and subjected to concerted challenge. At the same time, Wodiczko uses the project as a whole to articulate a nexus of blocked or disavowed connections between art's ethical and aesthetic vocations, its analytical and performative functions, between the formal grandeur of a new public building and the social squalor that collects around its base. These strategies and concerns come together in the *Poliscar* **(pp. 71–73)**, an articulation device for countering the infantilized (*infans:* adj. speechless) status of homeless men and women through the establishment of a homeless network adapted to the communicative conditions prevailing in the horizontal "information" cities of the late twentieth century.

From the outset, Wodiczko has taken pains to stress the Janus-like character of the Homeless Vehicle Project—the way it feeds into the local economy of (can and bottle) redemption while at the same time providing the visibility that is the necessary precondition for the eventual enfranchisement of evict communities. In the *Poliscar* this double-sided (or two-faced) disposition of the project is retained, though the vehicle's practical and communicative functions have been brought into even closer alignment. The *Poliscar* is a tramp steamer designed for tomorrow's world.

In addition to the now-expandable storage compartment and sleeping spaces, the vehicle bristles with Citizens Band radio aerials, electronic sensors, and video transmitters. Driven by an auxiliary gasoline-powered motor, the *Poliscar* comes complete with specially designed wheel and track systems for negotiating curbs, potholes, soft ground, etcetera.[33] The rotatable triangular "communications unit" located at the top of the cab contains a TV monitor, loudspeakers, an electronic signboard, a solar panel, a video camera that also functions as a surveillance camera, an unfolding TV-broadcast antenna, and hazard lights. The operator, enclosed within the reinforced Fiberglas chassis, becomes invisible, shielded from the elements and the scrutiny of passersby while having visual access to the street via the video cameras and removable windshields.

In a move that exposes through mimicry the design-led strategy of planned obsolescence, Wodiczko applies the "progressive" dynamic of product development to the life-world of evicted men and women; and in the process he consigns the supermarket cart to the dustbin of history. The *Poliscar* is an ironic rhetorical statement conjugated in the future perfect tense so beloved of techno-freak designers. Here, the artist introduces us to a new social category—the accessorized evict. He lists the essential items "that the urban nomad must carry with him or her at all times," to be secured in the locker situated beside the motor:

... water and other beverages; food supplies (e.g. special diet food); baby food; dog food; cooking tools; equipment for washing; emergency medical kit (including emergency shots for infections; medication for asthma, diabetics and for malnutrition, poisoning and drug or alcohol overdose; sleeping aids; vitamins; birth control; pregnancy tests; AIDS tests, etc, along with a medical history); gas mask; umbrella; suntan lotion and sunglasses; alarm clock, stationery; books; toys and games; audio and video tapes; disposable bags; spare parts; tools (e.g. flashlight, binoculars, tools for emergency repairs and for attaching the vehicle to other Poliscars); and valuables (money, personal and official documents, food stamps, drug and alcohol reserves, etc).[34]

A whole way of life is conjured up, in detail, round the *Poliscar*, which functions as vehicle of transmission for a new set of demands by an emergent "proto-community." Implied in Wodiczko's list of things is a list of rights: the right of homeless people to operate equipment, to bear children, to wear sunglasses and condoms, to own valuables and pets, to protect themselves from pollution and poison gas attacks, to drink alcohol, and to keep appointments (the alarm clock).

The most important entitlement remains the right to speak from a position, to initiate dialogue, and to "beg to differ." There can be no identity without difference, no community without a metaphorical frontier-effect, no boundary without culture, no culture without language and exchange, and "no alliance without treason" (Brendan Behan). The *Poliscar* offers a position from which nomadic evicts might begin to talk back—to resist or reverse police surveillance, exchange information, and coordinate tactics. It represents a mechanism for activating the latent networks of the heterogeneous community of evicts so that control over territory can be exercised internally over time and at a distance.

However, Wodiczko remains a (fantastical) realist. Access to the *Poliscar*, he suggests, should be restricted to potential evict-organizers. In the hands of competent volunteers drawn from the ranks of the homeless, the vehicles could perform the more general service of establishing a homeless network within the larger polis of active, legally protected citizens. The *Poliscar* as mobile (homeless) home could, in this way, give back voice and agency to a group of individuals condemned to silence and inaction. Insofar as the homeless literally live on the street, the *Poliscar*, as speech-act machine, promises to restore "the only true public of the city to itself."[35] Since the *Homeless Projection: A Proposal for Union Square* in 1986 (pp. 76, 77), Wodiczko has used the analogy between physical and metaphorical "public space" and the homeless condition, referring to both commemorative monuments and homeless evicts as "silent witnesses" to the betrayal of the promises of urban planners and developers and the civic ideals supposedly encoded in public architecture. Now, through the *Poliscar*, he exposes the exclusion produced by that betrayal not just of the homeless but of "us—the 'community'—from those real masses of 'strangers' from whom we are estranged and with whom we presume to have no common language."[36]

The *Poliscar* speaks out against that exclusion and reminds us that, in any dialogue or exchange, all positions are reversible. It reminds us that this reversibility is best regarded less as a threat to those boundaries that seem to guarantee our place in the world than as an

33 Ibid.
34 Ibid.
35 Ibid.
36 Ibid.

invitation—the fundamental dialogic promise of all sociality—to step outside ourselves, to give ourselves up, to be carried by the other like a bride across the threshold of the fractured and divided habitat of language, which remains for each of us a common point of origin, an always broken home. That promise is sufficiently important to warrant one last digression.

———

The classic texts of anthropological fieldwork and social exploration bear witness to the ambivalence of the writing subject's relation to the tabulated Other, who, whether knowingly or not, constitutes the object that draws the subject on. The prospect of dissolving the distance that separates the watcher and the watched is what motivates both the quest for knowledge and the fear of "going native," which always dogs the knowing subject from the shadows. Yet we might say that it is only when we fall beneath the shadow of the object, in that switching of positions, that *something else* gets through. What we call a "genuinely educative experience" is what comes back in the wake of that descent (*education* n. a leading-out): a return (though never to the same place) and a return, too, in that other sense—a return on an "investment," which, like the coin paid to the ferryman, represents a debt redeemed, the price extracted for the passage. It was, after all, not until Jack London stepped literally into "the other person's shoes" during the course of his investigations into conditions in London's East End in 1903 that he got to see what life was like in the "abyss." Disguised as a "common workman," he learned at once that, "In crossing crowded thoroughfares ... I had to be, if anything, more lively in avoiding vehicles, and it was strikingly impressed upon me that my life had cheapened in direct ratio with my clothes."[37] Only by merging briefly with his shadow, the "reverse-image" of the class to which he belonged, could London find that other London and the homely, *heimlich* violence of an order that demanded, then as now, that its shadows *get out of the way*.

Wodiczko's vehicles move differently, on different principles. As they are pushed or driven through a succession of physical spaces, discursive frames and contexts, as they trundle on toward the Walker Art Center from Fifth Avenue via Tompkins Square Park or the streets of Philadelphia, they attract non-evicts like a lure attracting fish. Wodiczko writes:

> Those in the middle class are well trained to consume. As good consumers they know how to quickly and accurately evaluate the 'value' of every new functional and symbolic form that appears before their commodity-tuned eyes. Many non-evicts were engaged and approached us to ask 'What is this for?' These same people see evicted individuals every day on the street and never ask questions. Now they are provoked to ask questions.[38]

With the *Poliscar* the splash of the lure in the water has become that much louder, the rhythm of seduction and inquiry that much more pronounced. We have all been led to this. At the end of the line, in the heart of the labyrinth, we find ourselves confronting a tanklike communications center operated by unseen hands. This, perhaps, is not what we were expecting at all. Through every stage of the project, Wodiczko has set about educating us as to what is at stake in the "homeless question," not by relaying the "findings" gleaned from his prolonged research into homelessness or by parading the homeless as victims or objects or

barely animate "issues," but by looking back at us from the other side of property, by hailing us, so to speak, through the loudspeakers mounted on the front of the *Poliscar* and making us turn round. We should hardly be offended to discover when we turn to face the face whose eyes (perhaps) we've been avoiding in the street that there is no one there (that we can see), just a speech-act machine, that it is, precisely, no one that is looking back at us.

Dick Hebdige, a reader in communications at Goldsmith's College, University of London, is the author of *Subculture: The Meaning of Style* (1979), *Cut 'n' Mix: Culture, Identity, and Caribbean Music* (1987), and *Hiding in the Light: On Images and Things* (1988).

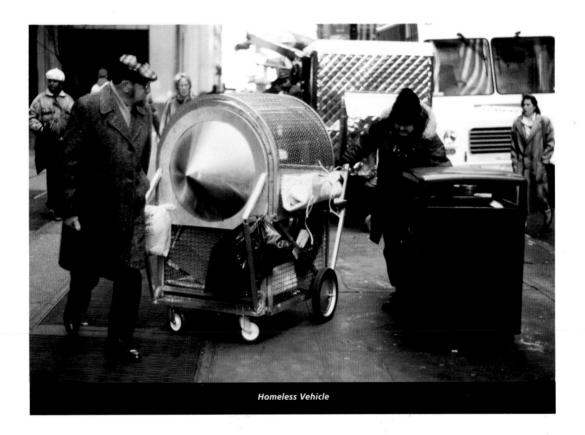

Homeless Vehicle

37 Jack London, *The People of the Abyss* (1904), quoted in Peter Keating, ed., *Into Unknown England, 1866–1913: Selections from the Social Explorers* (London: Fontana, 1976).
38 Supra, note 4.

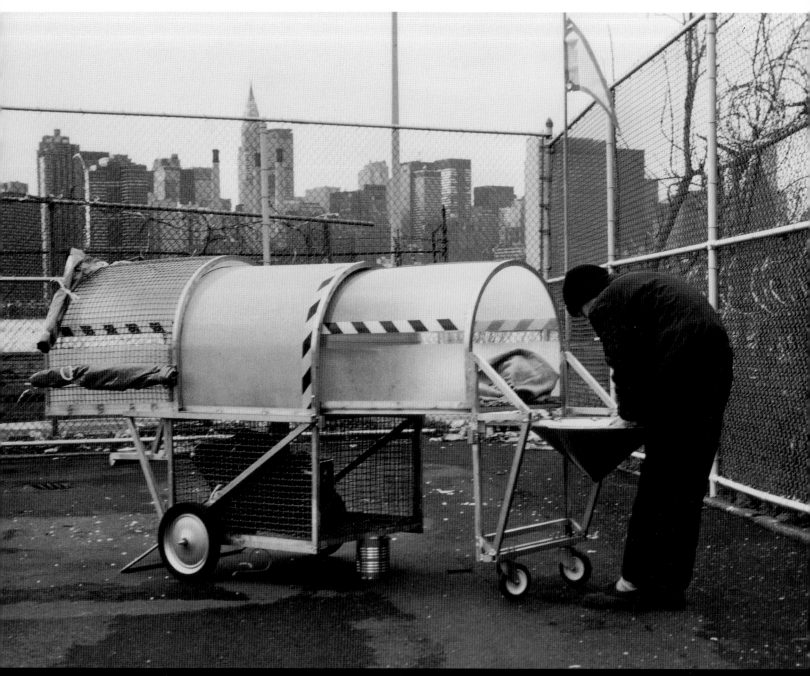

Above: *Homeless Vehicle*, 1988, in extended position. Right: Drawing for *Homeless Vehicle*, circa 1988.

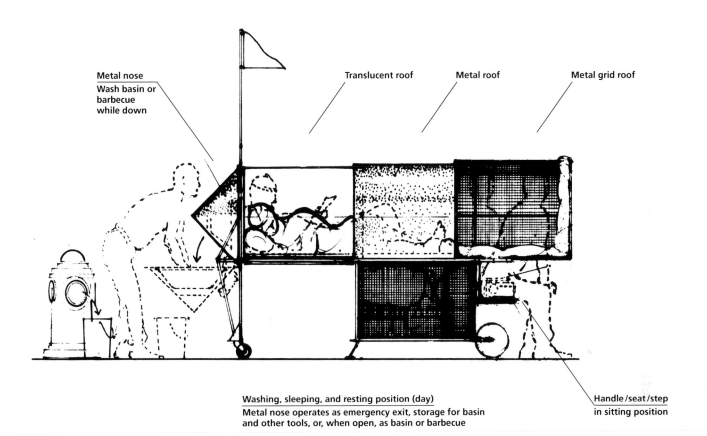

Metal nose
Wash basin or
barbecue
while down

Translucent roof Metal roof Metal grid roof

Handle/seat/step
in sitting position

Washing, sleeping, and resting position (day)
Metal nose operates as emergency exit, storage for basin
and other tools, or, when open, as basin or barbecue

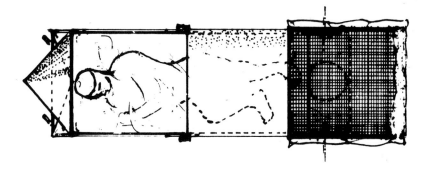

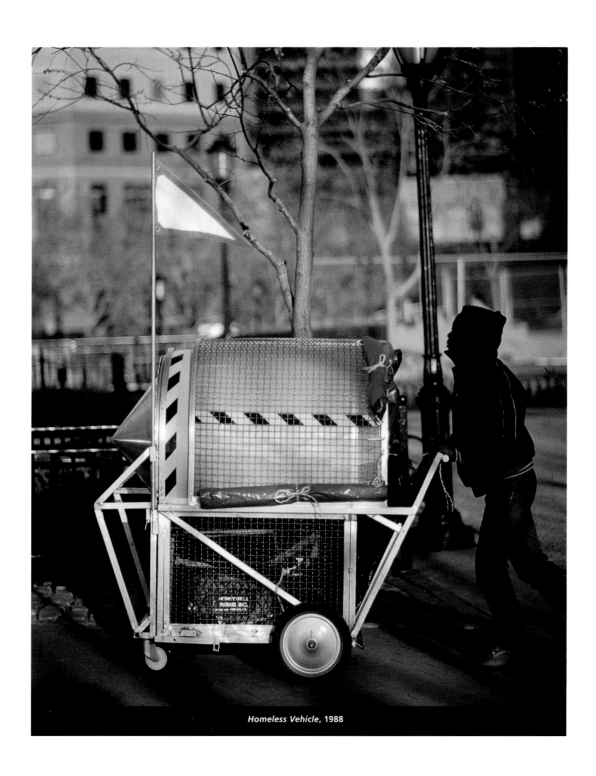

Homeless Vehicle, 1988

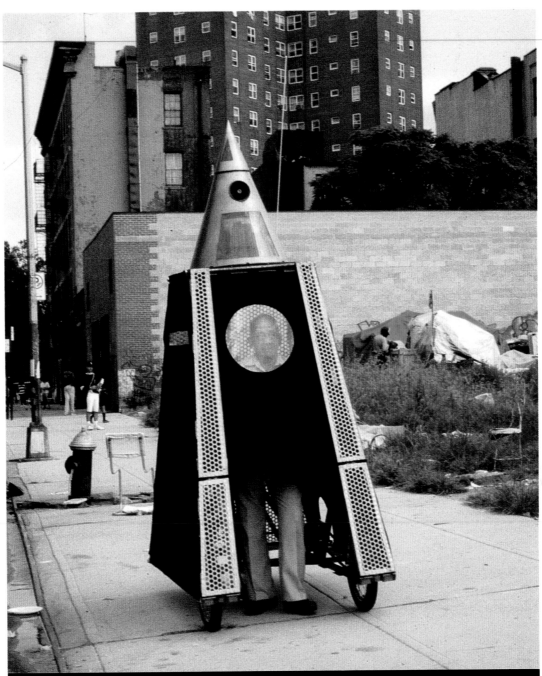

Poliscar, 1991

Wodiczko's Homeless Vehicle Project
Dick Hebdige

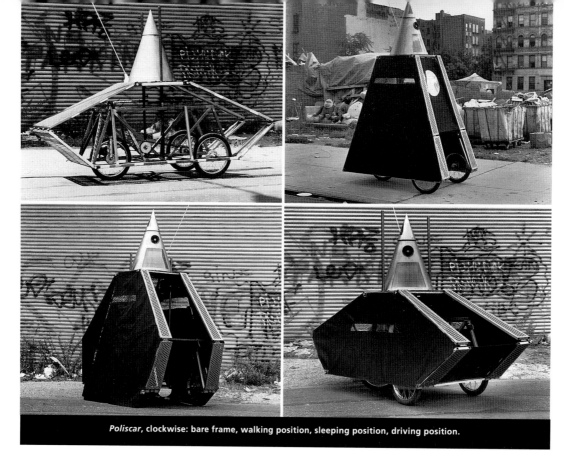

Poliscar, clockwise: bare frame, walking position, sleeping position, driving position.

The *Poliscar* is designed for a particular group of homeless persons, those who have communications skills and the motivation to work with the homeless population in organizing and operating the Homeless Communication Network, a mobile land-radio service. The CB-radio component of the network is comprised of mobile communication and living units (*Poliscars*) and one or more base stations. A base station is installed at a fixed location to communicate with the mobile units and other base stations. Key *Poliscars* within the Homeless Communication Network will be outfitted with portable microwave links that employ a line-of-sight video-transmission signal. Video signals from a *Poliscar* in one community can be directed to repeaters located on the eighty-second floor of the Empire State Building and transmitted as scheduled communications to *Poliscars* around the city.

Through the Homeless Communication Network and its equipment, the *Poliscar* will:

- increase the sense of security among those who live outside by transmitting emergency information regarding dangers facing both the homeless and non-homeless in troubled areas;
- help develop forms of communication necessary for the participation of homeless populations in municipal, state, and federal elections;
- develop a sense of social and cultural bonding among the members of the groups;
- help create and record not only images but also individual histories of the homeless;
- produce both image and sound programs that could help different groups and individuals extend and expand considerably the constituencies of existing action groups and constantly update information in areas such as legal aid, medical aid, and social-crisis aid; and
- help the economic system of the homeless population enter the larger economic system of the city through an advertising skills-and-communication system for job listings within certain labor markets.

The homeless population is the true public of the city, in that homeless people literally live on the street, spending their days and nights moving through the city, working and resting in public parks and squares. The contradiction of their existence, however, is that, while they are physically confined to public spaces, they are politically excluded from public space constitutionally guaranteed as a space for communication. They have been expelled from society into public space, but they are confined to living within it as silent, voiceless actors. As long as the voiceless occupy public space, rendering them their voice is the only way to make that space truly public.

Krzysztof Wodiczko, 1992

In a rotating cone structure at the top of the vehicle is a communications unit with a TV monitor and a loud-speaker. In the top section is a surveillance camera, which can rotate independently.

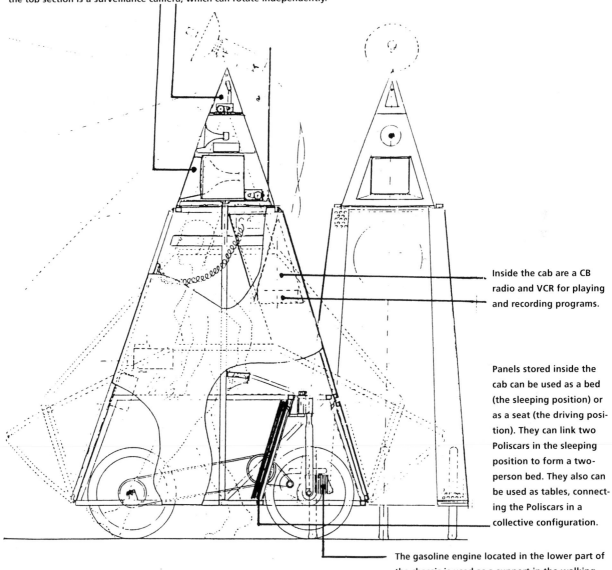

Inside the cab are a CB radio and VCR for playing and recording programs.

Panels stored inside the cab can be used as a bed (the sleeping position) or as a seat (the driving position). They can link two Poliscars in the sleeping position to form a two-person bed. They also can be used as tables, connecting the Poliscars in a collective configuration.

The gasoline engine located in the lower part of the chassis is used as a support in the walking position and for driving.

Projections

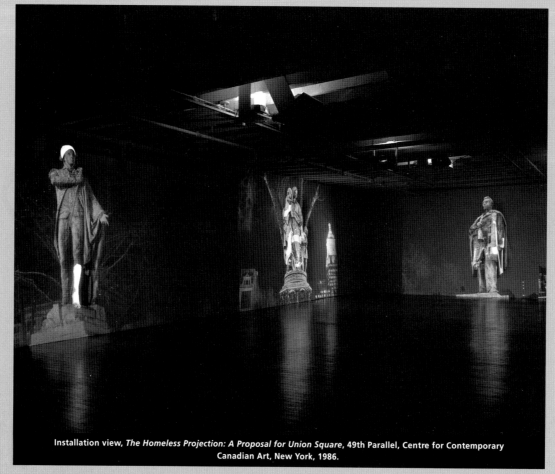

Installation view, *The Homeless Projection: A Proposal for Union Square*, 49th Parallel, Centre for Contemporary Canadian Art, New York, 1986.

The gentrification of New York City's Union Square district in the 1980s forced many low-income inhabitants out of the area's low-rent apartments and single-room occupancy hotels, which were replaced by luxury condominiums. In this gallery installation, Wodiczko dramatized the plight of these "evicts" by proposing the slide projection of attributes relating to them—bandages, crutches, wheelchairs, and derelict buildings—onto images of the statues of Lafayette, Washington, Lincoln, and the allegorical figure of Charity, which are located in Union Square Park.

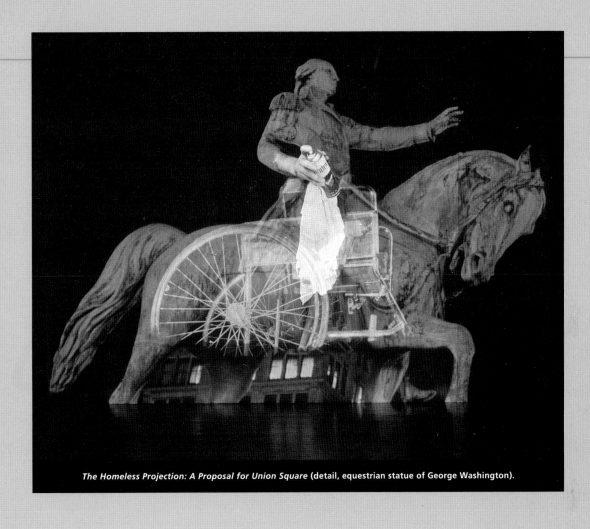

The Homeless Projection: A Proposal for Union Square (detail, equestrian statue of George Washington).

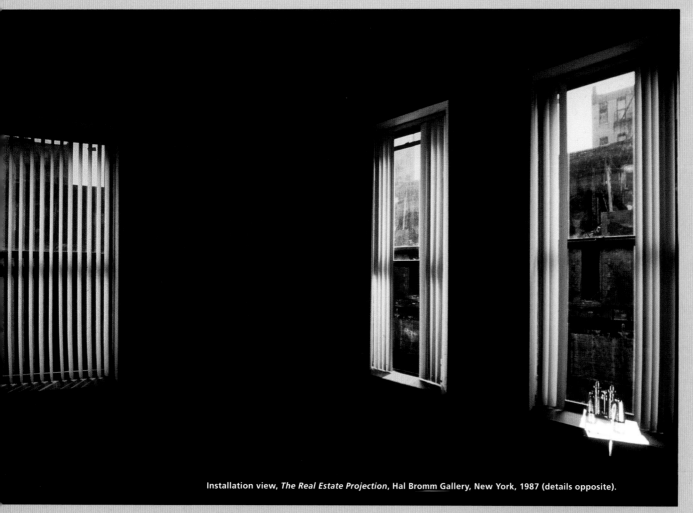

Installation view, *The Real Estate Projection*, Hal Bromm Gallery, New York, 1987 (details opposite).

In 1987 the Hal Bromm Gallery was located in New York City's East Village, a derelict neighborhood then in the early stages of gentrification. Onto the windowless gallery walls Wodiczko projected slide images of window views from a newly renovated apartment located just around the corner. On one of these windows he super-imposed the image of a pair of binoculars resting on several real estate-related magazines.

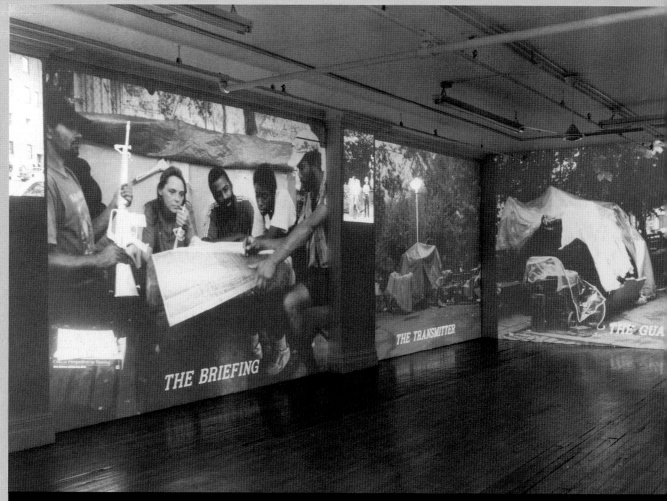

THE BRIEFING

THE TRANSMITTER

THE GUA

Installation view, *New York City Tableaux: Tompkins Square*, Exit Art, New York, 1989.

In the summer of 1988 the New York Police Department responded to complaints about drug activity and the presence of homeless people living in Tompkins Square Park, on the city's Lower East Side, by enforcing a forgotten old law requiring city parks to close at 1 am. For months thereafter, the park was the scene of clashes between police and a coalition of local residents, housing activists, squatters, and homeless people. In an August 10, 1988, article the *New York Times* covered the dispute under the headline "Class Struggle Erupts along Avenue B." For this installation, Wodiczko staged images of inhabitants of Tompkins Square Park and superimposed on them slides of weapons and communications equipment.

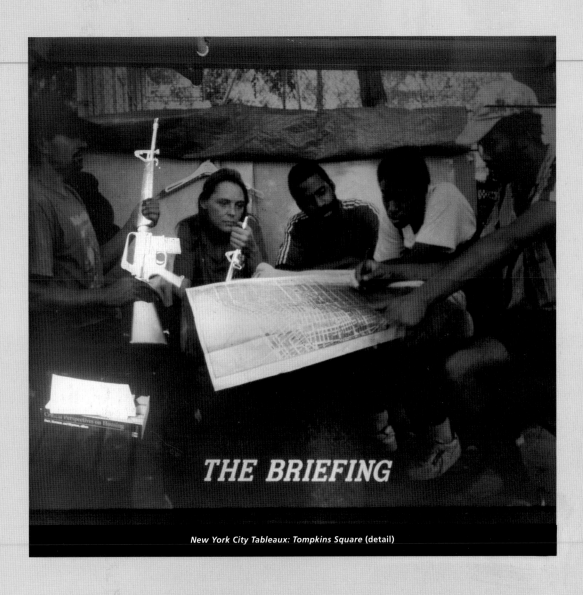

THE BRIEFING

New York City Tableaux: Tompkins Square (detail)

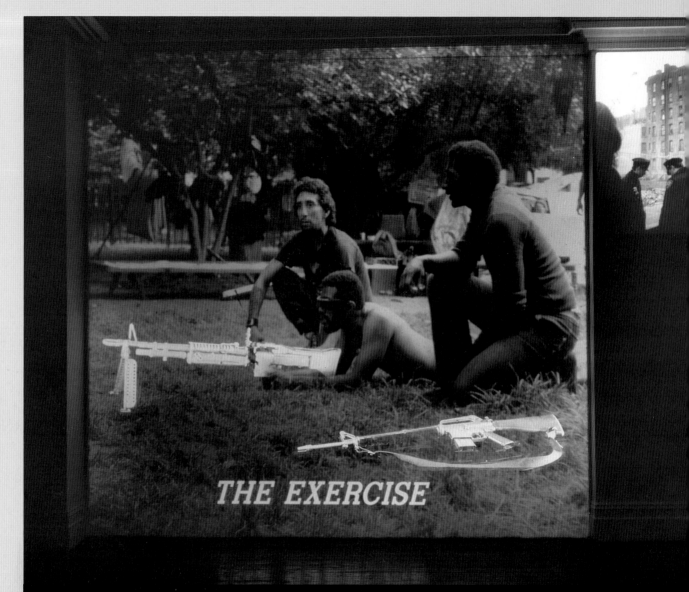

THE EXERCISE

New York City Tableaux: Tompkins Square (details)

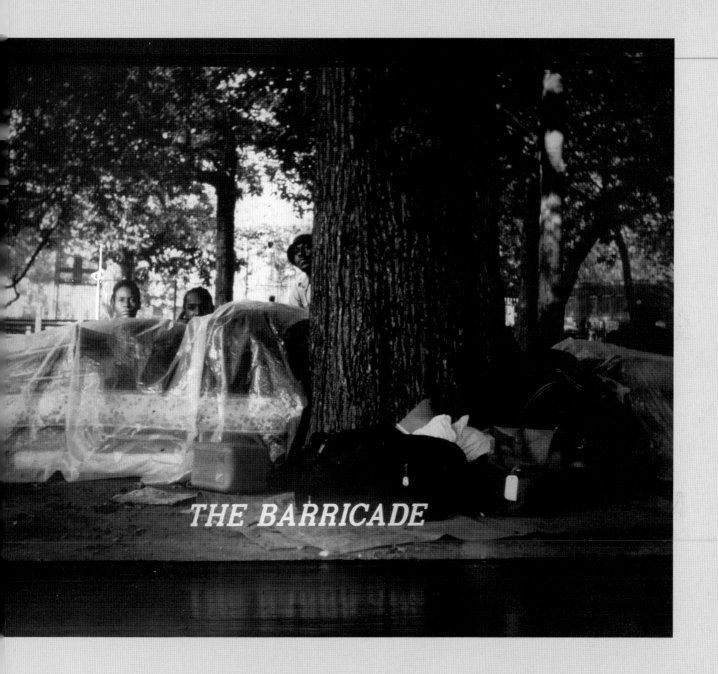

THE BARRICADE

"The attack must be unexpected, frontal, and must come with the night when the building, undisturbed by its daily functions, is asleep and when its body dreams of itself, when the architecture has its nightmares. This will be a symbol-attack, a public psycho-analytical seance, unmasking and revealing the unconscious of the building, its body, the 'medium' of power."

Krzysztof Wodiczko

Public Projections

With contributions by Lois E. Nesbitt and Michelle Piranio

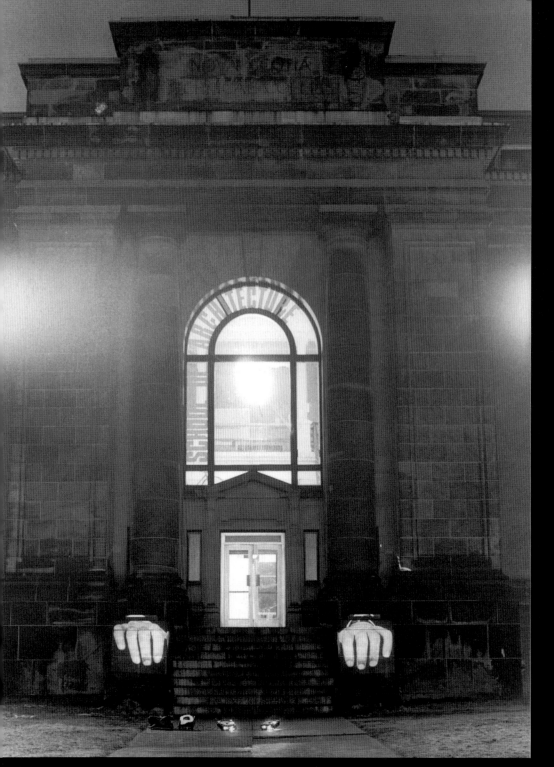

School of Architecture, Technical University of Nova Scotia, Halifax, 1981. Organized by the Centre for Art Tapes and Eye Level Gallery, Halifax, in conjunction with a solo exhibition at Eye Level Gallery.

"My interest is in the ideology of public space. I am interested in how architecture in the so-called 'public domain' operates culturally. I am not about revolutionary messages on walls. I want to analyse the relationship between the human body, the body of someone who lives here, and the social body and the body of the architectural and spatial forms around that body."

(KW in Steve Rogers, "'Territories 2: Superimposing the City," *Performance Magazine*, August 9, 1985.)

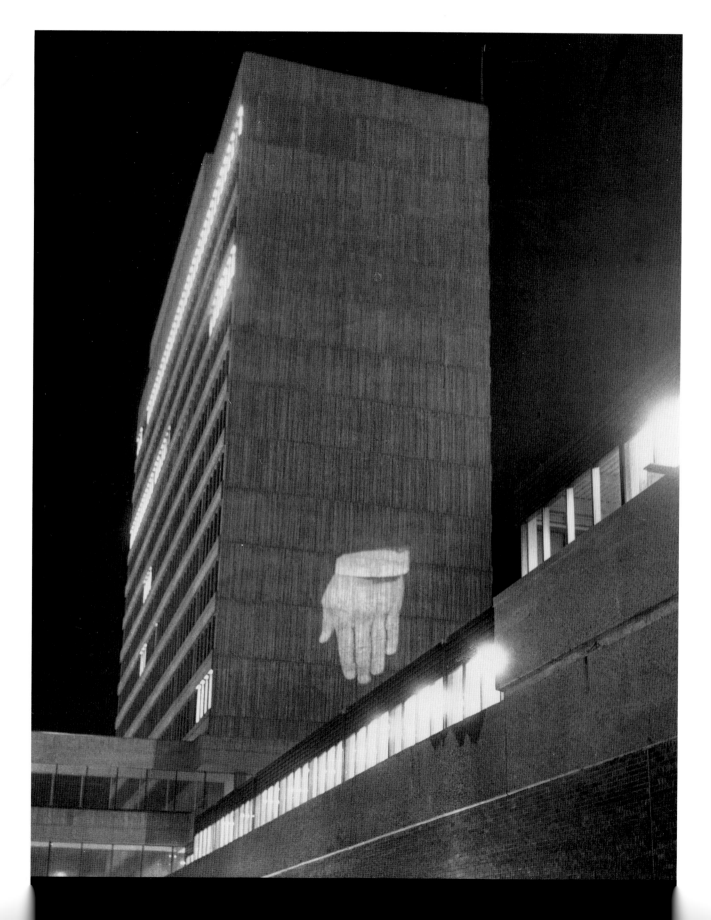

"In the process of our socialization, the very first contact with a public building is no less important than the moment of social confrontation with the father, through which our sexual role and place in society [are] constructed. Early socialization through patriarchal sexual discipline is extended by the later socialization through the institutional architecturalization of our bodies. Thus the spirit of the father never dies, continuously living as it does in the building which was, is, and will be embodying, structuring, mastering, representing, and reproducing his 'eternal' and 'universal' presence as a patriarchal wisdom-body of power."
(KW, "Public Projection," *Canadian Journal of Political and Social Theory* 7, Winter–Spring 1983.)

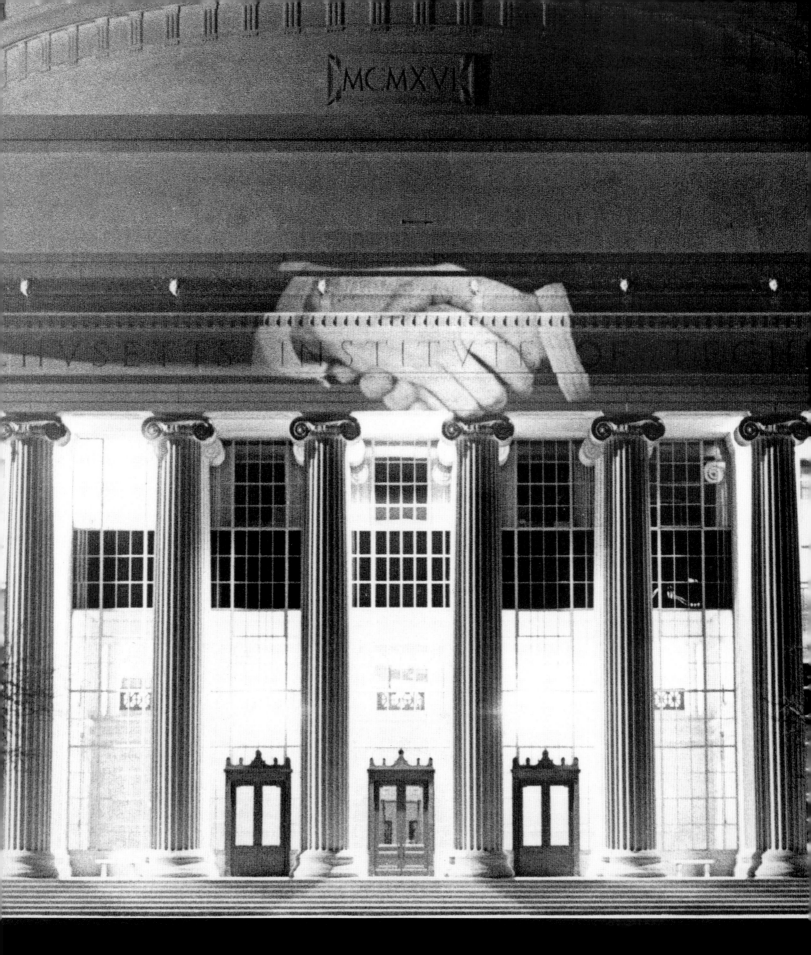

"The building is not only an institutional 'site of the discourse of power,' but, more importantly, it is a metainstitutional, spatial medium for the continuous and simultaneous symbolic reproduction of both the general myth of power and of the individual desire for power. For these purposes, the building is 'sculptured' to operate as an [aesthetic] structure, thus assisting in the process of inspiring and symbolically concretizing (reflecting) our mental projections of power."

(KW, "Public Projection," *Canadian Journal of Political and Social Theory* 7, Winter–Spring 1983.)

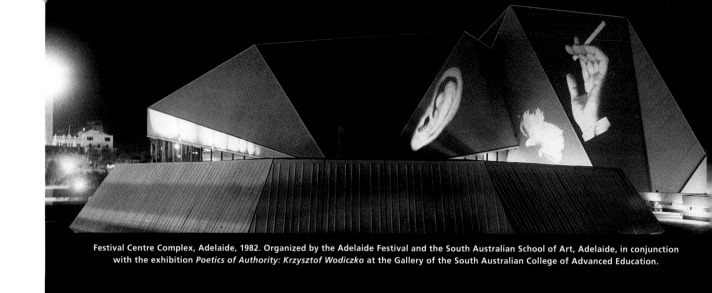

Festival Centre Complex, Adelaide, 1982. Organized by the Adelaide Festival and the South Australian School of Art, Adelaide, in conjunction with the exhibition *Poetics of Authority: Krzysztof Wodiczko* at the Gallery of the South Australian College of Advanced Education.

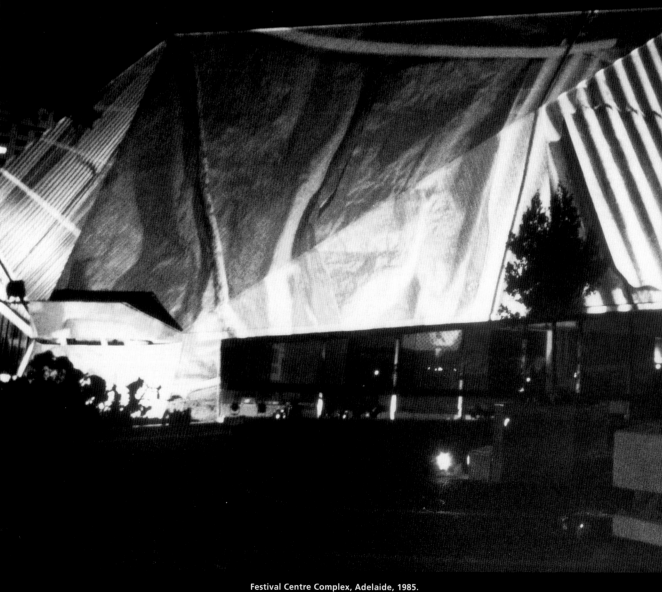

Festival Centre Complex, Adelaide, 1985.

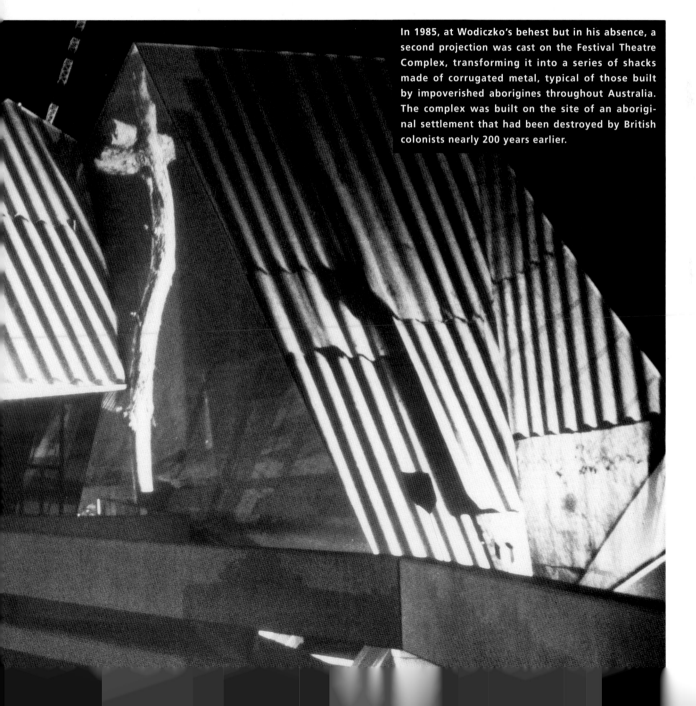

In 1985, at Wodiczko's behest but in his absence, a second projection was cast on the Festival Theatre Complex, transforming it into a series of shacks made of corrugated metal, typical of those built by impoverished aborigines throughout Australia. The complex was built on the site of an aboriginal settlement that had been destroyed by British colonists nearly 200 years earlier.

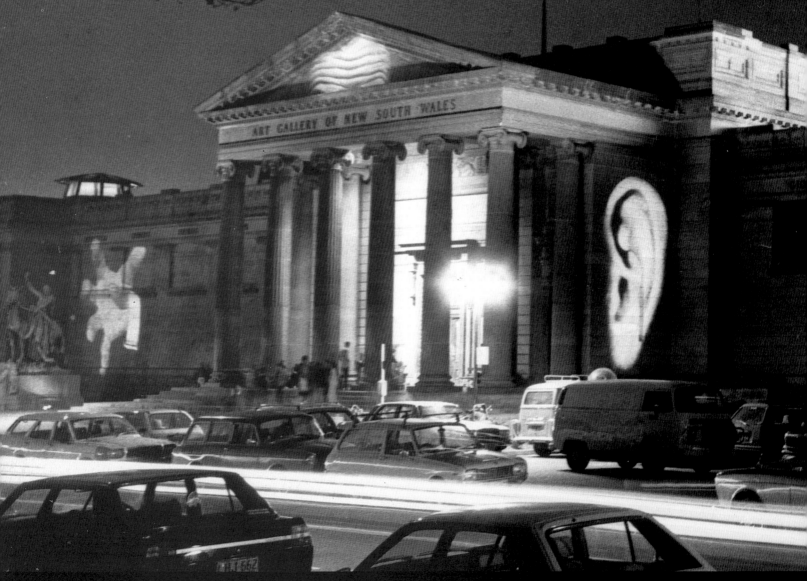

This projection, presented on the opening night of the *Biennale*, featured changing images of hands opening and closing in a grasping gesture. The exhibition was on view inside the building.

"Confrontation with the monstrous scale of some buildings, their symmetry and all of the bodily metaphors they contain forced me to start photographing these images in a special way. I needed to fragment them so they could reassemble on the surfaces of the buildings according to what these surfaces and parts of buildings suggested to me." (KW in Leah Ollman, "At the Galleries," *Los Angeles Times*, January 28, 1988.)

Art Gallery of New South Wales, Sydney, 1982. Organized for *The Biennale of Sydney.*

The projection shows missiles pointed down toward a crowd of people gathered on the steps of the building. On either side of the missiles, over carved inscriptions honoring those who died for their country, Wodiczko projected identical symmetrical images of women in lamentation—a fragment of Jacques-Louis David's 1789 painting *The Lictors Carrying off the Bodies of the Sons of Brutus*. The painting deals with personal sacrifice for the sake of the state. The inclusion of these figures underscores the concept of mourning, a role traditionally ascribed to women in time of war.

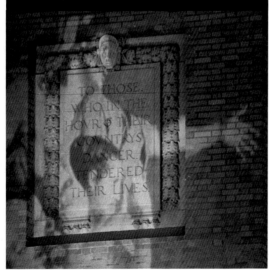

"The meaning of city monuments—whether intentional or unintentional, historic or contemporary—must be secured today, as in the past, through the ability of the inhabitants to project and superimpose their critical thoughts and reflections on the monument forms.... Not to speak through the city monuments is to abandon them and to abandon ourselves, losing both a sense of history and the present.... Today, more than ever before, the meaning of our monuments depends on our active role in turning them into sites of memory and critical evaluation of history as well as places of public discourse and action. This agenda is not only social or political or activist, it is also an aesthetic mission." (KW, *Krzysztof Wodiczko WORKS*, exhibition brochure, Hirshhorn Museum and Sculpture Garden, Washington, D.C., 1988.)

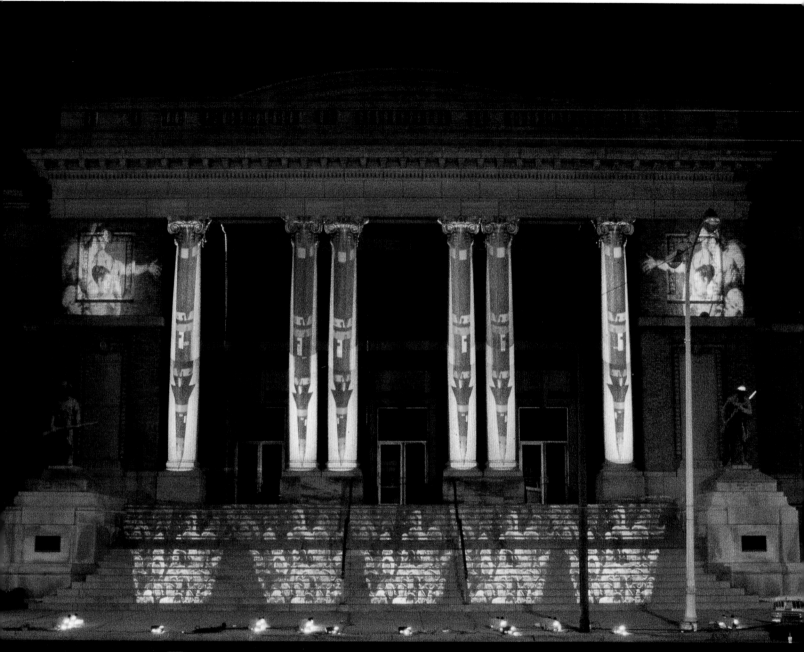

Memorial Hall, Dayton, Ohio, 1983. Organized by the City Beautiful Council, Dayton.

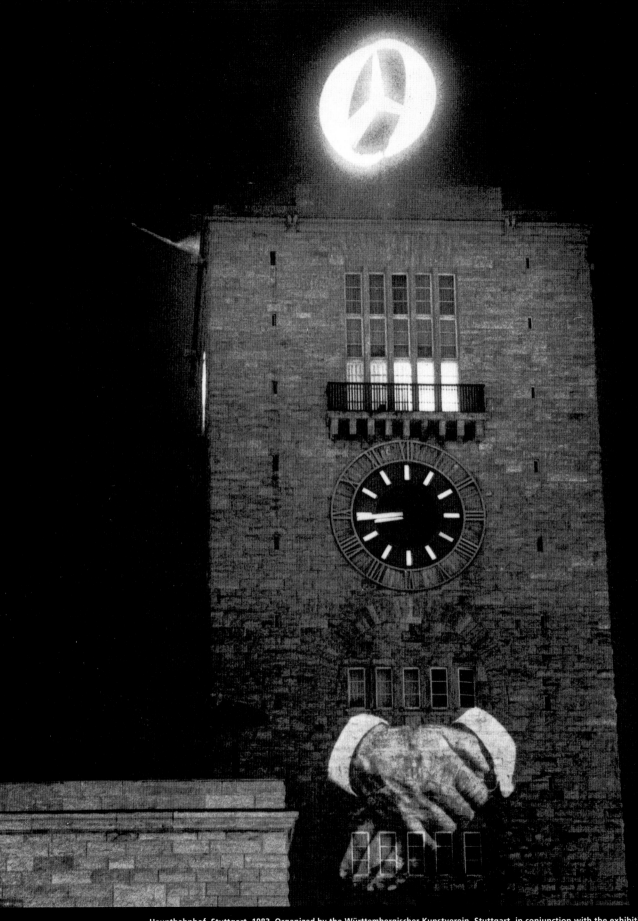

Hauptbahnhof, Stuttgart, 1983. Organized by the Württembergischer Kunstverein, Stuttgart, in conjunction with the exhibition *Künstler aus Kanada: Räume und Installationen* (*Artists from Canada: Rooms and Installations*).

A rotating Mercedes-Benz sign is located atop the tower of the Hauptbahnhof. At the time of the projection the Mercedes-Benz plant in Stuttgart employed many *Gastarbeiter* (guest workers). Wodiczko was dissatisfied with the final form of this projection: the pair of corporate hands at the top were supposed to have been accompanied by a pair of guest worker's hands projected below. Due to an alleged shortage of funds, however, the latter never appeared.

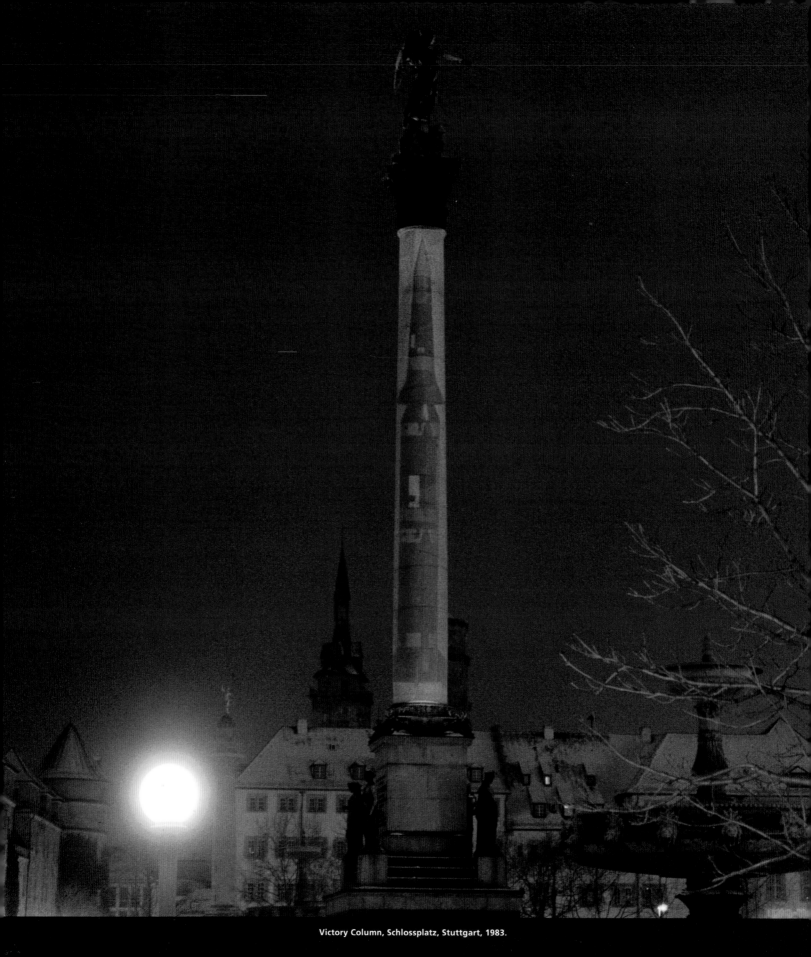

Victory Column, Schlossplatz, Stuttgart, 1983.

This projection took place during the 1983 national election campaign in West Germany. A plan to deploy Pershing 2 missiles in that country—endorsed by the Christian Democratic Party, whose slogan was that peace could be achieved only through strength—was a critical issue in the campaign.

"Every built structure is pregnant with a metaphor of the body and of another object ... like missiles, which operate in the contemporary world as neoclassic columns." (KW in *Counter-Monuments: Krzysztof Wodiczko's Public Projections*, exhibition catalogue, Hayden Gallery, List Visual Arts Center, Massachusetts Institute of Technology, Cambridge, 1987.)

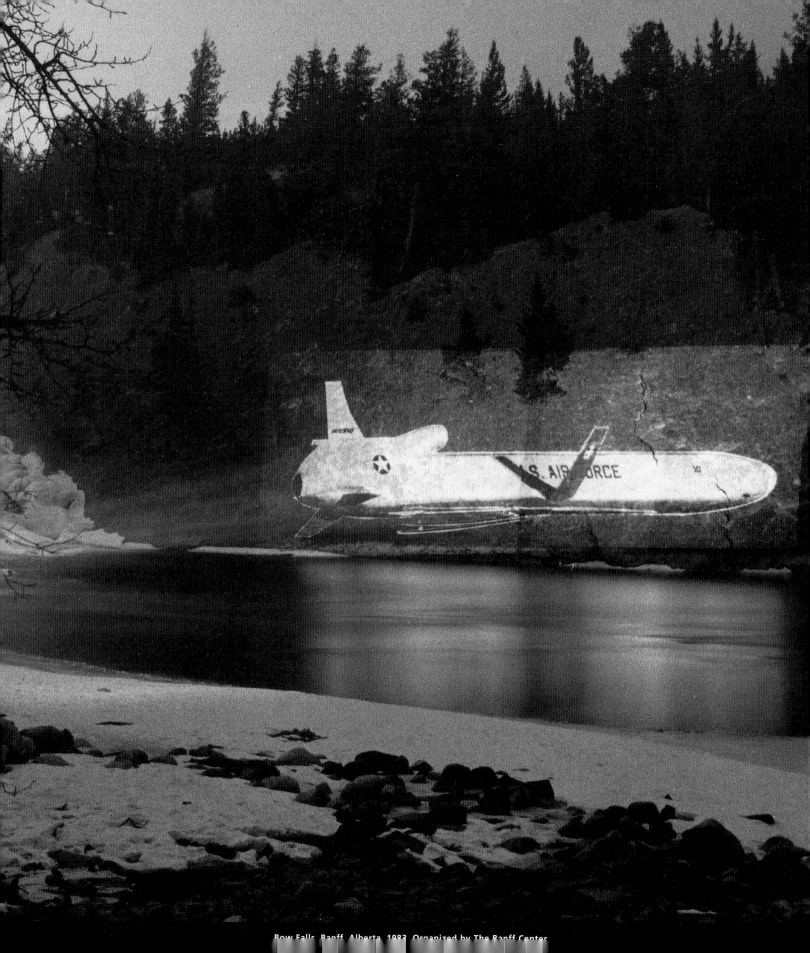

Bow Falls, Banff, Alberta, 1983. Organized by The Banff Center

"The Bow Falls projection may appear to be an anomaly in the sequence of my urban architectural work, but it actually is an interesting parallel, a kind of equivalent site to the Victory Column in Stuttgart, for example. In one part of the world they were deploying Pershing 2s; in another part trying to engage Canada in the testing of their new weapons. At that time there was enormous pressure being brought on [Canadian Prime Minister Pierre] Trudeau from all sides not to allow the Americans to use Alberta and the Northern Territories to test cruise missiles in the name of the similarity between the Canadian and Soviet landscapes. In a way the missile was already in that canyon, a lost, romantic missile, a weapon moving along, almost mimicking the horse in a cowboy movie." (KW in *Counter-Monuments: Krzysztof Wodiczko's Public Projections*, exhibition catalogue, Hayden Gallery, List Visual Arts Center, Massachusetts Institute of Technology, Cambridge, 1987.)

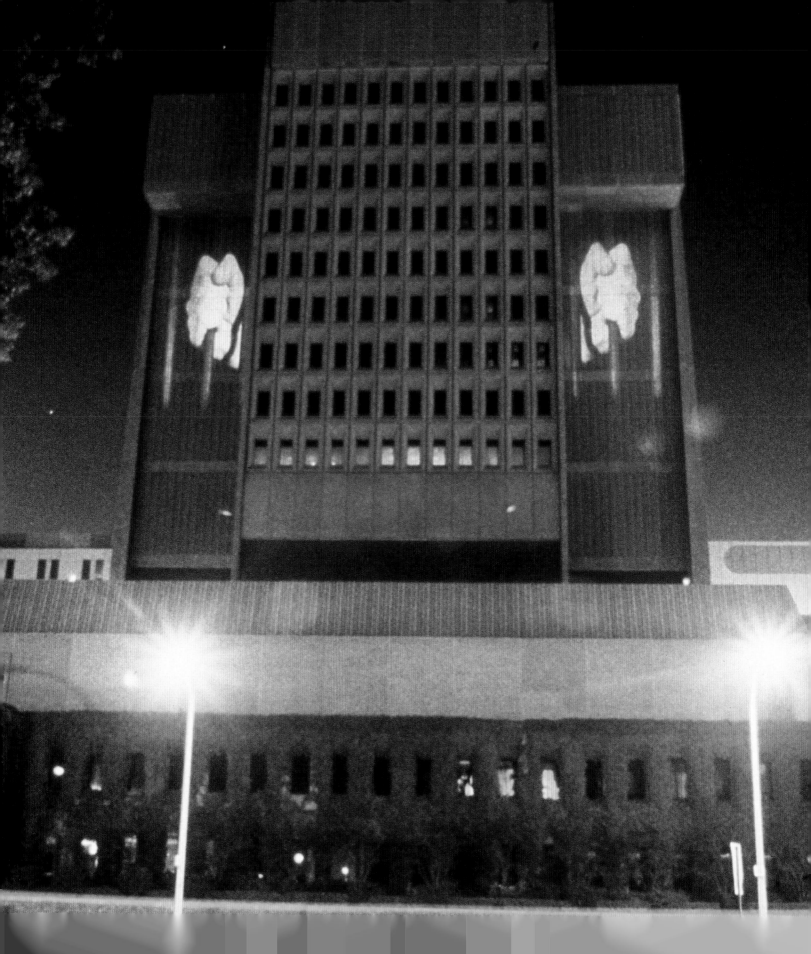

The hands wrapped around steel bars were projected on the wings of the building that house holding cells for detainees awaiting trial.

"The intervention lasts longer than the work itself. In fact, in many ways the power of the projection can be better understood when the projectors have been switched off. Something has been broken—at least for those who know the building, who work in the building, who grew up looking at this building. For those who saw the projection—even for only five minutes—the building will never return to its original power. For them the (building's mask) has been stripped away; the building has lost the power of its costume. And, on the following evenings when the physical projection is no longer there, another projection takes place—a mental one." (KW in Richard Schwarze, "The Intent Is to 'Demystify'," Dayton *Journal Herald*, May 21, 1983.)

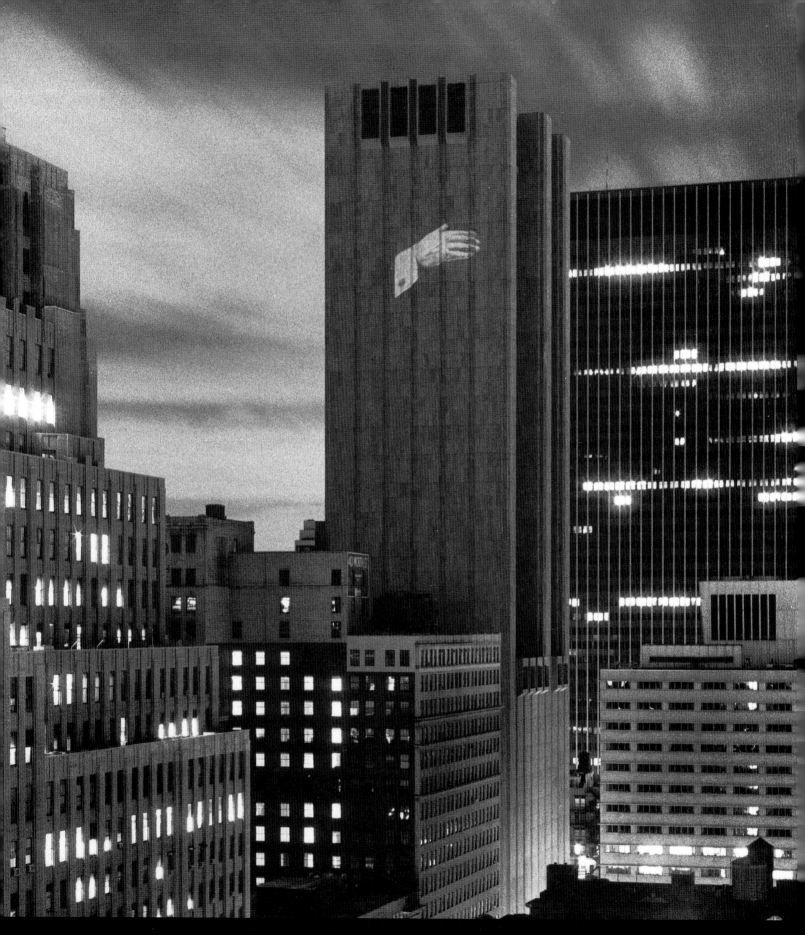

This projection took place on November 2, four days before the United States presidential election. The building is located in lower Manhattan, in New York's financial district. On the north face of the building, forty stories up, Wodiczko projected an image of an enormous open hand that appeared to be pressed to the heart of the structure in a pledge of allegiance; the hand had been taken from a photograph of President Ronald Reagan. "By creating a spectacle in which a fragment of the governing body, the presidential hand, was asked to stand for corporate business, Wodiczko offered a suggestion about the class identity of those forces that—hidden under the guise of God, State, and Nation—are the actual receivers of the pledge of allegiance." (Ewa Lajer-Burcharth, "Understanding Wodiczko," in *Counter-Monuments: Krzysztof Wodiczko's Public Projections*, exhibition catalogue, Hayden Gallery, List Visual Arts Center, Massachusetts Institute of Technology, 1987.)

"The attack must be unexpected, frontal, and must come with the night when the building, undisturbed by its daily functions, is asleep and when its body dreams of itself, when the architecture has its nightmares. This will be a symbol-attack, a public psychoanalytical seance, unmasking and revealing the unconscious of the building, its body, the 'medium' of power. By introducing the technique of an outdoor slide montage and the immediately recognizable language of popular imagery, the Public Projection can become a communal, aesthetic counter-ritual. It can become an urban night festival, an architectural 'epic theater,' inviting both reflection and relaxation, where the street public follows the narrative forms with an emotional engagement and a critical detachment." (KW, "Public Projection," *Canadian Journal of Political and Social Theory* 7, Winter–Spring 1983.)

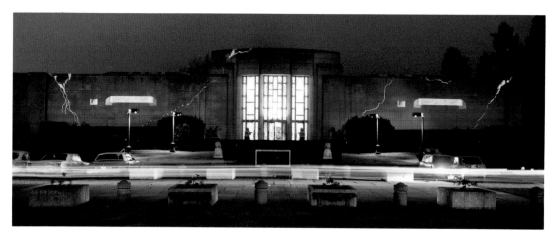

"Presenting itself publicly as a timeless functional monolith, well camouflaged by the pale and bloodless surface, the Wall operates behind its purifying appearance as a full-blooded, fleshy ideological medium. To protect its undercover activity, a conspiring Wall must be a Wall-to-Itself. The Cultural aim of the Critical Public Art is to publicly Unwall the Wall." (KW, "The Wall," *Quintessence* 6, Dayton: City Beautiful Council, 1984.)

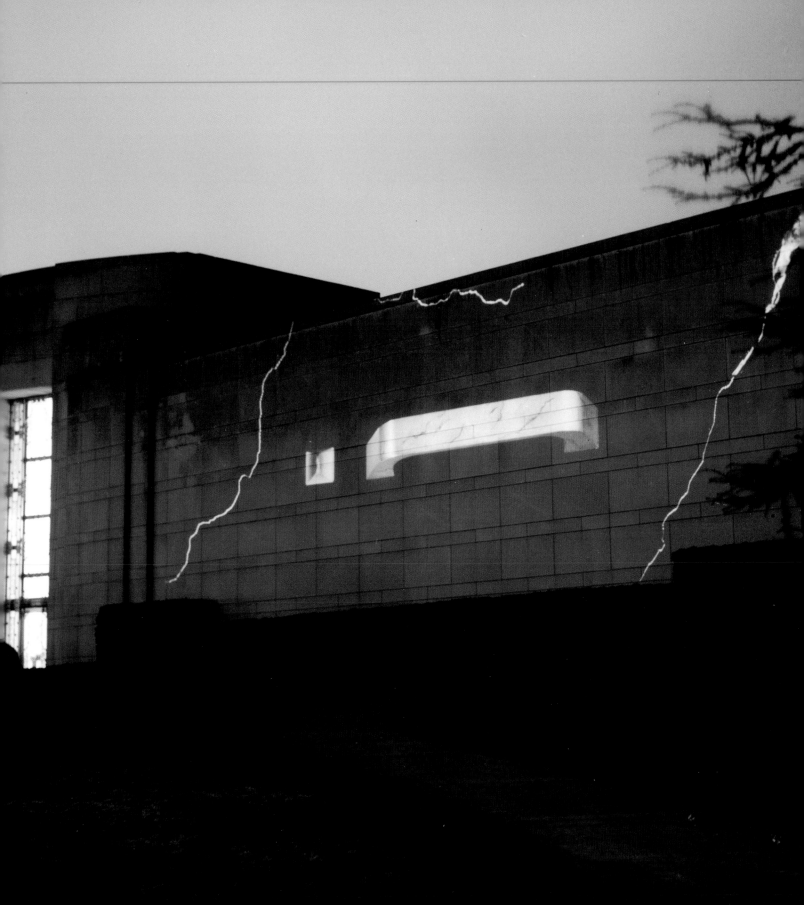

Seattle Art Museum, 1984. Organized by the Center on Contemporary Art, Seattle, in conjunction with the exhibition *Public Comments*

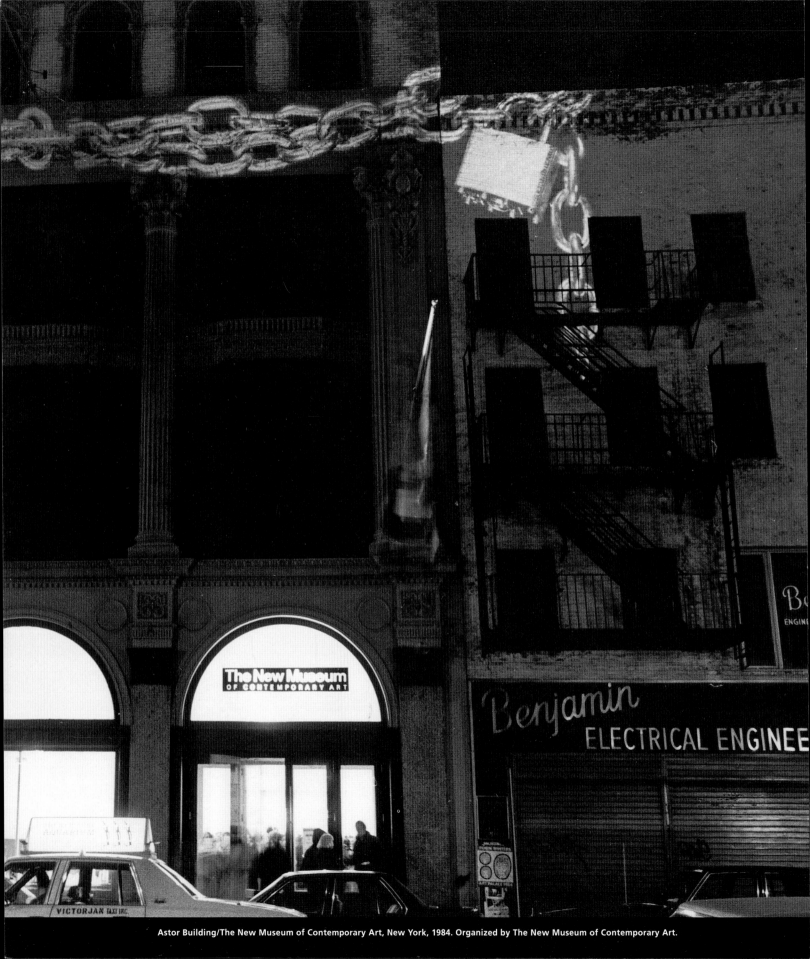

Astor Building/The New Museum of Contemporary Art, New York, 1984. Organized by The New Museum of Contemporary Art.

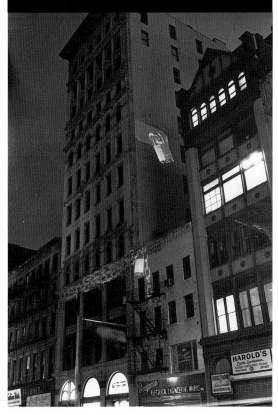

At the time of this projection, the space above the museum was slated to be converted into a group of luxury loft condominiums. The development project failed, however, leaving the space unoccupied for more than three years, during a period when increasing numbers of people were living on the streets of New York City.

"The situation at that time was very dramatic. It was winter, and I was living very close to the main shelter for homeless men and quite close to a shelter for women. I saw many people living on the street, trying to survive the bitter-cold temperatures by burning tires. It was therefore shocking to me to see one of the largest buildings in the entire neighborhood empty.... There are, in fact, two exhibition spaces there. One is for The New Museum exhibitions, and next door there is an exhibition of the former state of the building and how it will look after renovation, a real estate exhibition. There is obviously a connection between the presence of the museum and the subsequent conversion of the entire surrounding area into one of art galleries and other art-related institutions and businesses.... The bottom padlock was decided upon later, when I learned more about the connections between the museum and this art/real estate operation." (KW [with Douglas Crimp, Rosalyn Deutsche, and Ewa Lajer-Burcharth], "Conversation with Krzysztof Wodiczko," October 38, Winter 1986.)

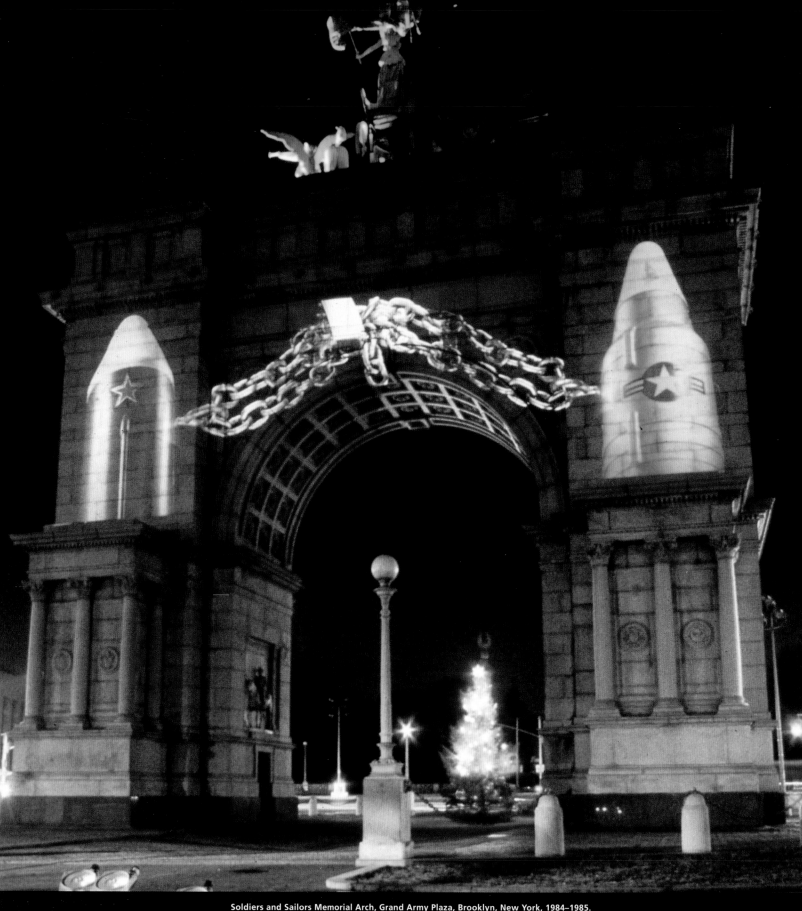

Soldiers and Sailors Memorial Arch, Grand Army Plaza, Brooklyn, New York, 1984–1985.
Organized by the Prospect Park Administrator's Office, New York City Department of Parks and Recreation.

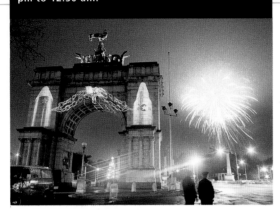

The projection was created as part of the borough of Brooklyn's annual New Year's Eve celebration, which included fireworks, music, and refreshments; it lasted one hour, from 11:30 pm to 12:30 am.

"This is a monument to the Northern army, so the south side of the arch is very busy with representations of the army marching south to liberate the South from 'wrongdoing.' The monument has absolutely nothing to say about the North, because if it did it would have to reflect on itself.... Ironically, this arch, which is conceived as receiving the victorious Northern army and which uses the typical classicizing Beaux-Arts style in the work of [Augustus] St. Gaudens, is challenged by two small, realist bas-relief sculptures by [Thomas] Eakins placed inside the arch. They are the only two figures actually walking north, coming back from the war, extremely tired. As far as I know, this is the only monument in the world that contains such an internal debate, aesthetically and historically.... The people viewing the projection offered their own interpretations. What I liked was that everyone was trying to impose his or her reading upon others. It turned into a political debate based on reading the symbols and referring to the contemporary political situation. It was a time when the public was being prepared for impending peace talks between the U.S. and Soviet governments. There were great expectations about coming back to the conference table and perhaps for a reduction of the arms race.... Because the debate was open and easily heard, all the readings were most likely received by everyone, and hopefully this social and auditory interaction helped the visual projection survive in the public's memory as a complex experience. For a moment at least, this 'necro-ideological' monument became alive." (KW [with Douglas Crimp, Rosalyn Deutsche, and Ewa Lajer-Burcharth], "Conversation with Krzysztof Wodiczko," *October* 38, Winter 1986.)

Nelson's Column, Trafalgar Square, London, 1985. Organized by the Institute for Contemporary Art and The Artangel Trust in conjunction with a solo exhibition at Canada House, London.

"The aim of the memorial projection is not to 'bring life to' or 'enliven' the memorial nor to support the happy, uncritical, bureaucratic 'socialization' of its site, but to reveal and expose to the public the contemporary deadly life of the memorial. The strategy of the memorial projection is to attack the memorial by surprise, using slide warfare, or to take part in and infiltrate the official cultural programs taking place on its site. In the latter instance, the memorial projection will become a double intervention: against the imaginary life of the memorial itself, and against the idea of social-life-with-memorial as uncritical relaxation. In this case, where the monumental character of the projection is bureaucratically desired, the aim of the memorial projection is to *pervert this desire* monumentally." (KW, "Memorial Projection," *October* 38, Winter 1986.)

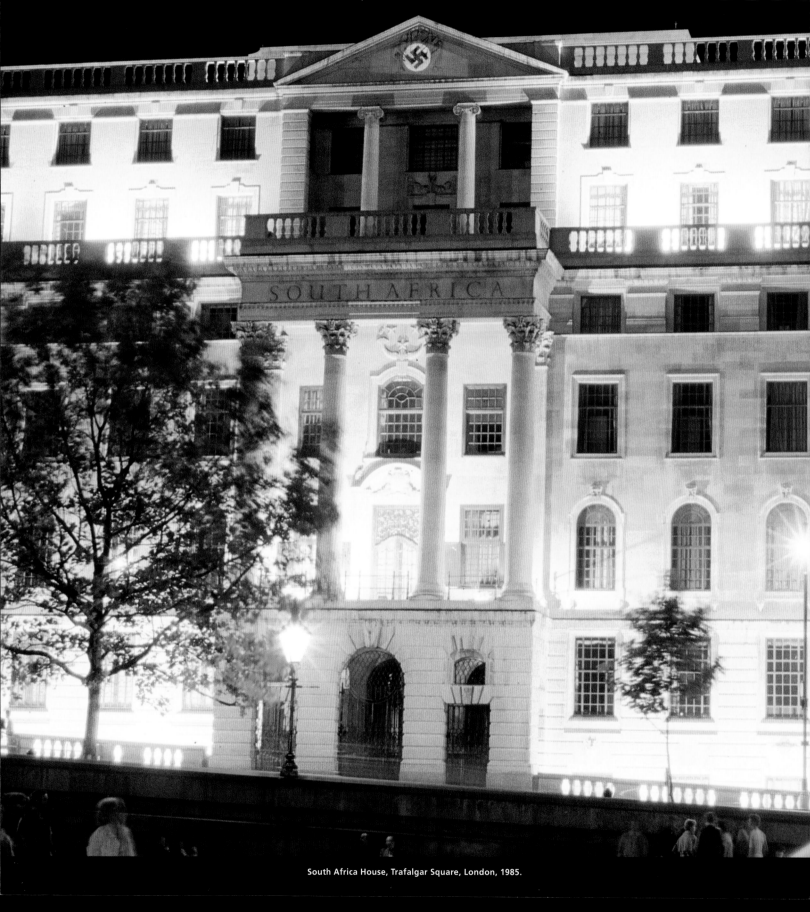

South Africa House, Trafalgar Square, London, 1985.

While he was working on the Nelson's Column projection, Wodiczko improvised this image as a gesture of support for anti-apartheid groups then picketing in front of South Africa House; it was suspended after two hours, decreed a "public nuisance" by the police. South African officials sent a letter of protest to the Canadian embassy, located on the other side of Trafalgar Square, demanding an official explanation. The Canadian government responded by saying that the actions of a Canadian citizen did not necessarily represent the views of the Canadian government. No further legal action was taken.

"Many people would have liked the opportunity to affect this building, for example those who were demonstrating in front of it just at that time.... It's public art, and one must respond to changing circumstances. It was just at this time that a delegation had come from South Africa to ask the British government for more money, which Thatcher actually gave them, a very shameful act.... All I had to do was to use one of the projectors from the Nelson's Column projection and turn its 400mm lens ninety degrees. It was projected over the sign in the pediment, which many people knew. There is a relief of a boat, underneath which it says 'Good Hope.'" (KW [with Douglas Crimp, Rosalyn Deutsche, and Ewa Lajer-Burcharth], "Conversation with Krzysztof Wodiczko," *October* 38, Winter 1986.)

"Postcards and images of this projection were distributed after the event. Many people told me that even though they hadn't seen the actual projection (i.e., they had only seen media images of it), somehow when they look at the pediment the swastika is seen as missing, as a kind of afterimage." (KW in Roger Gilroy, "Projection as Intervention," *New Art Examiner* 16, February 1989.)

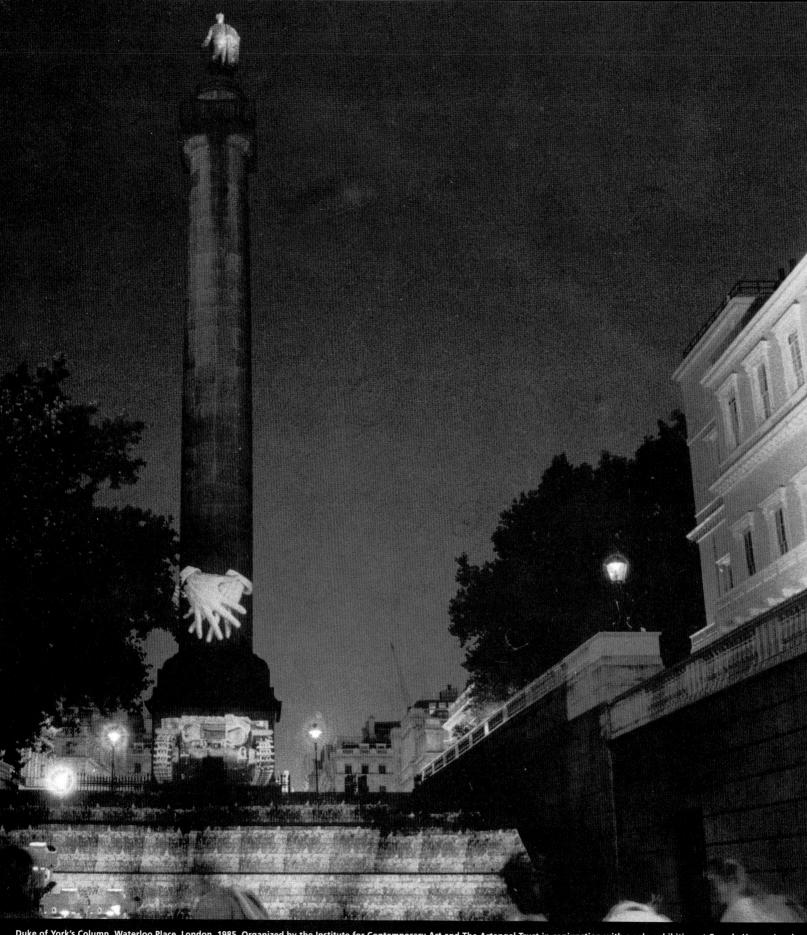

Duke of York's Column, Waterloo Place, London, 1985. Organized by the Institute for Contemporary Art and The Artangel Trust in conjunction with a solo exhibition at Canada House, London.

This projection, presented at the same time as the Nelson's Column projection, occurred after a bitter mineworkers' strike in Wales. The work consisted of three elements: projected on the steps of the monument were images of crowds of British mineworkers; an image of tank treads appeared at the base of the column; and, above the tank, two male hands crossed in a gesture of modesty. The projection was timed to coordinate with an official son-et-lumière spectacle, entitled "The Heart of the Nation," commemorating key moments in British imperial history, which took place simultaneously on Horse Guard's Parade.

"Since the 18th century at least, the city has operated as a grand aesthetic curatorial project, a monstrous public art gallery for massive exhibitions, permanent and temporary, of environmental architectural 'installations'; monumental 'sculpture gardens'; official and unofficial murals and graffiti; gigantic 'media shows'; street, underground and interior 'performances'; spectacular social and political 'happenings'; state and real-estate 'land art projects'; economic events, actions and evictions (the newest form of exhibited art); etc., etc. To attempt to 'enrich' this powerful, dynamic art gallery (the city public domain) with 'artistic art' collections or commissions—all in the name of the public—is to decorate the city with a pseudocreativity irrelevant to urban space and experience alike." (KW, "Strategies of Public Address: Which Media, Which Public?" In Hal Foster, ed., *Dia Art Foundation Discussions in Contemporary Culture*, no. 1, Seattle: Bay Press, 1987.)

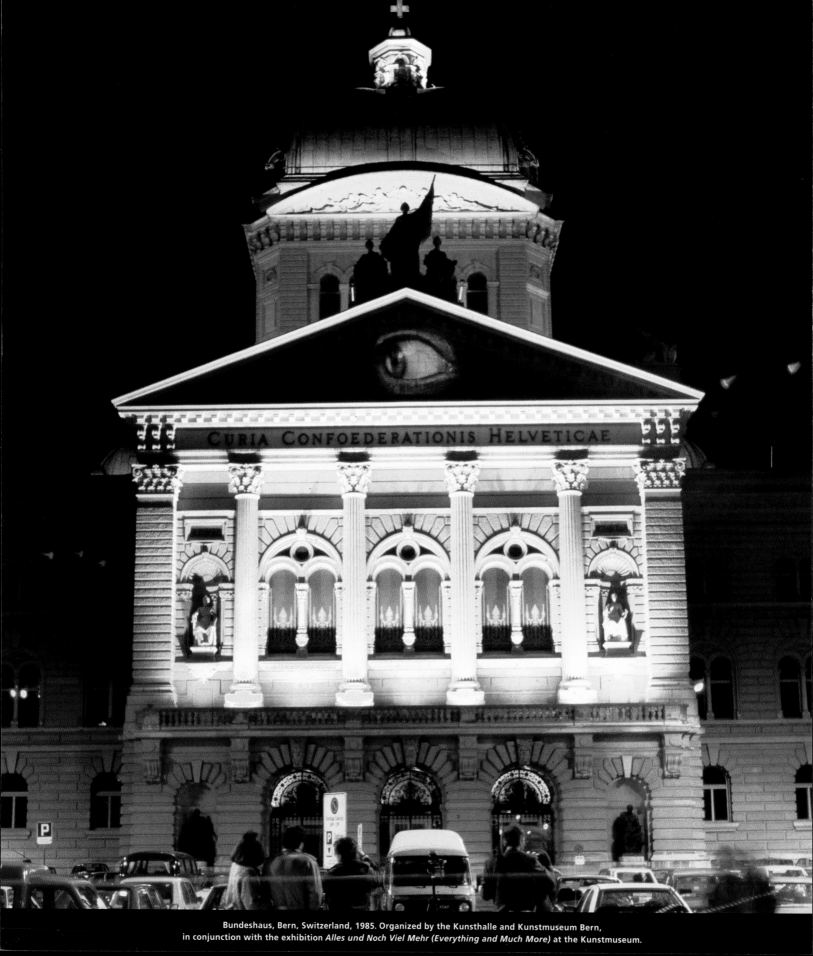

Bundeshaus, Bern, Switzerland, 1985. Organized by the Kunsthalle and Kunstmuseum Bern,
in conjunction with the exhibition *Alles und Noch Viel Mehr (Everything and Much More)* at the Kunstmuseum.

"I knew I wanted to project onto the pediment, since it was the only free surface on the building. It was a question of what would be acceptable, and then, when accepted, what would make a point. I figured no one would object to the image of an eye, and at the same time they wouldn't have to know that the eye would change the direction of its gaze, looking first in the direction of the national bank, and then at the canton bank, then the city bank of Bern, then down to the ground of the Bundesplatz, under which is the national vault containing the Swiss gold, and finally up to the mountains and the sky, the clear, pure Calvinist sky.... I had spent a certain amount of time in bars in Bern and I learned there about the Swiss gold below the parking area in front of the parliament, a fact which most people in Switzerland take for granted. It's not, after all, so bad to be a tourist. Sometimes you learn things that local residents take for granted and are then able to expose the obvious in a critical manner." (KW [with Douglas Crimp, Rosalyn Deutsche, and Ewa Lajer-Burcharth], "Conversation with Krzysztof Wodiczko," *October* 38, Winter 1986.)

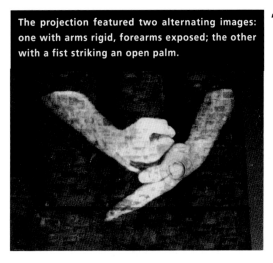

The projection featured two alternating images: one with arms rigid, forearms exposed; the other with a fist striking an open palm.

"This project was on the city hall in Derry, Ireland. The building is located just in front of the city wall, which contains cannons which are pointed at the building. The cannons, gifts from the citizens of London during the eighteenth century, were intended to reinforce the power of the British tradition. The tower was destroyed at one point by the IRA, by a person who was later imprisoned for this act. During his imprisonment, the political situation changed and the Catholics gained power. The Protestants moved across the river to a stronghold in the center of the city, protected by the British Army. The election for the City Council put this guy who was still imprisoned into office. The tower was rebuilt.... It was obvious that my mission was to speak to both Catholics and Protestants for whom there is no shared icon. In a way it was the most difficult projection for me to do. The area was a battle zone.... While I was projecting, there were seven policemen with guns around us. Why I had to be protected, I don't know. It became a military operation, that projection. I was not particularly shocked by this, but it was certainly more tense than I ever remember in Poland, including 1957 or 1968, or during the seventies. It was more frightening to see how people live normally under these circumstances, that they can actually adjust to such conditions. It was so much more frightening in Ireland than in Poland because there the situation has such a long history. People are born who don't remember anything else. To remember something else might be the reason for public art." (KW, "Projections," *Perspecta: The Yale Architecture Journal* 26, 1990.)

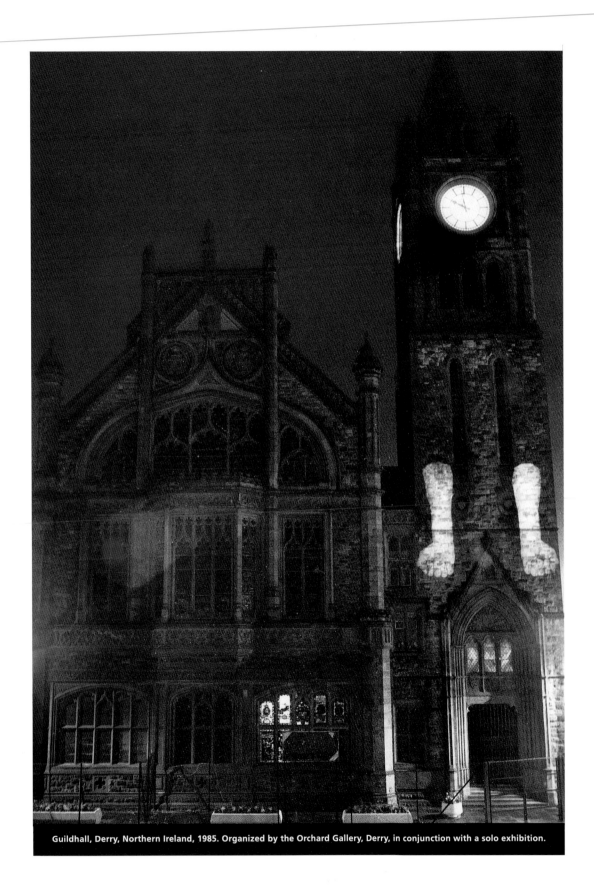

Guildhall, Derry, Northern Ireland, 1985. Organized by the Orchard Gallery, Derry, in conjunction with a solo exhibition.

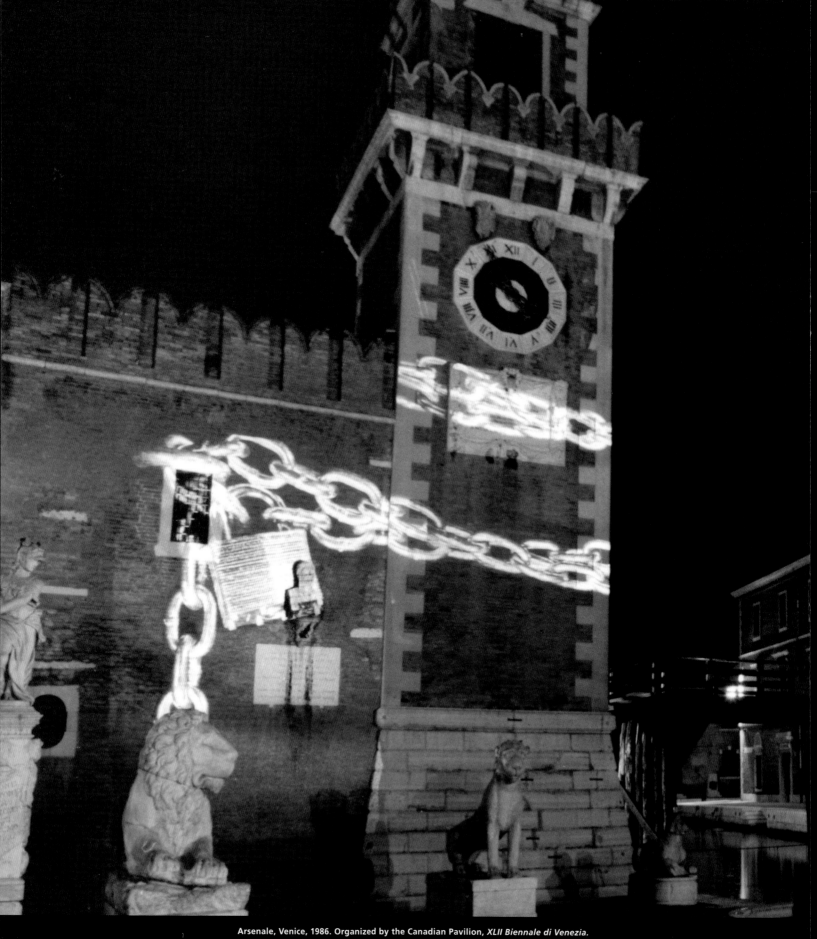

Arsenale, Venice, 1986. Organized by the Canadian Pavilion, *XLII Biennale di Venezia.*

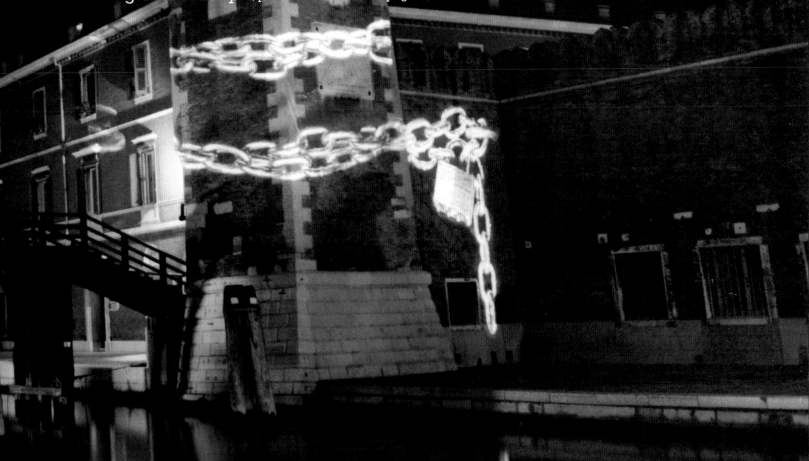

The Arsenale is the old military shipyard of Venice. Every two years it houses the *Aperto* section of the Venice Biennale, a major international art fair.

"The new world empire of tourism (travel, entertainment, art, and leisure) has turned the ruins of the old world financial-military empire of Venice into an art-Disneyland and shopping-for-the-past plaza. In alliance with the international 'Save Venice' movement, this new empire has converted (renovated) the once lavish and decadent capital of capital, that glorious, floating pioneer of the multinational corporate World Trade Center, into a tourist playground and imaginary 'refuge' from the politically and economically troubled world of today. Such a refuge cannot, however, really succeed in Venice. The escape it offers must function as a semiconscious return to the golden roots of today's global reality." (quotation continued on page 127)

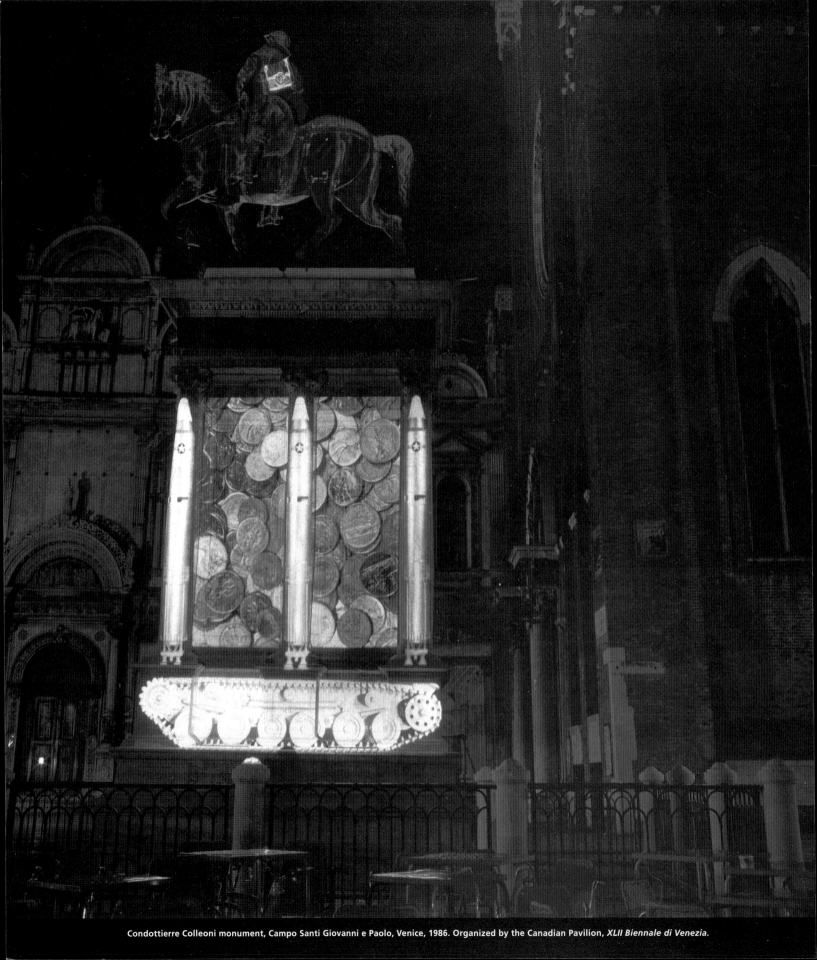

Condottierre Colleoni monument, Campo Santi Giovanni e Paolo, Venice, 1986. Organized by the Canadian Pavilion, *XLII Biennale di Venezia*.

Near the end of the fifteenth century the sculptor Verrocchio was commissioned to create a statue memorializing the mercenary general Bartolommeo Colleoni, who had commanded the Venetian army. The bronze Colleoni monument (1483–1488) became a paradigm for subsequent military equestrian statuary.

"The gilded architecture of Venice, thin as its own image, has been copied, perfected, magnified, and mass-produced throughout the cities, suburbs, and entertainment centers of Europe and North America. Thus the imaginary escapes and semiconscious returns of Venice are easily furnished by the 'gondolas' of the Chicago World's Fair, the 'Piazza San Marco' of Disneyworld in Florida, the 'Grand Canal palaces' of apartment towers, the 'campanili' of city halls, factories, churches, banks, fire and train stations, and by the 'Condottierre Colleoni' of all colonial and post-colonial heroic urban monuments. The tourist, familiar with contemporary commercial, religious, and militaristic slogans, draws upon this 'knowledge' in order to discover Venice. Armed with the popular literature of art history, travel guides, and Italian dictionaries, the tourist begins a consumer love affair with the Venetian past, shopping for its difference, its richness, and its seductive historical atmosphere." (quotation continued on page 129)

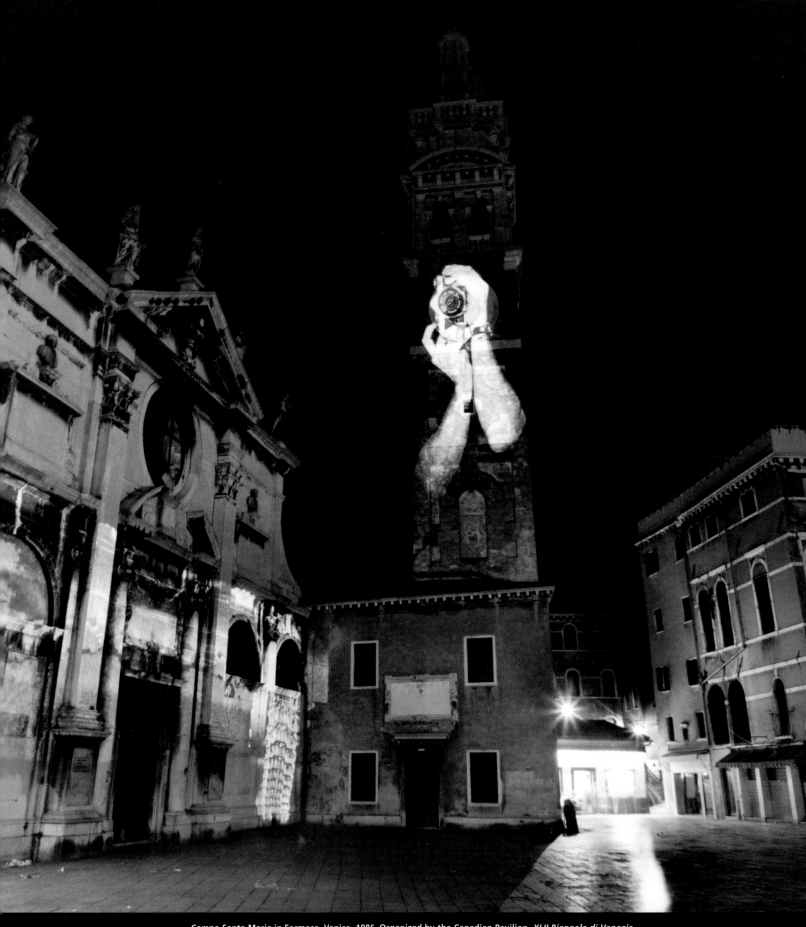

Campo Santa Maria in Formosa, Venice, 1986. Organized by the Canadian Pavilion, *XLII Biennale di Venezia*.

"Always proud to be sought after, Venice this summer finds itself aswarm with poor, untidy suitors and abandoned by its affluent American lovers ... the city government and the local tourist industry are making unaccustomed efforts to woo tourists from the United States —many of whom decided against coming because of a perceived threat of terrorist violence against Americans.... With American tourism down by at least 75 percent this year, the Venetians felt obliged to act." (Roberto Suro, "Venice Yearns for Tourists Who Sleep in Hotels," *New York Times*, August 9, 1986.)

"Today, mercenary pirates of political terrorism are threatening to cut off the commercial routes of tourism's global empire, of which Venice is a strategic center. To secure this empire's operations, in particular its overseas summer crusades, the imperial jumbo-jet fleet demands military protection. Thus the contemporary fear of terrorism joins with the fear of the entire empire of tourism, finding its center today in Venice, whose embattled history and architectural memory are haunted by it already. ▪ To recognize the imaginary Venice as the true Venice of today! As the site of the merciless cultural and economic 'terrorism' of the world empire of tourism, and the site of fear of the merciless 'tourism' of world terrorism, ancient and contemporary! ▪ To infiltrate the Venetian tourist entertainments with counterfeit spectacles aimed at the uncritical consumption of historical Venice and her present-day myth! ▪ To interrupt this Venetian tourist romance, this shopping for the imaginary past and present! ▪ To take Venetian architecture as a historical 'screen' for the critical projections of the present! ▪ To turn the projectors upon Venice as a historical fetish of a contemporary reality! ▪ To project the symbols of the present onto those of the past! ▪ To confront publicly their illusive difference and embarrassing similarity!" (KW, "The Venice Projections," projection leaflet, 1986; reprinted in *October* 38 [Winter 1986].)

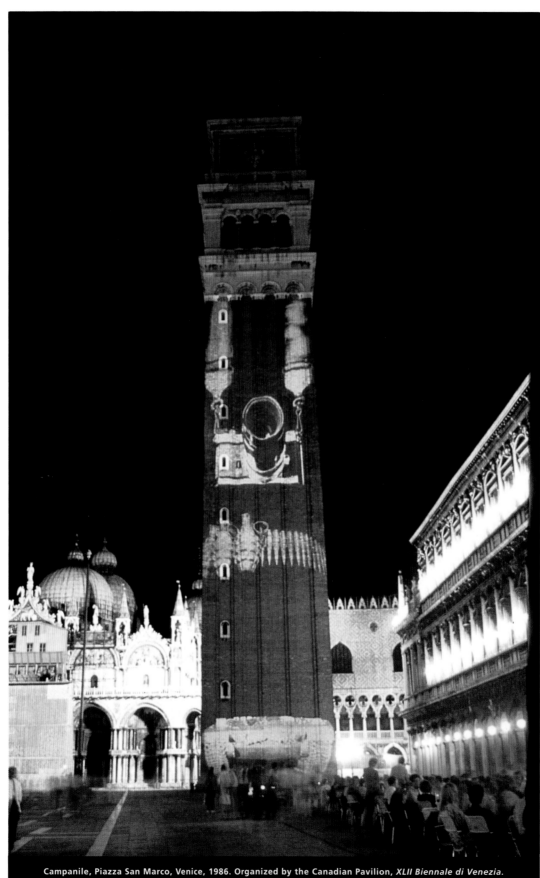

Campanile, Piazza San Marco, Venice, 1986. Organized by the Canadian Pavilion, *XLII Biennale di Venezia*.

Wodiczko created two different versions of this projection, one featuring tank treads at the base, the other, a pair of military boots.

"I have deliberately avoided putting sound into my work, from a mistrust of the rampant mythologizing of the *son-et-lumière* tradition. The meaning of existing sound, however, changes during my projections. In Venice, for example, the Piazza San Marco is animated til midnight by the sound of two competing orchestras simultaneously playing standard versions of European/American restaurant/operetta repertory. This piazza is the only truly ideological space, designed from the beginning as public, state architecture in Venice. It was conceived for official parades, galas, processions, executions, welcoming the troops home or seeing them off, accepting (or rejecting) public announcements, even capitulating to foreign powers. The campanile was always the most important element because the bells were used to call those meetings. Now that space has been turned into Disneyland, the muzak camouflaging the fear of terrorism while creating a surrealistic, ironic commentary on the invasion of tourism and the city's glorious, imperial past. At midnight, at the end of the projection, the bells began to ring, but because of the projection they became different bells. They were somewhere in the head, in the memory of that tower. Though they were funny initially on top of that muzak, one soon realized that there was some serious warning in relation to the distraction of meaning taking place down on the piazza." (KW in *Counter-Monuments: Krzysztof Wodiczko's Public Projections,"* exhibition catalogue, Hayden Gallery, List Visual Arts Center, Massachusetts Institute of Technology, Cambridge, 1987.)

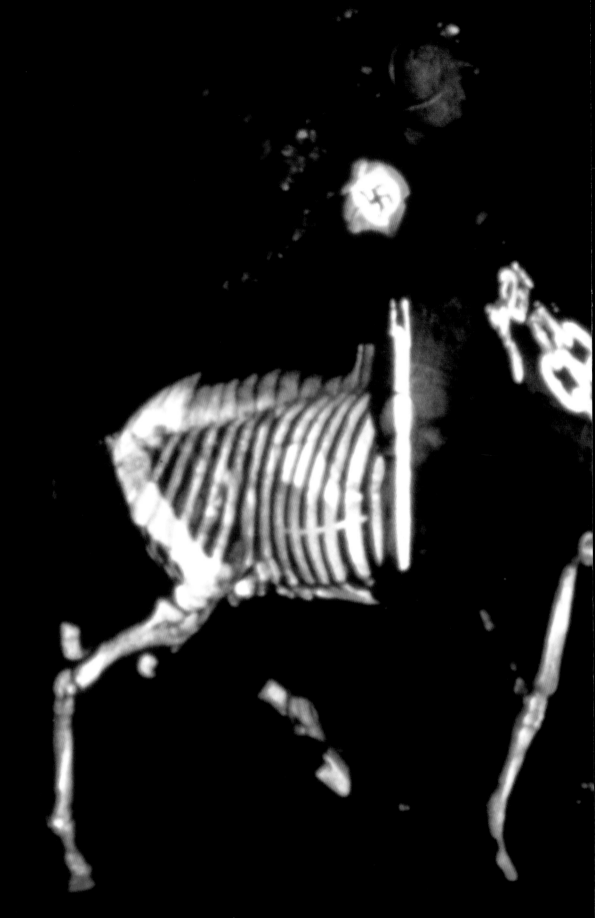

Replica of the Condottierre Colleoni monument, Academy of Fine Arts, Warsaw, 1986. Organized by Galeria Foksal, Warsaw, in conjunction with a solo exhibition.

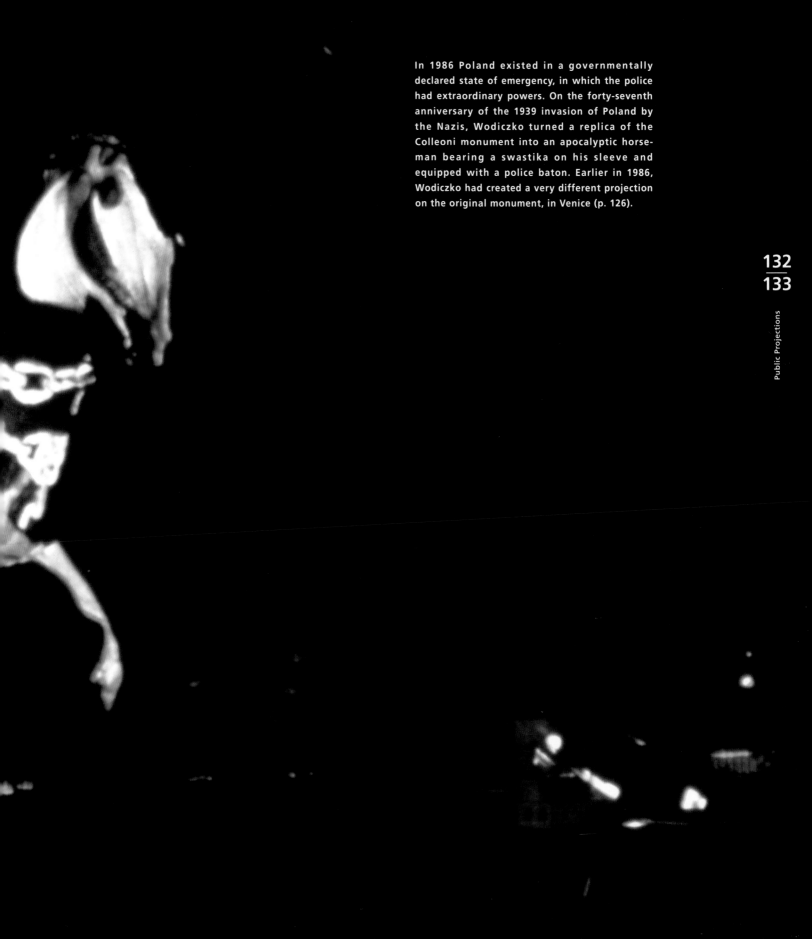

In 1986 Poland existed in a governmentally declared state of emergency, in which the police had extraordinary powers. On the forty-seventh anniversary of the 1939 invasion of Poland by the Nazis, Wodiczko turned a replica of the Colleoni monument into an apocalyptic horseman bearing a swastika on his sleeve and equipped with a police baton. Earlier in 1986, Wodiczko had created a very different projection on the original monument, in Venice (p. 126).

Allegheny County Memorial Hall, Pittsburgh, 1986. Organized by the Mattress Factory, Pittsburgh.

In addition to housing military memorabilia, the Allegheny County Memorial Hall serves as a concert hall. Wodiczko's conjunction of death and music revives the imagery of the Dance of Death, a popular theme in European art of the Middle Ages.

"All War Memorials in the United States operate as culture sites, performing social functions for the community of the city. In order to see music, lectures, opera, sporting events, in order, in other words, to have access to culture, one must go through the showers. One passes through displays, environmental arrangements of images, memorabilia, and mythical objects, like the bullet which grazed the leg of some general on some date, or a crutch, skull or uniform associated with some battle.... On one hand there is this sweet sound, on the other, cannons." (KW in *Counter-Monuments: Krzysztof Wodiczko's Public Projections*, exhibition catalogue, Hayden Gallery, List Visual Arts Center, Massachusetts Institute of Technology, Cambridge, 1987.)

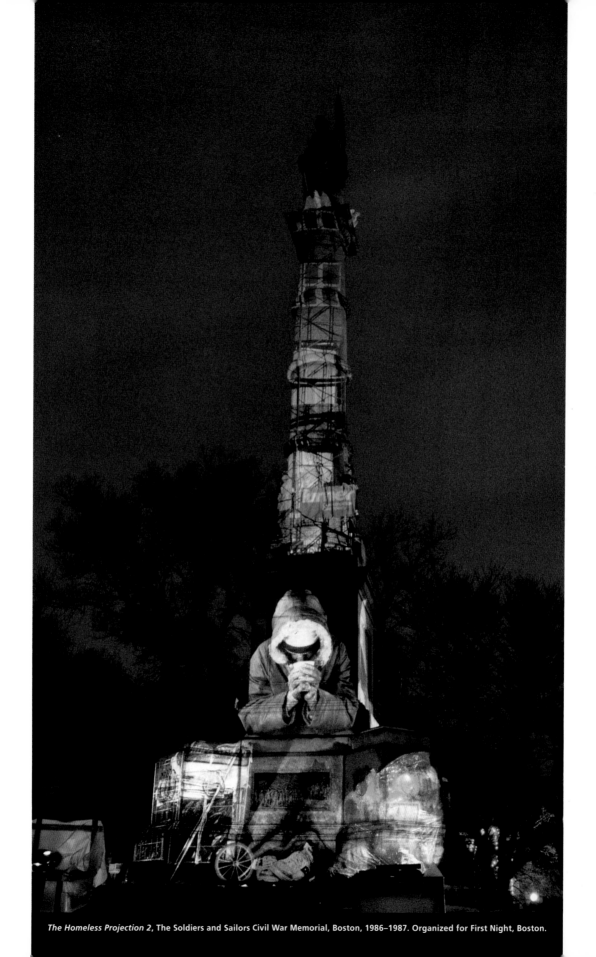

The Homeless Projection 2, The Soldiers and Sailors Civil War Memorial, Boston, 1986–1987. Organized for First Night, Boston.

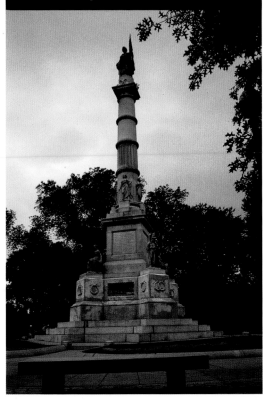

Part of Boston's New Year's Eve festival First Night, this projection was seen by more than 200,000 people. Images of homeless people and their habitats were projected onto all four sides of the base of the memorial. Wodiczko beamed onto the column the image of a Boston condominium building then under construction.

"State architecture appears solid, symbolically full, rooted in sacred historic ground, while real-estate architecture develops freely, appropriating, destroying, redeveloping, etc. A monstrous evicting agency, this architecture imposes the bodies of the homeless onto the 'bodies'—the structures and sculptures—of state architecture, especially in those ideological graveyards of heroic 'history' usually located in downtown areas." (KW, "Strategies of Public Address: Which Media, Which Public?" In Hal Foster, ed., *Dia Art Foundation Discussions in Contemporary Culture*, no. 1, Seattle: Bay Press, 1987.)

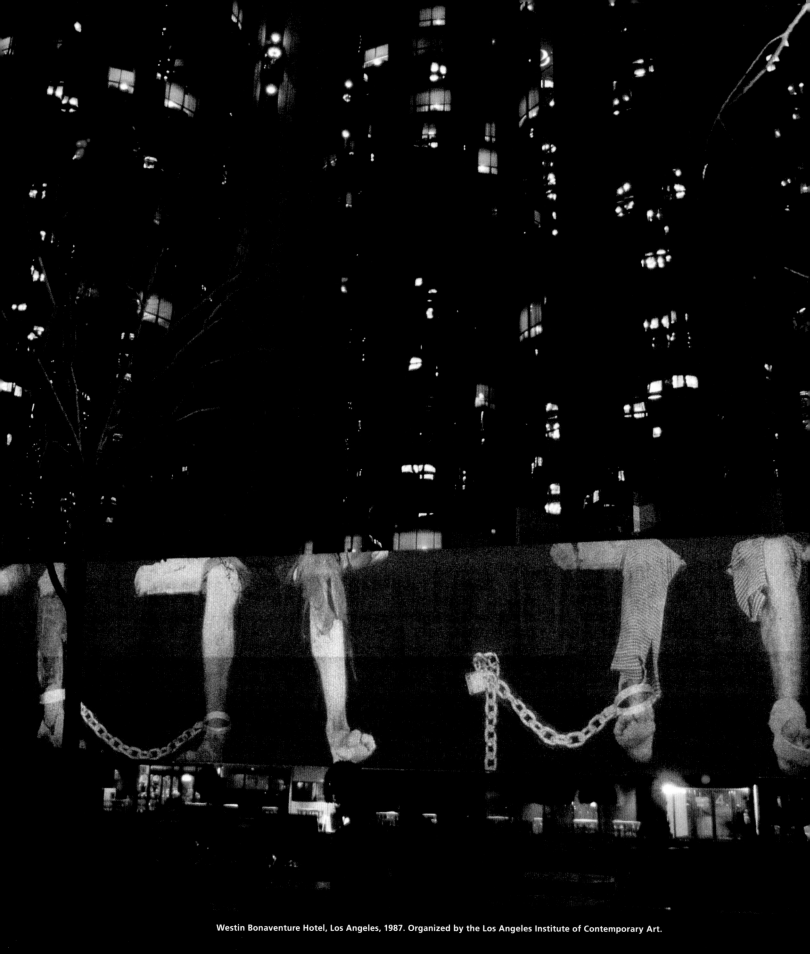

Westin Bonaventure Hotel, Los Angeles, 1987. Organized by the Los Angeles Institute of Contemporary Art.

Opened in 1976, the five-towered, steel-and-glass Westin Bonaventure Hotel is part of an ultra-modern commercial complex located in the heart of downtown Los Angeles. One of its main attractions is a high-security atrium court featuring flowering vines, fountains, and reflecting pools. On the podium base of the hotel Wodiczko projected images of poverty and incarceration evocative of the seamiest aspects of the city's center.

"Dominant culture in all its forms and aesthetic practices, in what it says and does not say, remains in gross contradiction to the lived experience, communicative needs and rights of most of society, whose labour is its sole base. Transmitted not only by the media but also by the Built Environment, and controlled by its commercial and political sponsorship, it creates miscommunication, alienation, misrepresentation and life-in-fantasy while holding a monopoly over public life, education, and the development of a communicative experience as well as over the representation of all the vital public issues, of individual life in society and of its history." (KW, *Matrix 103*, exhibition brochure, Hartford: Wadsworth Atheneum, 1989.)

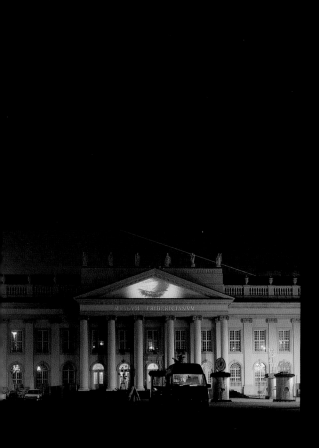

Museum Fridericianum, Kassel, West Germany, 1987.
Organized for *documenta 8*, Kassel.

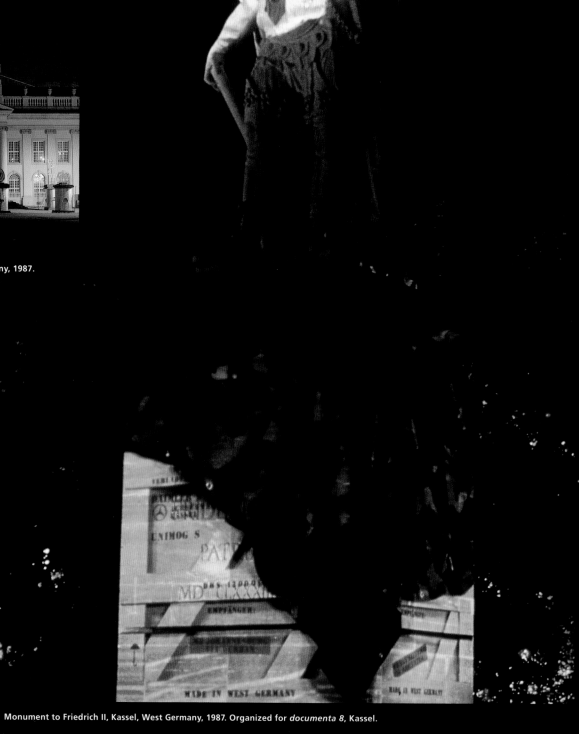

Monument to Friedrich II, Kassel, West Germany, 1987. Organized for *documenta 8*, Kassel.

Friedrich II, Count of Hesse-Kassel, was a renowned supporter of science and the arts. He founded the Fridericianum, one of the first public museums in Europe (and the institution that hosts the *documenta* exhibition, mounted every five years), with funds raised through the *Soldatenhandel*, the sale of Hessian peasants to the British army. Wodiczko considers the sale of human beings to pay for culture analogous to the funding mechanisms of the *documenta* itself, whose organizers that year accepted funds from companies that had interests in South Africa.

"On the monument to Count Friedrich II, I confront his glorious but also egomaniacal heroic acts—the spreading of ideas of the Enlightenment and the popularizing of aristocratic culture, the promotion of art and science —with his dubious economic and political acts, which served as the monetary source for all of his cultural and artistic projects. His politics, incidentally, were a source of criticism even in his lifetime. Gazing proudly at one of these projects, the Museum Fridericianum, his obscene white body too bloated from gluttony to fit its heroic Roman armor, the Count cannot conceal his ravenous hunger for conquest, his imperial appetite for plundering foreign territories (look at Austria). He is interested in political and cultural power over the world. (One thinks about the Polish crown.) He also knows that the trade in soldiers in the 18th century (12,000 farmers were sold to Great Britain for 21,276,778 Talers in order to support that country's war against American independence) is hardly different from Daimler Benz's use of slave labor today by exploiting "guest workers" to make military equipment such as Unimogs [four-wheel-drive utility trucks, parts of which are produced in Kassel] and deliver it to South Africa, where it is used to subjugate blacks; and knowing of Mercedes' and the Deutsche Bank's South African dealings, yet accepting donations from them in order to organize *documenta 8* in the Fridericianum and the Orangerie Gardens— places Friedrich II built with money from the trade in soldiers."

(KW in *documenta 8* exhibition catalogue, 1987.)

The tower of the Martin Luther Kirche is one of several landmark structures that survived the World War II bombings of Kassel. Six months before the *documenta 8* projection took place, the city had experienced an "evacuation alert" for the first time since the war — this time due to the threat of polluted air from the factories of Leipzig and Frankfurt.

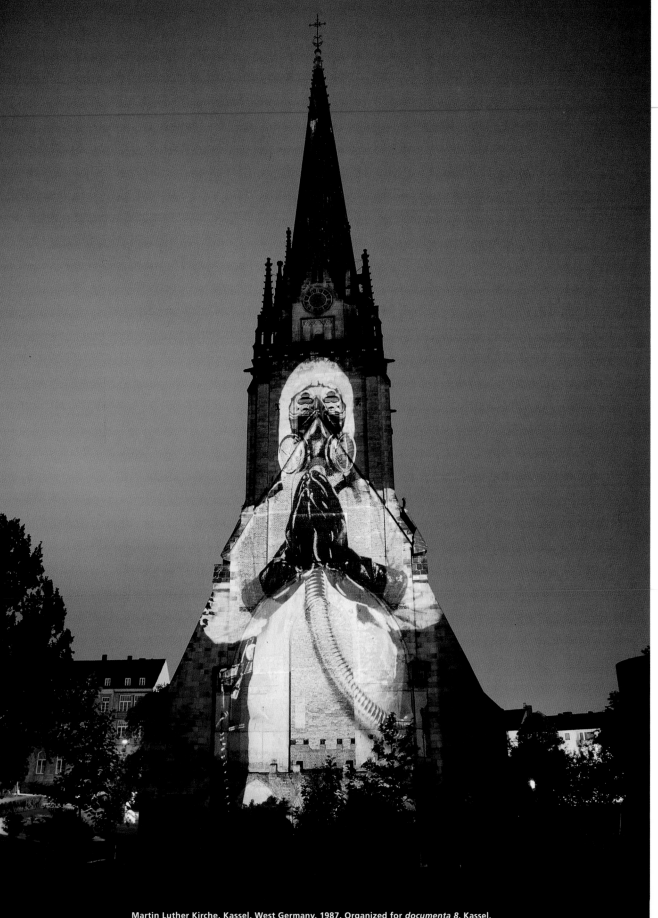

Martin Luther Kirche, Kassel, West Germany, 1987. Organized for *documenta 8*, Kassel.

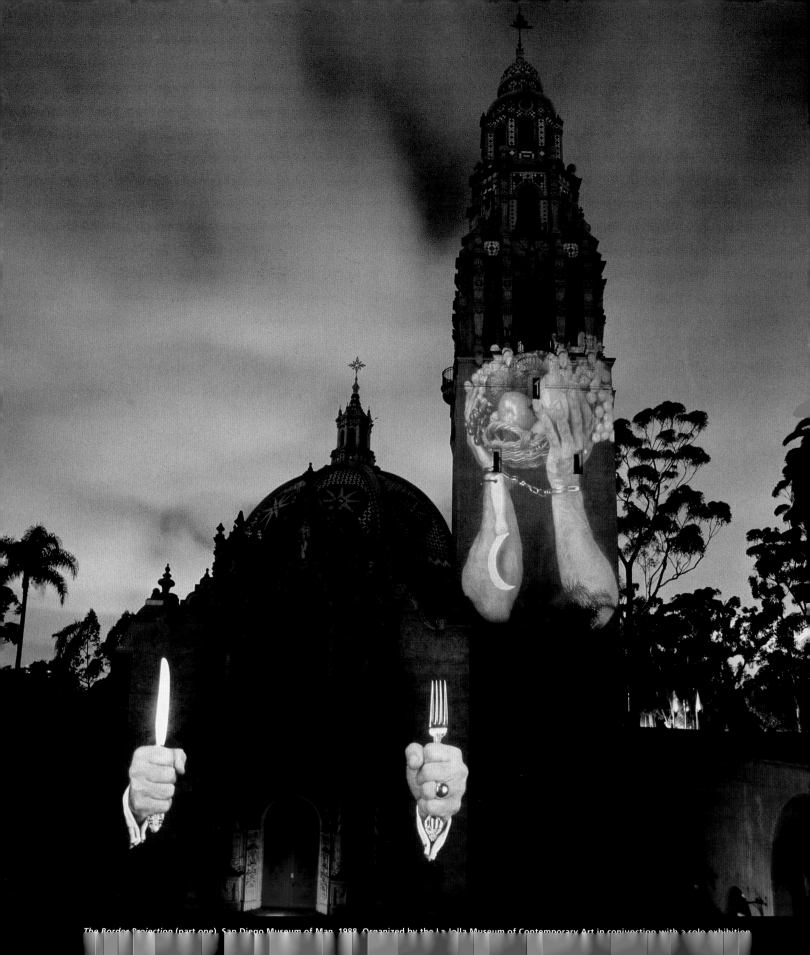

The Border Projection (part one), San Diego Museum of Man, 1988. Organized by the La Jolla Museum of Contemporary Art in conjunction with a solo exhibition.

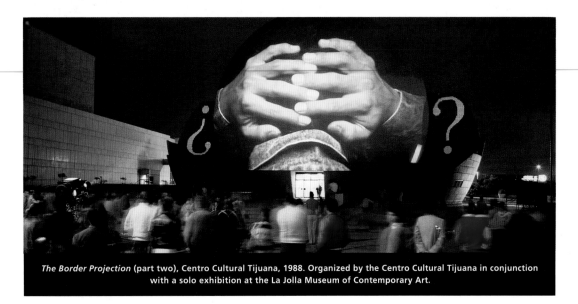

The Border Projection (part two), Centro Cultural Tijuana, 1988. Organized by the Centro Cultural Tijuana in conjunction with a solo exhibition at the La Jolla Museum of Contemporary Art.

These two projections occurred on consecutive nights in San Diego and Tijuana. The United States-Mexico border between the two cities is the busiest crossing point for Mexican illegal aliens. The towering Museum of Man building, erected as the centerpiece of the Panama-California Exposition of 1915–1916 celebrating the opening of the Panama Canal, reflects Spanish Colonial style. Onto its facade, which "vaunts figural sculptures of kings, conquerors, pioneers, and martyrs pivotal to San Diego's colonial history ... Wodiczko projects the repressed inheritance of the city's Spanish past. He makes explicit the implicit ambitions toward property, ownership, and slavery endemic to colonialism by transforming the facade into a heroically proportioned consumer. The museum's entrance is his gaping mouth, while his cuffed and bejeweled hands are armed, not with a cross or a sword, but with an ornate knife and fork of ominous scale. The consumer defiantly demands and defends his right to consume without regard for the producer, whose handcuffed arms, projected on the tower, offer the fruits of his labor." (Madeleine Grynsztejn, *San Diego Museum of Contemporary Art: Selections from the Permanent Collection*, San Diego Museum of Contemporary Art, La Jolla, 1990.)

Located seventeen miles south of San Diego, Tijuana is among the busiest of international-border towns; some thirty-eight million people cross the United States-Mexico border there annually. The Centro Cultural, designed by Manuel Rosen, was built in 1982 for the display and celebration of Mexican heritage. To point up the plight of the illegal alien, Wodiczko projected an image of a man with his hands clasped behind his head—the position taken when one is arrested and searched—onto the structure's domed Space Theater, where the film *The People of the Sun*, tracing the history of Mexican civilization, is screened daily.

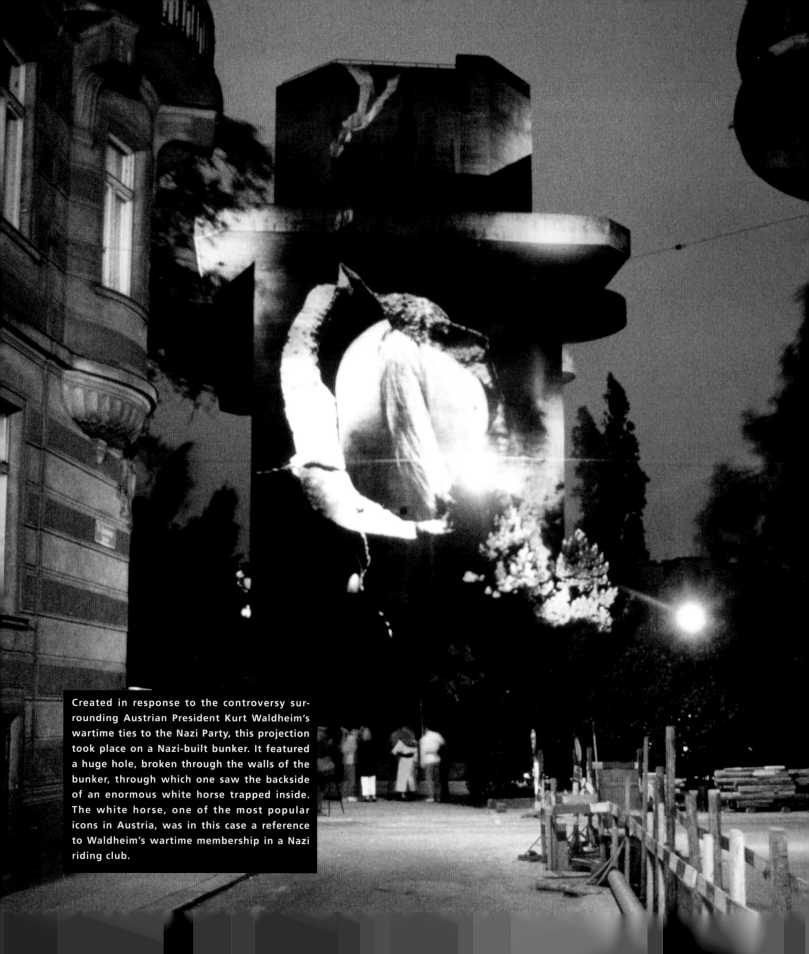

Created in response to the controversy surrounding Austrian President Kurt Waldheim's wartime ties to the Nazi Party, this projection took place on a Nazi-built bunker. It featured a huge hole, broken through the walls of the bunker, through which one saw the backside of an enormous white horse trapped inside. The white horse, one of the most popular icons in Austria, was in this case a reference to Waldheim's wartime membership in a Nazi riding club.

In conjunction with the Flakturm projection Wodiczko displayed another image on the Neue Hofburg, the building from which Hitler made his infamous Anschluss speech in 1938 rationalizing Germany's annexation of Austria. The projection combines the wings of an eagle, symbol of Germany, with the logo of the Noricum corporation, the Austrian arms manufacturer that in 1988 was tried for simultaneously selling weapons to Iran and Iraq, in violation of Austria's official neutrality in the long war between those countries.

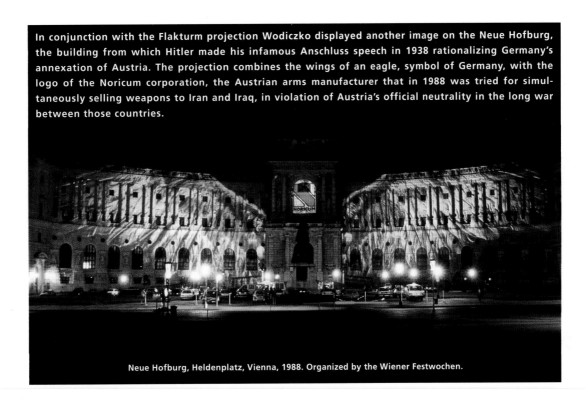

Neue Hofburg, Heldenplatz, Vienna, 1988. Organized by the Wiener Festwochen.

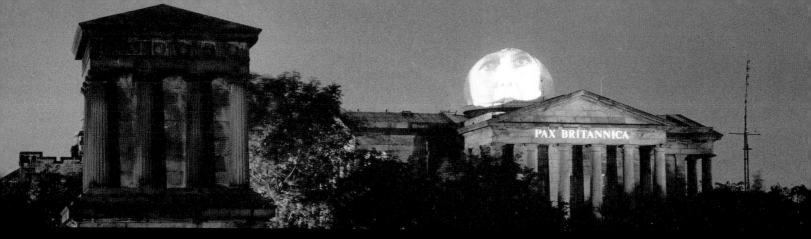

New Observatory, Calton Hill, Edinburgh, 1988.

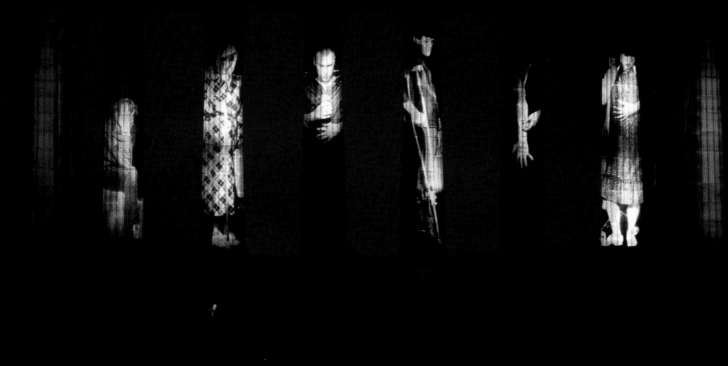

MORITURI TE SALUTANT

National Monument, Calton Hill, Edinburgh, 1988. Organized by The Artangel Trust, London, and the Fruitmarket Gallery, Edinburgh, for the Edinburgh Festival.

The projection was presented for ten nights during the Edinburgh Festival. The Parthenon-like National Monument, which due to lack of funds was never finished, was built to commemorate those who fell in the Napoleonic wars. Wodiczko projected images of the homeless, the "new city monuments," onto six of the monument's Doric columns. Above, running along the entablature, appeared the Latin inscription *Morituri te salutant*. (Those who are about to die salute you.) Opposite the National Monument, on the cupola of the nearby New Observatory, the face of British Prime Minister Margaret Thatcher was projected, accompanied by the words *Pax Britannica*.

"The forms and structures of architecture are permanent, but the circumstances change, and the changing circumstances confer new meaning on those forms." (KW in Steve Rogers, "Territories 2: Superimposing the City," *Performance Magazine*, August 9, 1985.)

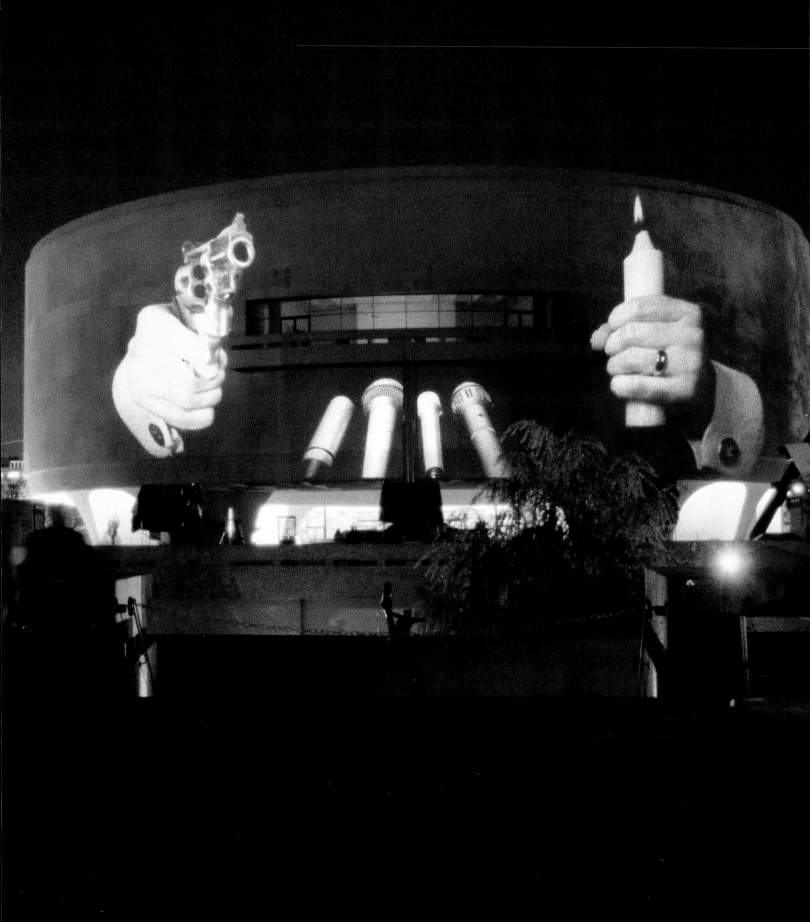

Hirshhorn Museum, Washington, D.C., 1988. Organized by the Hirshhorn Museum and Sculpture Garden as part of the exhibition series WORKS.

This projection on the facade of the Hirshhorn Museum building overlooking the Mall took place over three consecutive nights during the week preceding the 1988 United States presidential election.

"Everyone takes away his own meaning.... For me, it is what I think of politics in this election, resembling more and more a crime story. For example, [Republican presidential candidate] George Bush on one hand is for the death penalty and on another is anti-abortion, on one hand he goes on about 'a thousand points of light' and on another defends guns and a strong militaristic policy. Media and microphones are also used as weapons." (KW in Kara Swisher, "Art off the Wall," *Washington Post*, October 26, 1988.)

R. C. Harris Water Filtration Plant, Toronto, 1988. Organized by Visual Arts Ontario in conjunction with the exhibition *WaterWorks*.

The projection, of a crying bureaucrat signing a document over a glass of water and a dead fish, addresses a political and environmental issue of the time that had to do with water consumption. Concurrent with drought conditions in the agricultural regions of the western provinces and Ontario, Canada's House of Commons was nearing final passage of Free Trade legislation with the United States. Related to these talks was the request by certain United States state governments for the diversion of water from the Great Lakes for use by these states, a process that would lower water levels to a critical point.

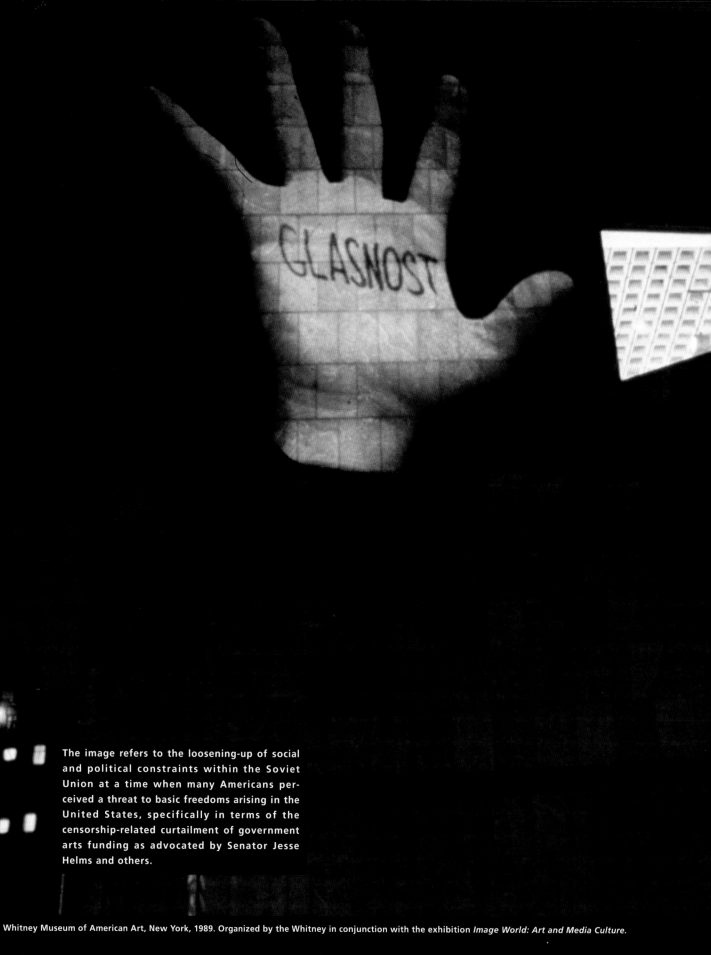

The image refers to the loosening-up of social
and political constraints within the Soviet
Union at a time when many Americans per-
ceived a threat to basic freedoms arising in the
United States, specifically in terms of the
censorship-related curtailment of government
arts funding as advocated by Senator Jesse
Helms and others.

Whitney Museum of American Art, New York, 1989. Organized by the Whitney in conjunction with the exhibition *Image World: Art and Media Culture.*

The *Tuxedo Royale* serves as a floating casino
in Newcastle harbor.

DON'T WALK, BOOGIE.

Tuxedo Royale, Tyne River, Newcastle upon Tyne, England, 1990. Organized by First Tyne International, Newcastle upon Tyne, in conjunction with the exhibition *A New Necessity*.

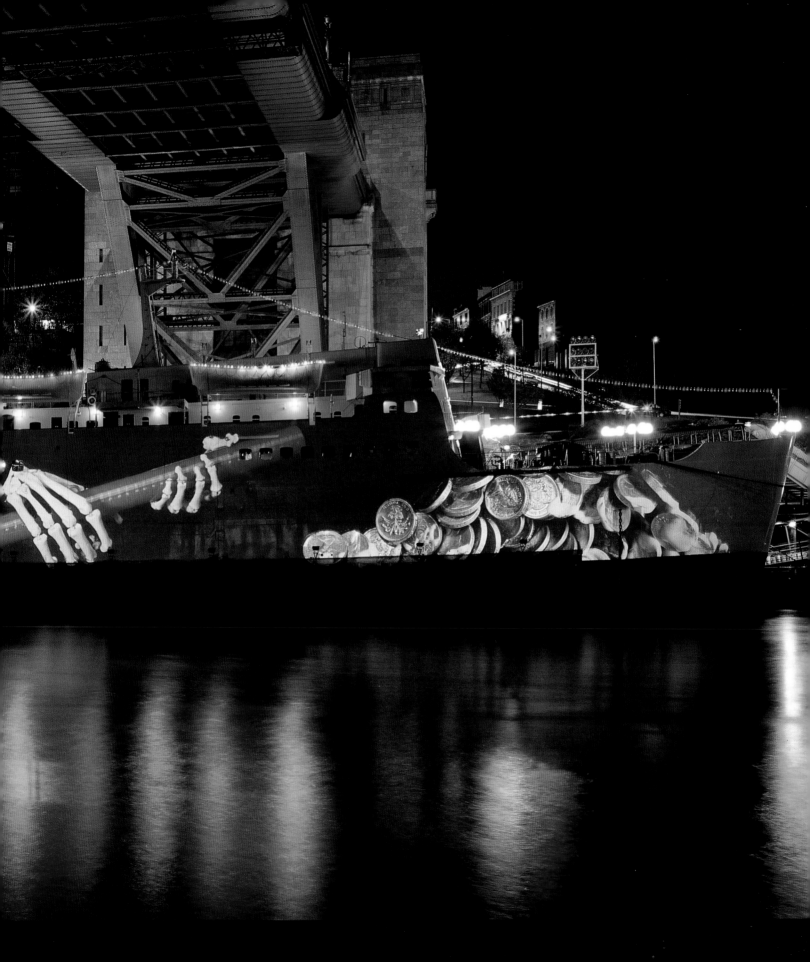

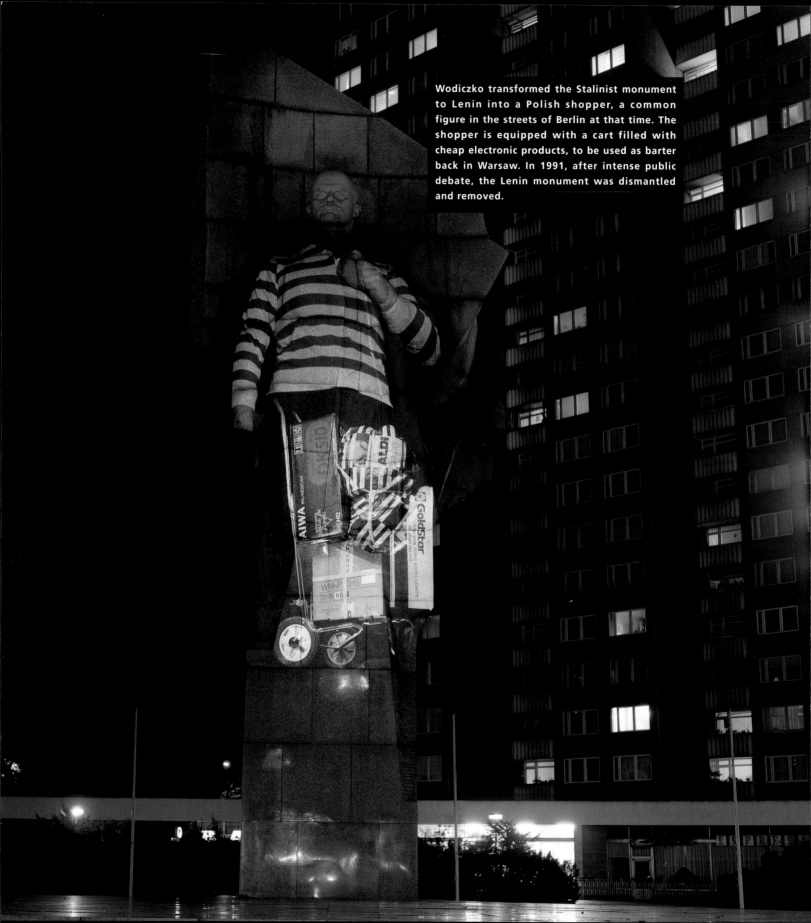

Wodiczko transformed the Stalinist monument to Lenin into a Polish shopper, a common figure in the streets of Berlin at that time. The shopper is equipped with a cart filled with cheap electronic products, to be used as barter back in Warsaw. In 1991, after intense public debate, the Lenin monument was dismantled and removed.

"The projections are a confrontation between what these structures are supposed to say and what they really mean—their bodies and gestures and the bodies and gestures of the people who are forced to live in their cities, i.e., real lives versus the idealism of the monument ... the conditions of life under which the monument has to lie, embarrassed, but ready to be used as a sentimental slogan. What to do with these monuments, then, if they are suffering in relation to reality, if they are useless, irrelevant, abandoned? I think they should be protected from destruction and engaged because they are not just things of the past. They are very often historical witnesses. They become evidence of mistakes of history, or the shame of contemporary time, or maybe both at the same time." (KW in Ned Rifkin and Phyllis Rosensweig, *WORKS 88*, exhibition catalogue, Washington, D.C.: Hirshhorn Museum and Sculpture Garden, 1988.)

The Huth-Haus projection was paired with the one beamed on the Lenin monument in East Berlin. Potsdammer Platz is the planned site of the future headquarters of several major German corporations that stand to benefit from the reunification of Germany.

Huth-Haus, Potsdammer Platz, West Berlin, 1990. Organized by the Deutscher akademischer Auschtauschdienst in conjunction with the exhibition *Die Endlichkeit der Freiheit*.

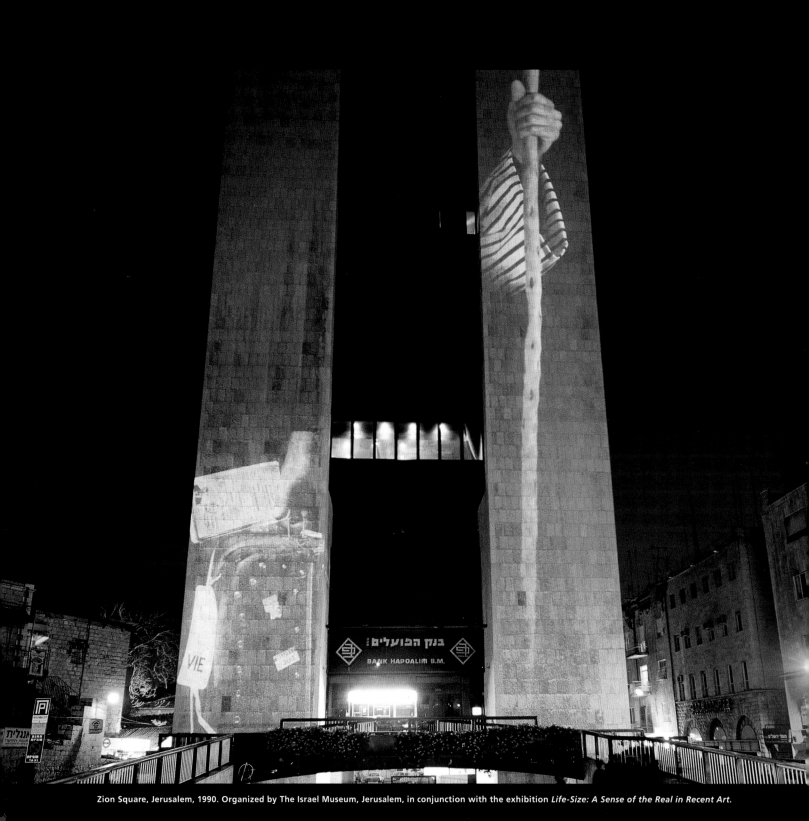

Zion Square, Jerusalem, 1990. Organized by The Israel Museum, Jerusalem, in conjunction with the exhibition *Life-Size: A Sense of the Real in Recent Art.*

For the Israel Museum Wodiczko chose to do a projection on the theme of the emigration of Soviet Jews to Israel, commonly referred to as "Exodus '90." Wodiczko chose as his site a faceless modern bank building in busy Zion Square, an edifice he described as resembling "someone who arrived [and] turned himself or herself into a work of stone." He wanted to transform the building into a "monument to this nomad who became a state, real estate, something immobile." The projection exploits the building's bifurcated structure: one side depicts an arm holding a staff, recalling the Exodus from Egypt; the other shows a hand holding a suitcase and a visa, representing the exile of Jews from the Soviet Union.

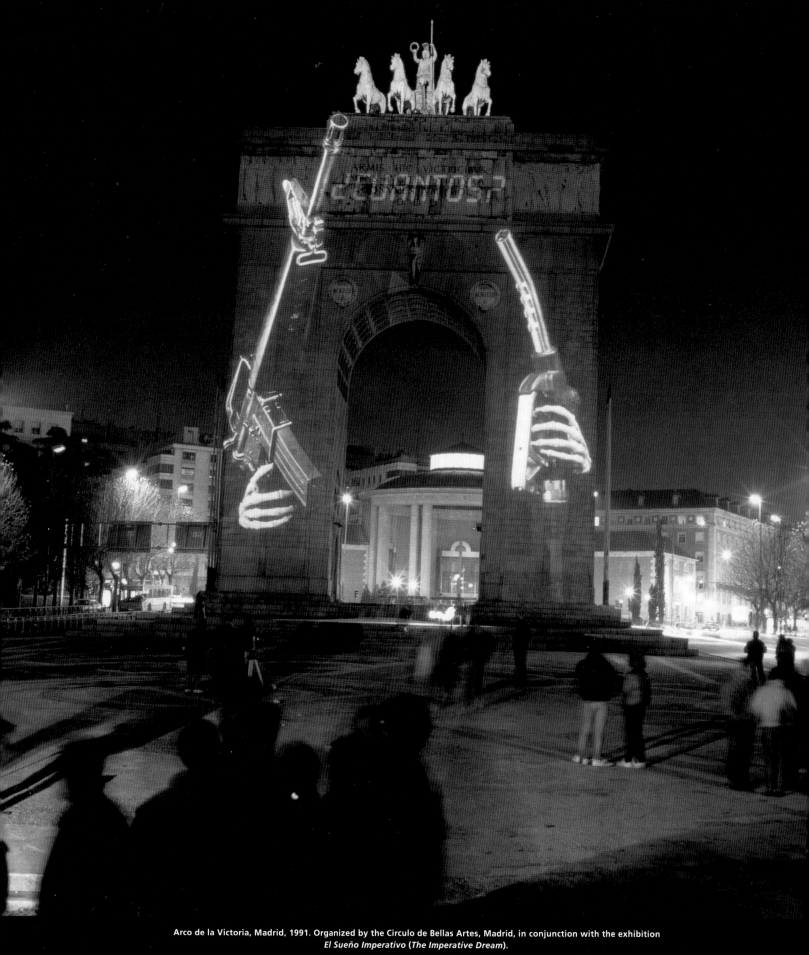

Arco de la Victoria, Madrid, 1991. Organized by the Circulo de Bellas Artes, Madrid, in conjunction with the exhibition *El Sueño Imperativo* (*The Imperative Dream*).

This projection appeared three days after the outbreak of the Gulf War, in January 1991. Onto the triumphal arch, commemorating the ultimate victory of Generalissimo Francisco Franco in the Spanish Civil War, Wodiczko beamed the image of a pair of skeletal hands, one holding an assault rifle and the other clasping the nozzle of a gas pump. Above these images was projected the question, *¿Cuantos?* (meaning both How much? and How many?)

"My work doesn't necessarily have a specific political message. It reveals the contradiction of the environment and the events actually taking place there. It is to do with the politics of space and the ideology of architecture. City centers are political art galleries." (KW in Louisa Buck, "Projections: Bright Lights, Big City: The Work of Krzysztof Wodiczko," *The Face* 98, June 1988.)

BIOGRAPHY

Krzysztof Wodiczko
Born Warsaw, Poland, 1943
Lives in New York City

1965

Group exhibition:
13 Bienal Internacional de São Paulo, São Paulo
(group architectural project)

1967

First trip to Paris

First contact with critics Wieslaw Borowski and Andrzej
Turowski and artists Zbigniew Gostomski and Henryk
Stazewski, founders of Warsaw's Galeria Foksal

Begins collaboration with director Jozef Patkowski
and Experimental Studio (Studio Experymentalne),
Warsaw, which lasts until 1976

1968

Graduates with M.F.A. in industrial design from
Academy of Fine Arts (Akademia Sztuk Pieknych),
Warsaw

Works as industrial designer at UNITRA, Warsaw,
designing popular electronic products (1968–1970)

1969

Collaborates with Andrzej Dluzniewski and Wojciech
Wybieralski on design proposal for memorial to
victims of Majdanek concentration camp, Poland

Performs with *Personal Instrument* in streets of Warsaw

Participates in *Biennale de Paris*, Paris, as a leader of
a group architectural project

Teaching assistant:
Basic Design Program, Department of Architecture of
Interiors, Academy of Fine Arts, Warsaw (1969–1970)

1970

Works as industrial designer at Polish Optical Works
(Polskie Zaklady Optyczne), Warsaw, designing
professional optical, mechanical, and electronic
instruments (1970–1977)

Instructor:
Engineering and Aesthetics, Warsaw Polytechnic
Institute (Politechnika Warszawska) (1970–1975)

Collaborates with Szabolc Esztenyi on sound perfor-
mances with radios and other popular products,
Galeria 10 and Academy of Fine Arts, both in Warsaw

Collaborates with students from Academy of Fine Arts
on musical performance in the modeling workshop of the
academy's industrial design program, using industrial
machines and materials

Group exhibition:
*Information-Imagination-Activity (Informacja-
wyobraznia-dzialanie)*, Galeria Wspolczesna, Warsaw

1971

Begins work on *Vehicle*

Performs with *Personal Instrument*, Galeria
Wspolczesna, Warsaw

Group exhibitions:
Galeria Wspolczesna, Warsaw
*New Phenomena in Polish Art, 1960–1970 (Nowe zjawiska
w sztuce polskiej, 1960–1970)*, Zielona Gora, Poland
Galeria Akumulatory 2, Poznan

1972

Tests *Vehicle* in streets of Warsaw

Collaborates with Wlodzimierez Borowski and Jan
Swidzinski on the performance *Action in Space (Akcja
w przestrzeni)*, shown later at Galeria Adres, Lodz

Solo installation:
Przejscie (Corridor), Galeria Wspolczesna, Warsaw

1973

Solo exhibitions:
Vehicle (Pojazd), Galeria Foksal, Warsaw (catalogue)
Self-Portrait (Autoportret), Galeria Foksal, Warsaw
(catalogue)

1974

Solo exhibitions:
Drawing of a Stool (Rysunek taboretu), Galeria Foksal,
Warsaw (catalogue)
Corner (Naroznik), Galeria Akumulatory 2, Poznan

1975

First trip to United States

Artist-in-residence:
University of Illinois, Urbana

Solo exhibitions:
Krannert Center for the Performing Arts, University of
 Illinois, Urbana (catalogue)
Ladder (Drabina), Galeria Akumulatory 2, Poznan
Drawings of Lines (Rysunki linii), Galeria Foksal,
 Warsaw (catalogue)
N.A.M.E. Gallery, Chicago

Group exhibition:
Biennale de Paris, Paris

1976

First trip to Canada

Artist-in-residence:
Nova Scotia College of Art and Design, Halifax (also 1977)
York University, North York, Ontario
A Space, Toronto (also 1977)

Solo exhibitions:
Line (Linia), Galeria Foksal, Warsaw (catalogue)
*Show and Conversation about Line (Pokaz i rozmowa o
 linii)*, Galeria Akumulatory 2, Poznan
Drawings of Lines, Gallery St. Petri, Lund, Sweden
Drawings of Lines, A Space, Toronto
Drawings, Illusions, Lines, 1974–1976, Nova Scotia
 College of Art and Design, Halifax
Drawings of Lines, Véhicule, Montreal

1977

Moves to Canada, establishing residence in Toronto.

Begins work with New York art dealer Hal Bromm on
exhibitions and projection projects

Visiting professor:
Design and Studio Division, Nova Scotia College of Art
and Design, Halifax (1977–1979)

Instructor:
University of Guelph, Guelph, Ontario (also 1979)

Artist-in-residence:
York University, North York, Ontario

Visiting artist:
York University, North York, Ontario (also 1979, 1983, 1986)
Ontario College of Art, Toronto (also 1979, 1982, 1986)
Artists Space, New York

Solo exhibitions:
Galeria Akumulatory 2, Warsaw
References (Odniesienia), Galeria Foksal, Warsaw
 (catalogue)
References (second version), P.S. 1, The Institute for Art
 and Urban Resources, Long Island City, New York
Lines on Culture, IDA Gallery, York University, North
 York, Ontario
Lines on Art, Eye Level Gallery, Halifax, Nova Scotia
Lines on Culture, Hal Bromm Gallery, New York
Guidelines, Campus Gallery, University of Guelph,
 Guelph, Ontario (catalogue)
Guidelines, A Space, Toronto

Group exhibitions:
Moving, Hal Bromm Gallery, New York (catalogue)
documenta 6, Kassel, West Germany (catalogue)
*22 Polnische Künstler aus dem Besitz des Muzeum
 Sztuki, Lodz*, Kunstverein, Cologne

1978

Moves to Halifax, Nova Scotia

Visiting artist:
Yale University, New Haven

Solo exhibitions:
Guidelines, Artists Space, New York
Guidelines, Hal Bromm Gallery, New York

1979

Instructor:
Industrial Design Department, Ontario College of Art,
Toronto

Visiting artist:
Simon Fraser University, Vancouver (also 1982, 1985)

Solo exhibitions:
Vehicles, Optica, Montreal
Vehicles, Eye Level Gallery, Halifax, Nova Scotia
Vehicles, Gallery 76, Toronto

Group exhibitions:
Bienal de Desenho, Lisbon
The Biennale of Sydney, Art Gallery of New South
 Wales, Sydney
L'Avanguardia Polacca, 1910–1978, Palazzo delle
 Esposizioni, Rome; Teatro di Falcone, Genoa; and
 Museo Ca Pesaro, Venice (catalogue)
*Ten Polish Contemporary Artists from the Collection of
 the Muzeum Sztuki, Lodz*, Richard DeMarco Gallery,
 Edinburgh (catalogue)

1980

Receives permanent-resident status in Canada

Assistant professor:
Intermedia and Photography, Nova Scotia College of
Art and Design (1980–1981)

Visiting professor:
Cultural Studies Program, Trent University,
Peterborough, Ontario (also 1981, 1983, 1984)

First tests of outdoor slide projections:
University of Toronto (various locations), Toronto

Indoor projections:
Subway, Toronto. Projection stopped by subway
 authorities for unauthorized use of electricity.
Maritime Mall, Halifax, Nova Scotia (organized with
 technical assistance from the Nova Scotia College
 of Art and Design, Halifax)

Solo exhibition:
Hal Bromm Gallery, New York

1981

Moves to Toronto

Artist-in-residence:
South Australian School of Art, Adelaide (1981–1982)

Public projections:
The Confederation Centre for the Arts, Charlottetown,
 Prince Edward Island (organized by The Great
 George Street Gallery, Charlottetown, in
 conjunction with solo exhibition)
Nova Scotia Power Corporation Plant, Halifax
 (organized by the Centre for Art Tapes and Eye
 Level Gallery, Halifax, in conjunction with solo
 exhibition at Eye Level Gallery)
School of Architecture, Technical University of Nova
 Scotia, Halifax (organized by the Centre for Art
 Tapes and Eye Level Gallery, Halifax, in conjunction
 with solo exhibition at Eye Level Gallery)
Scotia Tower, Halifax (organized by the Centre for Art
 Tapes and Eye Level Gallery, Halifax, in conjunction
 with solo exhibition at Eye Level Gallery)
Art Gallery of Ontario, Toronto (organized by A
 Space, Toronto)
City Hall, Peterborough, Ontario (organized by Artspace,
 Peterborough, in conjunction with solo exhibition)
Empress Hotel, Peterborough, Ontario (organized by
 Artspace, Peterborough, in conjunction with solo
 exhibition). Projection stopped by police at request
 of hotel management.
Massachusetts Institute of Technology, Cambridge
 (organized with technical assistance from the
 Massachusetts College of Art, Boston)

Solo exhibitions:
Franklin Furnace, New York
Artspace, Peterborough, Ontario
Projections, The Great George Street Gallery,
 Charlottetown, Prince Edward Island
Eye Level Gallery, Halifax, Nova Scotia (catalogue)

Group exhibition:
Erweiterte Fotografie, 5 (*Expanded Photography, 5*)
Internationale Biennale, Vienna

1982

Guest lecturer in art history:
Visual Arts Program, The Banff Center, Banff, Alberta

Visiting artist:
University of Sydney, Sydney
University of British Columbia, Vancouver (also 1985, 1987)
Cooper Union School of Art, New York (also 1986, 1988)
Emily Carr Art School, Vancouver (also 1985)
New York Institute of Technology, Old Westbury

Public projections:
War Memorial, Adelaide (organized by the Adelaide
 Festival and the South Australian School of Art,
 Adelaide, in conjunction with the exhibition *Poetics of
 Authority: Krzysztof Wodiczko* at the Gallery of the
 South Australian College of Advanced Education)
Festival Centre Complex, Adelaide (organized by the
 Adelaide Festival and the South Australian School of
 Art, Adelaide, in conjunction with the exhibition *Poetics
 of Authority: Krzysztof Wodiczko* at the Gallery of the
 South Australian College of Advanced Education)
Mutual Life and Citizens Assurance Company Centre
 Tower, Sydney (organized for *The Biennale of Sydney*)
Art Gallery of New South Wales, Sydney (organized for
 The Biennale of Sydney)
Qantas International Centre, Sydney (organized for
 The Biennale of Sydney)
American Express Building, Sydney (organized for *The
 Biennale of Sydney*)

Solo exhibition:
Poetics of Authority: Krzysztof Wodiczko, Gallery of the
South Australian College of Advanced Education,
Adelaide (catalogue)

Group exhibition:
The Biennale of Sydney, Art Gallery of New South
Wales, Sydney

1983

Moves to New York City

Associate professor of fine arts:
New York Institute of Technology, Old Westbury (1983–1987)

Visiting artist:
The Banff Center, Banff, Alberta
University of Alberta, Calgary
University of Regina, Regina, Saskatchewan

Public projections:
Victory Column, Schlossplatz, Stuttgart
Hauptbahnhof, Stuttgart (organized by the
	Württembergischer Kunstverein, Stuttgart, in
	conjunction with the exhibition *Künstler aus
	Kanada: Räume und Installationen*)
Bow Falls, Banff, Alberta (organized by The Banff Center)
Museum of Natural History, Regina, Saskatchewan
	(organized by the Regina Art Gallery)
South African War Memorial, Toronto (organized by the
	Ydessa Art Foundation, Toronto, in conjunction with
	solo exhibition). Undertaken, with lawyer present,
	despite denial of permission to project by Toronto
	Historical Board. Police halt projection after two hours.
Memorial Hall, Dayton, Ohio (organized by the City
	Beautiful Council, Dayton)
Old Courthouse, Dayton, Ohio (organized by the City
	Beautiful Council, Dayton)
Sinclair Community College, Dayton, Ohio (organized
	by the City Beautiful Council, Dayton)
Federal Court House, London, Ontario (organized by
	the Greater London Art Gallery, London)

Solo exhibitions:
Hal Bromm Gallery, New York
Ydessa Art Foundation, Toronto

Group exhibitions:
Künstler aus Kanada: Räume und Installationen (*Artists
	from Canada: Rooms and Installations*), Württem-
	bergischer Kunstverein, Stuttgart (catalogue)
*Presences Polonaises: L'Art vivant autour du Musée de
	Lodz*, Centre National d'Art et de la Culture
	Georges Pompidou, Paris (catalogue)
Social Space, Walter Phillips Gallery, Banff, Alberta

1984

Receives Canadian citizenship

Visiting artist:
Rutgers University, New Brunswick, New Jersey
University of Washington, Seattle

Public projections:
Seattle Art Museum (organized by the Center on
	Contemporary Art, Seattle, in conjunction with the
	exhibition *Public Comments*)
AT&T Long Lines Building, New York (organized by
	The Kitchen, New York)
Astor Building/The New Museum of Contemporary Art,
	New York (organized by The New Museum of
	Contemporary Art)

Conference Center, Ohio State University, Columbus
	(organized by the International Conference of
	Humanities on George Orwell's *1984*)
Penthouse Building, New York (organized by the Tower
	Gallery, New York, in conjunction with the exhibi-
	tion *Body Politic*)
Soldiers and Sailors Memorial Arch, Grand Army
	Plaza, Brooklyn, New York (organized by the
	Prospect Park Administrator's Office, New York City
	Department of Parks and Recreation)

Solo exhibition:
Hal Bromm Gallery, New York

Group exhibitions:
Public Comments, Center on Contemporary Art, Seattle
Body Politic, Tower Gallery, New York
New York/Canada, 49th Parallel, Centre for
	Contemporary Canadian Art, New York

1985

Visiting professor:
Nova Scotia College of Art and Design, Halifax

Visiting professor:
California Institute of the Arts, Valencia (also 1986)

Visiting artist:
University of Western Ontario, London

Public projections:
Performing Arts Center, State University of New York
	at Purchase (organized by the Neuberger Museum,
	State University of New York at Purchase, in
	conjunction with solo exhibition)
Nelson's Column, Trafalgar Square, London (organized
	by the Institute for Contemporary Art and The
	Artangel Trust, London, in conjunction with solo
	exhibition at Canada House, London)
South Africa House, Trafalgar Square, London. Pro-
	jection stopped by police after two hours as "public
	nuisance" at request of South African officials.
Duke of York's Column, Waterloo Place, London
	(organized by the Institute for Contemporary Art
	and The Artangel Trust, London, in conjunction with
	solo exhibition at Canada House, London)
Bundeshaus, Bern, Switzerland (organized by the
	Kunsthalle and Kunstmuseum Bern in conjunction
	with the exhibition *Alles und Noch Viel Mehr* at the
	Kunstmuseum)
Royal Bank of Canada, Place Ville-Marie, Montreal
	(organized by the Centre International d'Art
	Contemporain, Montreal, in conjunction with the
	exhibition *Aurora Borealis*)
Guildhall, Derry, Northern Ireland (organized by the
	Orchard Gallery, Derry, in conjunction with solo
	exhibition)

Cenotaph and Grand Parade War Memorial, Halifax
(organized by the Anna Leonowens Gallery, Nova
Scotia College of Art and Design, Halifax, in
conjunction with solo exhibition)

Solo exhibitions:
Neuberger Museum, State University of New York at
Purchase
Canada House, London
Orchard Gallery, Derry, Northern Ireland
Ydessa Art Foundation, Toronto
Robert McLaughlin Gallery, Oshawa, Ontario
Public Projections, Anna Leonowens Gallery, Nova
Scotia College of Art and Design, Halifax (brochure)

Group exhibitions:
Aurora Borealis, Centre International d'Art
Contemporain, Montreal (catalogue)
Alles und Noch Viel Mehr (Everything and Much More),
Kunstmuseum Bern, Switzerland (catalogue)
Eastern Europeans in New York, El Bohio, New York
*Entre a Ciência e a Ficção (Between Science and
Fiction)*, part of *18 Bienal Internacional de São
Paulo*, São Paulo (catalogue)

1986

Receives resident-alien status in United States

Visiting artist:
Academy of Fine Arts, Warsaw
Concordia University, Montreal
Nova Scotia College of Art and Design, Halifax (also 1987)
Maryland Institute, College of Art, Baltimore
University of Victoria, Victoria, British Columbia

Public projections:
Arsenale, Venice (organized by the Canadian
Pavilion, *XLII Biennale di Venezia*)
Condottierre Colleoni monument, Campo Santi
Giovanni e Paolo, Venice (organized by the
Canadian Pavilion, *XLII Biennale di Venezia*)
Campo Santa Maria in Formosa, Venice (organized by
the Canadian Pavilion, *XLII Biennale di Venezia)*
Campanile, Piazza San Marco, Venice (two versions)
(organized by the Canadian Pavilion, *XLII Biennale
di Venezia*)
Fine Arts Center, University of Massachusetts, Amherst
Allegheny County Memorial Hall, Pittsburgh
(organized by the Mattress Factory, Pittsburgh)
Replica of Condottierre Colleoni monument, Academy
of Fine Arts, Warsaw (organized by Galeria Foksal,
Warsaw, in conjunction with solo exhibition)
The Homeless Projection 2, The Soldiers and Sailors
Civil War Memorial, Boston (organized for First
Night, Boston)

Solo exhibition:
Galeria Foksal, Warsaw

Group exhibitions:
Jana Sterbak, Krzysztof Wodiczko, 49th Parallel, Centre
for Contemporary Canadian Art, New York
(brochure). Displays *The Homeless Projection: A
Proposal for Union Square.*
XLII Biennale di Venezia, Venice (catalogue)
Wallworks, John Weber Gallery, New York (catalogue)
Ten, Hal Bromm Gallery, New York (catalogue)
Real Property, City Without Walls, Newark, New Jersey
Nexus Center of Contemporary Art, Atlanta
Expanding Commitment, Maryland Institute, College
of Art, Baltimore (catalogue)
The Interpretation of Architecture, YYZ Gallery,
Toronto (catalogue)
Lumières: Perception-Projection, Centre International
d'Art Contemporain, Montreal (catalogue)

1987

Begins collaboration with writer David Lurie, leading
to Homeless Vehicle Project

Guest professor:
Sculpture Division, Cooper Union School of Art, New York
(also 1989)

Visiting artist:
School of the Art Institute, Chicago

Public projections:
Westin Bonaventure Hotel, Los Angeles (organized
by the Los Angeles Institute of Contemporary Art)
Museum Fridericianum, Kassel, West Germany
(organized for *documenta 8*, Kassel)
Monument to Friedrich II, Kassel (organized for
documenta 8, Kassel)
Martin Luther Kirche, Kassel (organized for *documenta
8*, Kassel)
Real Estate Projection, Chicago (organized by the
Randolph Street Gallery, Chicago)

Solo exhibitions:
*Counter-Monuments: Krzysztof Wodiczko's Public
Projections*, Hayden Gallery, List Visual Arts
Center, Massachussetts Institute of Technology,
Cambridge (catalogue)
The Real Estate Projection, Hal Bromm Gallery, New York

Group exhibitions:
documenta 8, Kassel (catalogue)
Immigrants and Refugees: Heroes or Villains, Exit Art,
New York

Poetic Injury: The Surrealist Legacy in Postmodern Photography, Alternative Museum, New York (catalogue)

Liberty and Justice, Alternative Museum and Group Material, New York (catalogue)

Art against AIDS, American Foundation for AIDS Research, New York (catalogue)

1988

Tests four variants of *Homeless Vehicle* in various locations in Manhattan and Brooklyn (1988–1989)

Visiting professor:
Academy of Fine Arts, Warsaw

Guest professor:
Department of Photography, School of the Arts, California Institute of the Arts, Valencia

Assistant professor:
Department of Photography, University of Connecticut, Hartford Art School, Hartford (1988–1989)

Visiting artist:
Academy of Fine Arts, Vienna
University of Arizona, Tempe
California State University, Northridge
University of California, Santa Cruz
University of California, San Diego
University of Texas at Austin (also 1990)

Public projections:
The Border Projection (part one), San Diego Museum of Man (organized by the La Jolla Museum of Contemporary Art in conjunction with solo exhibition)
The Border Projection (part two), Centro Cultural Tijuana (organized by the Centro Cultural Tijuana in conjunction with solo exhibition at the La Jolla Museum of Contemporary Art)
Flakturm, Arenberg Park, Vienna (organized by the Wiener Festwochen)
Neue Hofburg, Heldenplatz, Vienna (organized by the Wiener Festwochen)
National Monument and National Observatory, Calton Hill, Edinburgh (organized by The Artangel Trust, London, and the Fruitmarket Gallery, Edinburgh, for the Edinburgh Festival)
Hirshhorn Museum, Washington, D.C. (organized by the Hirshhorn Museum and Sculpture Garden as part of the exhibition series WORKS)
R. C. Harris Water Filtration Plant, Toronto (organized by Visual Arts Ontario in conjunction with the exhibition *WaterWorks*)

Solo exhibitions:
La Jolla Museum of Contemporary Art, La Jolla, California (brochure)
Kunstgewerbeschule, Vienna
WORKS, Hirshhorn Museum and Sculpture Garden, Washington, D.C. (catalogue and brochure)

Group exhibitions:
Temporary Public Art, The Storefront for Art and Architecture, New York
Public Image: Homeless Projects by Krzysztof Wodiczko and Dennis Adams, The Institute for Contemporary Art, The Clocktower Gallery, New York (catalogue)
WaterWorks, R. C. Harris Water Filtration Plant, Toronto (catalogue)
Public Discourse, Real Artways, Hartford (catalogue)
The Presence of Absence, Independent Curators Incorporated, New York (catalogue)
Wiener Festwochen, Vienna (catalogue)

1989

Tests *Homeless Vehicle* in various locations in Philadelphia

Begins work with Bruce Ferguson and Restless Productions, New York, on the mounting of public projections

Proposes lighting project for Philadelphia's City Hall in conjunction with Light Up Philadelphia. Not executed.

Works with inhabitants of Tompkins Square Park in staging photographs for the exhibition *New York City Tableaux: Tompkins Square Park*

Public projection:
Whitney Museum of American Art, New York (organized by the Whitney in conjunction with the exhibition *Image World: Art and Media Culture*)

Solo exhibitions:
Matrix 103, Wadsworth Atheneum, Hartford (brochure)
New York City Tableaux: Tompkins Square, Exit Art, New York. Traveled to: The Painted Bride Art Center, Philadelphia; Portland Art Museum, Portland, Oregon; Washington Project for the Arts, Washington, D.C.; and Wexner Center for the Visual Arts, Columbus, Ohio, through 1991 (catalogue)
Hal Bromm Gallery, New York
Galerie Gabrielle Maubrie, Paris

Group exhibitions:
Galeria Foksal, 1966–1988: Gallery-Archive-Collection, Galeria Foksal, Warsaw (catalogue)
Image World: Art and Media Culture, Whitney Museum of American Art, New York (catalogue)

The Photography of Invention: American Pictures of the 1980s, National Museum of American Art, Washington, D.C. (catalogue)

Magiciens de la Terre, Centre National d'Art et de la Culture Georges Pompidou, Paris (catalogue)

Vision and Unity, Van Reekum Museum, Apeldorn, the Netherlands (catalogue)

1990

Visiting professor:
Summer Institute, Simon Fraser University, Vancouver

Assistant professor:
Department of Photography and Studio, California Institute of the Arts, Valencia

Public projections:
Tuxedo Royale (ship), Tyne River, Newcastle upon Tyne, England (organized by First Tyne International, Newcastle upon Tyne, in conjunction with the exhibition *A New Necessity*)

Zion Square, Jerusalem (organized by The Israel Museum, Jerusalem, in conjunction with the exhibition *Life-Size: A Sense of the Real in Recent Art*)

Huth-Haus, Potsdammer Platz, West Berlin (organized by the Deutscher akademischer Auschtauschdienst [DAAD] in conjunction with the exhibition *Die Endlichkeit der Freiheit*)

Lenin monument, Leninplatz, East Berlin (organized by the Deutscher akademischer Auschtauschdienst [DAAD] in conjunction with the exhibition *Die Endlichkeit der Freiheit*)

Group exhibitions:
A New Necessity, First Tyne International, Newcastle upon Tyne, England (catalogue)

Life-Size: A Sense of the Real in Recent Art, The Israel Museum, Jerusalem (catalogue)

Die Endlichkeit der Freiheit (The Finitude of Freedom), DAAD, West Berlin

Illegal America, Exit Art, New York (brochure)

The Decade Show, The New Museum of Contemporary Art, New York (catalogue)

Galerie Gabrielle Maubrie, Paris

El Sueño Imperativo (The Imperative Dream), Circulo de Bellas Artes, Madrid

Rhetorical Image, The New Museum of Contemporary Art, New York (catalogue)

1991

Builds and tests *Poliscar* prototype on Manhattan's Lower East Side

Delivers commencement address, Nova Scotia College of Art and Design, Halifax

Visiting professor:
Ecole National Supérieure des Beaux Arts, Paris (1991–1992)

Visiting artist:
Massachusetts Institute of Technology, Cambridge
Ohio University, Athens

Public projections:
Arco de la Victoria, Madrid (organized by the Circulo de Bellas Artes, Madrid, in conjunction with the exhibition *El Sueño Imperativo*)

Oud-Amelisweerd, Bunnik, the Netherlands (organized by the Centraal Museum, Utrecht, in conjuction with the exhibition *Night Lines*)

Solo exhibitions:
Poliscar, Josh Baer Gallery, New York (brochure)
Galerie Gabrielle Maubrie, Paris

Group exhibitions:
The Projected Image, San Francisco Museum of Modern Art (brochure)

Night Lines, Centraal Museum, Utrecht, the Netherlands (catalogue)

Power: Its Myths and Mores in American Art, 1961–1991, Indianapolis Museum of Art (catalogue)

Devices, Josh Baer Gallery, New York

The Political Arm, John Weber Gallery, New York

The Art of Advocacy, Aldrich Museum of Contemporary Art, Ridgefield, Connecticut

1992

Produces *Alien Staff* prototype in collaboration with Fundació Antoni Tàpies and SOS Racisme, Barcelona

Assistant professor:
Massachusetts Institute of Technology, Cambridge

Solo exhibitions:
Muzeum Sztuki, Lodz (catalogue)

Krzysztof Wodiczko: instruments, projecciós, vehicles, Fundació Antoni Tàpies, Barcelona (catalogue)

Galerie Gabrielle Maubrie, Paris (catalogue)

Group exhibitions:
Muzeum Sztuki w Lodzi, 1931–1992: Collection-Documentation-Actualité, Musée d'Art Contemporain and Espace Lyonnaise d'Art Contemporain, Lyon (catalogue)

Pour la suite du Monde (For the Continuation of the Planet), Musée d'Art Contemporain, Montreal (catalogue)

SELECTED BIBLIOGRAPHY

Note: Catalogues and brochures for exhibitions not cited here are parenthetically noted in the Biography (pp. 164–170).

Writings and Statements by the Artist

Ostrowski, Andrzej (pseud.) and Karl Beveridge. "West/East: The Depoliticization of Art." *Fuse* (March 1980), pp. 140–143.

"Public Projection." *Canadian Journal of Political and Social Theory* 7 (Winter–Spring 1983), pp. 185–187. Reprinted in *Künstler aus Canada: Räume und Installationen.* exh. cat. Stuttgart: Württembergischer Kunstverein, 1983.

"For the De-Incapacitation of the Avant-Garde." *Parallelogramme* 7 (April–May 1984), pp. 22–26.

"The Wall." *Quintessence* 6. Dayton: City Beautiful Council, 1984, pp. 8–9. Reprinted in *Public Projections*, exh. brochure. Halifax: Anna Leonowens Gallery, Nova Scotia College of Art and Design, 1985.

"Memorial Projection." *October* 38 (Winter 1986), pp. 4–10.

"The Homeless Projection: A Proposal for the City of New York." In *Jana Sterbak, Krzysztof Wodiczko.* exh. brochure. New York: 49th Parallel, Centre for Contemporary Canadian Art, 1986. Reprinted in *October* 38 (Winter 1986), pp. 11–16.

"The Venice Projections." projection leaflet. Venice: Canadian Pavilion, *XLII Biennale di Venezia*, 1986. Reprinted in *October* 38 (Winter 1986), pp. 18–20.

"Conversation with Krzysztof Wodiczko" (with Douglas Crimp, Rosalyn Deutsche, and Ewa Lajer-Burcharth). *October* 38 (Winter 1986), pp. 22–51.

"Strategies of Public Address: Which Media, Which Public?" In Hal Foster, ed. *Dia Art Foundation Discussions in Contemporary Culture*, no 1. Seattle: Bay Press, 1987, pp. 41–45.

"Subject: Homeless Vehicle Project" (with David Lurie). *New Observations* 61 (October 1988), pp. 18–23.

"The Homeless Vehicle Project" (with David Lurie). *Sites* 20 (1988), pp. 58–59.

Krzysztof Wodiczko WORKS. exh. brochure. Washington, D.C.: Hirshhorn Museum and Sculpture Garden, 1988.

Matrix 103. exh. brochure. Hartford: Wadsworth Atheneum, 1988.

"The Homeless Vehicle Project" (with David V. Lurie). *October* 47 (Winter 1988), pp. 53–56.

"Projections." *Perspecta: The Yale Architecture Journal* 26 (1990), pp. 273–288.

"The Homeless Vehicle Project" (with David Lurie). In Mark O'Brien and Craig Little, eds. *Reimaging America: The Arts of Social Change.* Philadelphia: New Society Publishers, 1990, pp. 317–325

Artist's statement. *Rhetorical Image.* exh. cat. New York: New Museum of Contemporary Art, 1990, pp. 85–88.

The Homeless Vehicle Project (with David Lurie). Kyoto: Kyoto Shoin International, 1991 (ArT RANDOM series).

Poliscar. exh. brochure. New York: Josh Baer Gallery, 1991.

"Questionnaire," *Zone*, nos. 1 and 2. New York: Urzone, 1986, pp. 456–459

Writings about the Artist

Atkins, Robert. "Homicide, Homelessness and Winged Pigs." *Village Voice* 33 (February 16, 1988), p. 107.

_____. "Visual Havoc." *Elle* 5 (September 1989), p. 304.

Bach, Penny Balkin. "To Light Up Philadelphia: Lighting, Public Art, and Public Space." *Art Journal* 48 (Winter 1989), pp. 324–330.

Bain, Alice. "Screen on the Hill." *The List* (Scotland), August 19, 1988, p. 4.

Bonetti, David. "All Opposed..." *Boston Phoenix*, February 3, 1987, sec. 3, p. 9.

Borsa, Joan. "Krzysztof Wodiczko: Power and Ideology." *Vanguard* 12 (November 1983), pp. 14–17.

Bright, Deborah. "Public Projections and Private Images: Krzysztof Wodiczko and Eastern European Photography at MIT." *Afterimage* 14 (May 1987), pp. 5–7.

Buchanan, Nancy. "Krzysztof Wodiczko." *High Performance* 38 (1987), p. 82.

Buck, Louisa. "Projections: Bright Lights, Big City: The Work of Krzysztof Wodiczko." *The Face* 98 (June 1988), pp. 48–51.

Campbell, Duncan. "S.A.'s Nazi Slide." *City Limits*, September 6, 1985, p. 7.

Canogar, Daniel. "The Architecture of the Homeless." *Lapiz* 75 (1991), pp. 61–71.

Coleman, A. D. "Prophetic Porta-Home for 'Evicts'." *New York Observer* 3 (October 30, 1989).

Coutts-Smith, Kenneth. "Vehicles: Krzysztof Wodiczko at Optica, Montreal, and Eye Level, Halifax." *Artists Review* (Toronto) (April 1979), pp. 2–4.

Daniel, Krzysztof, Oscar, and Victor. "Conversations about a Project for a Homeless Vehicle." *October* 47 (Winter 1988), pp. 57–76.

Davies, Douglas. "Poland's Defiant Artists." *Newsweek*, August 1, 1983, pp. 72–73.

Dector, Joshua. "New York in Review." *Arts Magazine* 64 (January 1990), p. 97.

Deitcher, David. "When Worlds Collide." *Art in America* 78 (February 1990), pp. 120–127.

De la Croix, Horst et al. Gardner's *Art through the Ages*, 9th edn. San Diego: Harcourt Brace Jovanovich, 1991, pp. 1088–1089.

Demitrijevic, Nena. "Meanwhile, in the Real World." *Flash Art* 134 (May 1987), pp. 44–49.

Deutsche, Rosalyn. "Krzysztof Wodiczko's Homeless Projection and the Site of Urban 'Revitalization'." *October* 38 (Winter 1986), pp. 63–98. Reprinted in Carol Squires, ed. *The Critical Image: Essays on Contemporary Photography*. Seattle: Bay Press, 1990, pp. 88–120.

_____. "Uneven Development: Public Art in New York City." *October* 47 (Winter 1988), pp. 3–52. Reprinted in: Russell Ferguson, ed. *Out There: Marginalization and Contemporary Cultures*. Cambridge and New York: MIT Press and the New Museum of Contemporary Art, 1990, pp. 107–130; and Diane Ghirardo, ed. *Out of Site: A Social Criticism of Architecture*. Seattle: Bay Press, 1991, pp. 157–219.

Dollens, Dennis. "Homeless Vehicles." *ID Magazine of International Design* 35 (May–June 1988), p. 114.

"El Arco del Triunfo, convertido en soporte crítico de la guerra." *El Pais* (Madrid), January 20, 1990, p. 1

Faust, Gretchen. "New York in Review." *Arts Magazine* 66 (December 1991), p. 83.

Finkelpearl, Tom. "Public Image: Homeless Projects by Krzysztof Wodiczko and Dennis Adams." In Edward Leffingwell et al. *Modern Dreams: The Fall and Rise of Pop*. Cambridge and London: MIT Press and the Institute for Contemporary Art, New York, 1988, pp. 110–117.

Fleming, Martha. "Künstler aus Kanada." *Artforum* 22 (September 1983), pp. 81–82.

Foster, Hal. *Recodings*. Seattle: Bay Press, 1985, pp. 99–100.

Fulton, Jean. "Diary of a Projection." *New Art Examiner* 15 (January 1988), p. 72.

Gablik, Suzi. *The Reenchantment of Art*. New York: Thames and Hudson, 1991, pp. 100–102.

Gilroy, Roger. "Projection as Intervention." *New Art Examiner* 16 (February 1989), pp. 29–31.

Gitlin, Todd. "Fighting Words: Towards a Difficult Peace Movement." *Village Voice*, February 19, 1991, p. 136.

Grundberg, Andy. "Photography: Images and Issues." *New York Times*, May 22, 1987, p. C26

"A Conversation for Art's Sake." *Hartford Courant*, May 14, 1989, p. G1.

Heartney, Eleanor. "Krzysztof Wodiczko," *C* 23 (Fall 1989), pp. 29–31.

_____. "Living on Wheels," *ARTnews* 87 (Summer 1988), p. 18.

Hess, Elizabeth. "Secret (Homeless) Agent Man." *Village Voice*, September 24, 1991, p. 89.

_____. "No Place Like Home." *Art in America* 30 (October 1991), pp. 94–98.

Horne, Stephen. "Krzysztof Wodiczko." *Vanguard* 14 (November 1985), p. 30.

Howell, John. "Krzysztof Wodiczko." *Artforum* 23 (March 1985), pp. 99–100.

Hume, Christopher. "Not Your Average Slide Show." *Toronto Star*, April 16, 1983, p. H5.

_____. "Projecting Images of Ambiguity." *Toronto Star*, March 2, 1985, p. M5.

Isaacks, Joanna. "Review of *documenta 8*." *Parachute* 49 (December 1987), pp. 28–30.

Jarque, Pietta. "Posiciones radicales." *El Pais* (Madrid), December 22, 1990.

Jimenez, Carlos. "The American Disappointment." *Lapiz* 75 (1991), pp. 80–81.

Jones, Ronald. "Spotlight: Krzysztof Wodiczko." *Flash Art* 136 (October 1987), p. 101.

Joselit, David. "Projected Identities." *Art in America* 79 (November 1991), pp. 117–123.

Lajer-Burcharth, Ewa. "Urban Disturbances." *Art in America* 75 (September 1987), pp. 147–153, 197.

Leopard, Dan. "Krzysztof and the Pirates: Delimiting Intervention." *P-Form* 3 (February–March 1988), pp. 8–9.

Lovejoy, Margot. *Postmodern Currents.* Ann Arbor: UMI Research Press 1989, pp. 273, 284.

Lurie, David. "Krzysztof Wodiczko." *Arts* 60 (March 1986), p. 130.

McGonagle, Declan. "Art as an Issue of Place." *Alba* 7 (1988), pp. 14–17.

McNally, Owen. "Artist Projects: Strong Ideals in Concrete Images." *Hartford Courant*, September 11, 1988, p. 89.

Mahoney, Robert. "Krzysztof Wodiczko." *Arts* 62 (September 1987), pp. 108–109.

_____. "Krzysztof Wodiczko." *Arts* 63 (February 1989), p. 89.

Maxwell, Alisa. *Poetics of Authority: Krzysztof Wodiczko.* exh. cat. Adelaide: Gallery of the South Australian College of Advanced Education, 1982.

May, Derek (director-producer). *Krzysztof Wodiczko: Projections.* Documentary film. Montreal: National Film Board of Canada, 1991.

Michaud, Yves. "Des Deux côtés d'une vitre." In *L'Artiste et les commissaires.* Nîmes: Editions Jacquelin Chambon, 1989, pp. 203–219.

Nemiroff, Diana. *Melvin Charney, Krzysztof Wodiczko: Canada, XLII Biennale di Venezia, 1986.* Ottawa: National Gallery of Canada, 1986.

_____. "Identity and Difference—Canadians at Stuttgart." *Vanguard* 12 (Summer 1983), pp. 8–12, 72–73.

Newman, Michael. "Mysteries and Mercenaries: The Venice Biennale, 1986." *Artscribe International* 59 (September–October 1986), pp. 53–55.

Oliva, Achille Bonito. *Superart.* Milan: Giancarlo Politi, 1989.

Oille, Jennifer. "A Question of Place 2." *Vanguard* 10 (November 1981), pp. 12–17.

Ollman, Leah. "At the Galleries." *Los Angeles Times*, January 28, 1988, pt. 6, pp. 21–22.

Phillips, Patricia C. "Krzysztof Wodiczko." *Artforum* 26 (October 1987), p. 131.

_____. "Adams, Jaar, Wodiczko: des images parasites." *Art Press* 123 (March 1988), pp. 17–20.

Reisman, David. "Looking Forward: Activist Postmodern Art." *Tema Celeste* 29 (January–February 1991), pp. 58–62.

Rubey, Dan. "Krzysztof Wodicko." *ARTnews* 86 (November 1987), pp. 205–206.

Rogers, Steve. "Territories 2: Superimposing the City." *Performance Magazine*, August 9, 1985, pp. 37–38.

Salamon, Julie. "Art as Advocacy: A 'Mobile Home' for the Homeless." *Wall Street Journal*, April 4, 1989, p. A18.

Royoux, Jean-Christophe. "Résonances: Krzysztof Wodiczko." *Galleries Magazine* 46 (June–July 1992), pp. 56–59, 123–124.

Salisbury, Stephan. "Call it Cart Art: Here's a Vehicle That's Symbolic—and Useful." *Philadelphia Inquirer*, November 2, 1989. pp. 1c, 4c.

Schwarze, Richard. "The Intent Is to 'Demystify'." *Journal Herald* (Dayton, Ohio), May 21, 1983, p. 29.

Sherlock, Maureen. "Documenta 8: Profits, Populism, and Politics." *New Art Examiner* 15 (October 1987), pp. 22–25.

Smith-Rubenzahl, Ian. "Krzysztof Wodiczko: An Interview by Ian Smith-Rubenzahl." *C* 12 (Winter 1987), pp. 56–63.

Staniszewski, Mary Anne. "Urban Critic: City Lights." *Manhattan, Inc.* 4 (March 1987), pp. 151–158.

Stettler, Rachel. "Direct and Immediate Action: Wodiczko's Homeless Vehicle." *Issues: Public Art* (Winter–Spring 1989), p. 9.

Swisher, Kara. "Art off the Wall." *Washington Post*, October 26, 1988, p. D3.

Wallis, Brian, ed. *If You Lived Here: The City in Art, Theory, and Social Activism—A Project by Martha Rosler. Dia Art Foundation Discussions in Contemporary Culture*, no. 6. Seattle: Bay Press, 1991, p. 217.

Wilson, George. "Krzysztof Wodiczko's Homeless Vehicle Project." *Street News* (New York), April 1990, p. 19.

Wood, Paul. "Projection." *Artscribe* 73 (January–February 1989), pp. 12–13.

Wright, Patrick. "Home Is Where the Cart Is." *The Independent* (London), January 12, 1992, pp. 12–15.

Note: For Polish citations, see the bibliography in *Krzysztof Wodiczko.* exh. cat. Lodz: Muzeum Sztuki, 1992.

ACKNOWLEDGMENTS To bring an exhibition and accompanying book into being requires the assistance, collaboration, and support of a broad range of individuals and institutions. Though it is impossible to acknowledge them all, I would like to express my appreciation for the work of a number of key participants in the development of *Public Address: Krzysztof Wodiczko*.

For their help in securing loans and documentary materials for the exhibition and book, I would like to thank Stuart Anthony and Jeanette Ingberman, Exit Art, New York; Josh Baer, Halley Hallenberg, and Anna Kustera, Josh Baer Gallery, New York; Paul Berger, Seattle; Hal Bromm, Hal Bromm Gallery, New York; Jaromir Jedlinski, Muzeum Sztuki, Lodz, Poland; Ken Pelka, New York; and Rod Slemmons, Seattle. My coauthors, Dick Hebdige, Patricia C. Phillips, and Andrzej Turowski, have contributed important new insights into the artist's achievements. For their advice, insights, and efforts, I am grateful to Manuel Borja-Villel, Fundació Antoni Tàpies, Barcelona; Rosalyn Deutsche, New York; Bruce Ferguson, Restless Productions, New York; Madeleine Grynsztejn, San Diego Museum of Contemporary Art, La Jolla; Judith Martin, University of Minnesota, Minneapolis; Kathleen McLean, St. Paul; and Lois E. Nesbitt, New York. Suzanne Delehanty, Contemporary Arts Museum, Houston, lent vital support to the project in its early stages.

Additional advice, information, and encouragement were provided by Mariella Bisson, Prospect Park Administration, Brooklyn; Tom Finkelpearl, formerly of the Clocktower Gallery, Long Island City, New York; Warren Niesluchowski, Institute for Contemporary Art, Long Island City; Leonard Polakiewicz, University of Minnesota, Minneapolis; and Bob Riley, San Francisco Museum of Modern Art. I would also like to thank Gary Grefenberg, Minnesota Capitol Area Architectural and Planning Board, St. Paul, for his efforts in making possible the public projection that will accompany the Minneapolis presentation of the exhibition.

I owe an extraordinary debt of gratitude to the Walker Art Center staff, key members of which are listed on page 176. I want to extend special thanks to Martin Friedman, former director of the Walker Art Center, who initially authorized the development of this exhibition, and to Kathy Halbreich, who has lent enthusiastic support since taking over as director in 1991. Phil Freshman and Kristen McDougall shepherded this book through editing and design, respectively. Toby Kamps, Susan Lambert, Margaret Lee, and Michelle Piranio contributed their significant research skills. I also am grateful for the advice and encouragement of my curatorial colleagues at the Walker, Liz Armstrong, Gary Garrels, and Joan Rothfuss. My assistant and secretary, Henrietta Dwyer, bolstered me through the entire process with her good humor, organization, and tireless efforts on behalf of this project.

I wish to thank my wife, Julie Yanson, for her love, patience, and support; and our new son, Sam, for providing me with the joyous energy needed to complete an undertaking of this scope. Lastly, I thank Krzysztof Wodiczko for his cooperation, dedication, and tenacity in seeing this project through—and for his inspiration, which has made it all both possible and necessary.

In addition to those just mentioned and to the institutions listed in the Biography (pp. 164–170), Krzysztof Wodiczko is grateful to Ian de Gruchy, Heidi Schlatter, Leslie Sharpe, and

Steven White for their valuable help. He also wishes to thank François Alacocque, Georg Althause, Ross Barnes, Jody Berland, Gavin Blake, Sherry Buckberrough, Jörg Burger, Gordon Burrow, Duncan Campbell, Johnnie Carson, Harry Chambers, Werner and Elaine Dannheisser, Willy Doherty, Katharina Duttmann, Johnnie Eisen, Dennis Farley, Iona Fischer, Lorne Fromer, Michael Glasmeir, Edith Glischke, Have Facilities, Ltd., London, the Henry Moore Foundation, London, Becky Hunt, Monika Idehen, John Kippin, Katy Kline, Tomasz Koprowski, Jerzy Kozinski, Erich Kramer, Salem Krieger, Roland Krüger, Sergo Kuruliszwili, the Lower Manhattan Cultural Center, New York, Brian MacNevin, Jean-Hubert Martin, John Massey, Derek May, Declan McGonagle, Celia Metcalf, Milos Miladinovic, Andrea Miller-Keller, Stefan Moses, Heinz Nagler, the National Garden Festival Gateshead, London, Diana Nemiroff, the New York State Council on the Arts, Kenneth Orchard, Andrew Petrusevics, Cathrin Pichler, Jane Rhodes, Charles Rice, Phyllis Rosenzweig, Alison Rossiter, Douglas Scotney, David Schmittlap, Dieter Schwerdtle, Jay Seagram, Douglas Sharpe, John Siow, Milada Slizinska, Lee Stalsworth, Elzbieta Teichman, Chopin Thermes, Reinhard Truckenmüller, Mar Villaespesa, the Visual Arts Board of the Australia Council, Underdale, Brian Wallis, and Eugen Wolf.

Peter Boswell

REPRODUCTION CREDITS Photographs in this book were supplied by and are reproduced courtesy of Krzysztof Wodiczko and Josh Baer Gallery, New York, with the exception of the following: **front cover** (inset) Lee Stalsworth, Hirshhorn Museum and Sculpture Garden, Smithsonian Institution, Washington, D.C.; **p. 17** Reale Fotographia Giacomelli; **p. 25** The Bettman Archive, New York; **pp. 26, 32,** and **36** (top) Muzeum Sztuki, Lodz; **p. 45** Philipp Scholz Rittermann; **pp. 54, 72** (top left and bottom right), and **back cover** Jadwiga Przybylak; **p. 72** (top right and bottom left) John Ranard; **pp. 81** (top), **82,** and **83** Larry Lamé, Exit Art, New York; **p. 100** Reinhard Truckenmüller; **p. 109** Tom Collicott, Seattle Art Museum; **p. 120** Roland Aellig; **p. 134** Mattress Factory, Pittsburgh; **pp. 144** and **145** Philipp Scholz Rittermann, San Diego Museum of Contemporary Art, La Jolla; **pp. 152** and **153,** Ian Smith-Rubenzahl, Visual Arts Ontario; **pp. 156–157** Chris Wainwright, Tyne International and Project; **pp. 158** and **159** Werner Zellien; **p. 160** Ya'acov Harlap, The Israel Museum, Jerusalem.